COLLECTIONS MANAGEMENT
FOR MUSEUMS

COLLECTIONS MANAGEMENT FOR MUSEUMS

Proceedings of
an International Conference
held in Cambridge, England
26–29 September 1987
The First Annual Conference of
The Museum Documentation Association

Edited by
D. Andrew Roberts

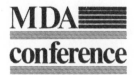

PUBLISHED BY
THE MUSEUM DOCUMENTATION ASSOCIATION
1988

First published 1988

The Museum Documentation Association
347 Cherry Hinton Road
Cambridge CB1 4DH
United Kingdom

(0223) 242848
+44 223 242848

ISBN 0 905963 61 X

Printed in Great Britain
by W. S. Maney and Son Limited
Leeds LS9 7DL

CONTENTS

PROCEDURAL AND POLICY DEVELOPMENTS IN INDIVIDUAL MUSEUMS

TRAINING AND ADVISORY DEVELOPMENTS

CONSULTANCY SUPPORT FOR MUSEUMS

COLLECTIONS MANAGEMENT SYSTEMS

PREFACE

Collections management was a natural choice for the first Annual Conference of The Museum Documentation Association: the International Conference on Collections Management for Museums, held in Cambridge in September 1987. The topic has become increasingly important to museums around the world as they work to control collections and demonstrate accountability, and as new computer systems become available for local adoption.

From a wealth of potential issues and contributors, it was possible to identify seven themes and over 30 speakers and chairs from the United Kingdom, Europe, Australia and North America. The resulting contributions have been used as the basis for the chapters in this book. Taken together they present an important review of collections management initiatives, with an emphasis on documentation, registration and automation principles and practice.

Four *surveys of collections management systems and practice* provide reviews of trends in the development of collections management in North America, Australia, the United Kingdom and the Nordic countries. *System design* is addressed in three papers which examine the scope, features and future possibilities for collections management systems. The positive development of the *role of professional groups* in the United States and Canada is complemented by an assessment of the need for registrars and a comparable professional group in the United Kingdom.

At a more practical level, eight papers examine different features of *procedural and policy developments in individual museums* in the United Kingdom, United States, Canada and Australia. The staff development and system change issues referred to in these papers are taken up in more depth in papers on *training and advisory developments* and *consultancy support* in the United Kingdom, the Netherlands, United States, Canada and Australia, and in a brief reference to the *systems forum and exhibition* held as part of the conference.

The Conference was the final element of a three-part programme, based in Cambridge from 20–29 September 1987. Preceded by the 1987 Annual Meeting of CIDOC (the Documentation Committee of the International Council of Museums) and a Study Tour to seven English museums, it attracted 150 delegates from 15 countries in five continents. The papers represent the formal proceedings; they were more than ably complemented by a systems exhibition, receptions, dinners, informal discussions and — the real high point — an international punt race on the River Cam.

The success of the conference was due in no small part to the input of the chairs and speakers. We were privileged to have contributors of such high standing, and gratefully acknowledge their enthusiastic support. The Chairs of each session have provided introductory chapters for these proceedings.

Philip Doughty chaired two sessions and — in his capacity as MDA Chairman — acted as the host at the receptions and a formal dinner. We were also honoured to have Professor Brian Morris — Chairman of the UK Museums and Galleries Commission — as a session chair and the guest speaker at the dinner. Their elegant contributions did much to enliven the conference.

My role as organiser was aided by willing help from other MDA staff. Particular recognition should be made of Stuart Holm, Steve Jones, Elizabeth Smith and Llywela Hopkins, each of whom had a key role, without which the conference would have come to a quiet halt.

ANDREW ROBERTS
December 1987

CONTRIBUTORS

TIMOTHY M. AMBROSE
Chapter 32

Timothy Ambrose, 37, is currently Acting Director of the Scottish Museums Council and is a member of the Museum Documentation Association's Executive Committee. He joined the Scottish Museums Council as Depute Director in 1982. He was previously Assistant Keeper of Archaeology for Lincolnshire Museums from 1977 to 1982, and Research Assistant in European Archaeology at the University of Oxford from 1980 to 1982. Prior to that he worked as an Archivist for the Ashmolean Library at the University of Oxford and as a Research Assistant for the Department of the Environment and the Danebury Trust.

He has published widely and recent publications include *New Museums: A Start-Up Guide* (HMSO, 1986) and *Education in Museums, Museums in Education* (ed., HMSO, 1987).

He is married with two daughters and lives in Edinburgh.

Dr PATRICK J. BOYLAN
Chapter 17

Aged 47, Patrick Boylan trained and worked as a secondary school science teacher before entering the Hull Museums in 1964, where he worked as Keeper of Geology and Natural History and also gained a distinction in the Museums Diploma. This was followed by four and a half years as Director of Museums and Art Gallery in Exeter before moving on to the same job with the City of Leicester in 1972.

In October 1973 he was appointed to his present post as Director of the new Leicestershire County Council, Museums, Art Galleries and Record Service which, following the recent demise of the metropolitan counties, is much the largest county museum service in the country. A major preoccupation over the past eight years has been the development and implementation of the use of computers and information technology in many aspects of the work of the Leicestershire Service, ranging far beyond the traditional museum documentation role. In this field, he is currently working on plans for the major new Snibston Industrial Heritage Museum development in northwest Leicestershire, which is planned to be information technology 'driven'.

Outside Leicestershire, he has been actively involved in professional staff training both in the UK and abroad for more than 20 years, and is currently the Chairman of the International Committee for the Training of Personnel of ICOM, whilst in the UK he is Professional Vice-President of the Museums Association. Numerous publications and consultancies, both nationally and internationally, in the fields of museum management and training have included 'The Changing World of Museums and Art Galleries' for the current INLOGOV review of the future of British local government and its services.

PHILIP S. DOUGHTY
Chapters 2 and 36

A Yorkshireman, educated at Archbishop Holgate's Grammar School, Barnsley, and Nottingham University where he read geology, Philip Doughty entered museums in 1963 as an Assistant Curator in Scunthorpe Museum. He is currently Keeper of Geology in the Ulster Museum, Belfast, one of the two national museums of Northern Ireland. He has had a career-long interest in the development of professional structures and procedures in museums, serving the Museum Professionals Group, the Museums Association and the British Association for the Advancement of Science. He was a founder member of the Geological Curators' Group of the Geological Society of London, the first of the 'new wave' curatorial groups,

and he served as Recorder, only standing down as its Chairman in 1986. His involvement with, and support for, modern documentation in museums dates from the early 1970s. He was Chairman of the Information Retrieval Group of the Museums Association to 1978 and a founder Executive Member of the Museum Documentation Association in 1977. He became Chairman of MDA in 1984.

His two current major enthusiasms are for the widespread introduction and practice of modern museum documentation based on a national standard, and the popularisation and elevation of science, particularly geology, to a balanced position in national cultural life. To this latter end he speaks widely, broadcasts locally and occasionally nationally, and has recently become the Recorder designate of Section C of the British Association for the Advancement of Science.

MAXINE ESAU
Chapter 21

Assistant Registrar, Central Catalogue, Australian National Gallery, Canberra since 1982. 1980–82 worked in the Registrar's Department as Records Clerk and Cataloguer. Eight years experience as technical officer in electronics and computer science. BA in Fine Art and Linguistics.

As Assistant Registrar, she coordinated the design of the IMAGES System and supervised the implementation of the Gallery's computer installation.

RICHARD FOSTER
Chapter 18

Director of National Museums and Galleries on Merseyside since 1986. Previously Director of Merseyside County Museums 1978–86. Director of Department of Museum Services, Oxfordshire 1970–78. Educated at London School of Economics and Manchester University. Fellow of the Society of Antiquaries, Fellow of Museums Association, Council Member of Museums Association 1977–80. Member of Executive of ICOM UK. His research interests are in the field of vernacular architecture, his museological interests are in exploring new ways of making collections more accessible to the public.

JENNIFER J. GAME
Chapter 4

BSc (Hons) and Grad. Dip. Lib.

Appointed the first Registrar at the Australian War Memorial and Museum in 1982. Sent on a study tour of North American museums in 1984 by the Australian Government. Responsible for the installation of MINISIS on a Hewlett Packard 3000/37 for collections management at the Memorial.

In 1986, appointed Registrar at the Australian National Maritime Museum to be opened in Sydney in 1988. Involved with the installation of a local area network of IBM compatible personal computers and multiuser RBASE V. Currently Manager, Conservation at the Australian National Maritime Museum.

JOHN C. HODGE
Chapter 29

Was appointed in 1975 to set up the first Museum Studies Course at the University of Sydney. He is a Science graduate (zoology) and an Education graduate from the University of Queensland where he worked as a Professional Officer for seven years. In 1967 he was appointed as the first Education Officer at the Queensland Museum where he remained until his present appointment. He is currently Senior Lecturer and Director of the Museum Studies Unit within Sydney University. In 1971 he was awarded a Churchill Fellowship to study museums as educational institutions in Great Britain, Europe and North America. He is an Associate of the Museums Association of Australia and Vice-Chairman of the Australian National Committee of ICOM. His research interests relate to educational evaluation of museum programmes and reed organ music.

JEANNE HOGENBOOM
Chapter 26

In 1980 Jeanne Hogenboom became an assistant in the Library of the Maritime Museum of Rotterdam.

Through an experiment on the registration of the museum's slides collection, she joined the MARDOC working group on 'registration of pictorial materials'. In 1982 she

became an employee of the MARDOC-foundation and was co-editor of the manual on registration of pictorial material, published in the same year. Since then she has worked in the MARDOC-team, on several aspects of museum documentation, such as: thesaurus-construction, system design and registration methods. Since 1986 she is a project adviser on documentary and art history information. She has nearly finished her studies in art history at the University of Amsterdam.

In 1986 Mrs Hogenboom became secretary of SIMIN (the information section of the Dutch museum association).

STUART HOLM
Chapter 25

Stuart Holm began his museum career as a newly qualified biology graduate seeking temporary voluntary work until he could get a 'proper' job as a biologist. A brief period helping to reorganise the stores at Hertford Museum made him aware from the outset of the need for good documentation. After voluntary work on an archaeological excavation, also at Hertford, he was appointed as Museum Assistant with the Pembrokeshire County Museum Service.

Having gained experience in general museum work, Stuart moved to Scunthorpe as Assistant Curator (Local History) where the need for better subject retrieval led him to experiment with classification schemes. Moving to the Black Country Museum he spent nearly ten years as Keeper of Social and Industrial History. These were formative years for the museum, which was just embarking on the creation of an open air social history and industrial museum on a site near Dudley. Achievements during this period were the development of techniques for recording and dismantling brick buildings and subsequently recreating them authentically on the museum site, and a major contribution to the SHIC classification system, now widely used by UK museums. He was the first chairman of the West Midlands Social and Industrial History Collections Research Unit and was responsible for introducing a computerised documentation system at the Black Country

Museum. This increasing commitment to documentation led to his appointment as MDA Advisory Officer, a post he has held since February 1985. Currently he is responsible for providing documentation advice and training throughout the UK and Channel Islands.

PETER HOMULOS
Chapter 7

Peter Homulos has been Director of the Canadian Heritage Information Network (CHIN) and its predecessor for over ten years, and Chairman of CIDOC since 1983.

CARSTEN U. LARSEN
Chapter 6

Title: museumsinspektør (curator), head of Documentation Department, National Museum of Denmark.

Education: 1983 exam. scient, in computer science, University of Copenhagen.

1985 mag. art. in prehistoric archaeology, University of Copenhagen. The finishing paper concentrating on implementing multivariate analysis in chronological aspects concerning urns of late Bronze Age in Denmark.

The Documentation Department consists of two offices, both funded by the Ministry of Culture.

The Central Cultural–Historical Archive was founded in 1982. The main aim is to register museological information of common interest in Denmark. Since the museum act of 1984 all historical museums report to this bureau. Thus the bureau is the national body for prehistoric and historic museums databases.

Office of Documentation at the National Museum was created in 1987 and will until 1994 use £5,000,000 in improving the documentation of the National Museum by the help of new technology. This office is the central body for all databases at the National Museum.

GEOFFREY D. LEWIS
Chapter 27

Director of Museum Studies, University of Leicester since 1977. Previously Director, Merseyside County Museums, Liverpool

and Director of Sheffield City Museums. Born in Brighton, England in 1933. MA (University of Liverpool). Fellow (and diplomate) of the Museums Association and of the Society of Antiquaries of London. President of the International Council of Museums (ICOM) since 1983; previously Chairman of the ICOM Advisory Committee and its International Documentation Committee (CIDOC). Past President of the Museums Association; founder and first Chairman of the Information Retrieval Group of the Museums Association (IRGMA) in 1967, precursor of the Museum Documentation Association (MDA).

RICHARD B. LIGHT
Chapter 8

Born and educated in Yorkshire, Richard Light attended Cambridge University to read Mathematics and Theoretical Physics. This was followed by a period working for the Institute of Electrical Engineers as an information scientist helping to produce Physics Abstracts, a monthly current awareness bulletin.

His first involvement with museums came when he moved in 1974 to the Sedgwick Museum, Cambridge, as a Research Assistant on a British Library-funded research project. His primary role was to manage the transfer of data on 440,000 fossils to a computer-based system, but he was also involved in helping the IRGMA committee to develop and test its multidisciplinary recording system.

In 1977 Richard joined the newly-formed Museum Documentation Association as a Research Officer. The early work of the Association concentrated on developing both manual and computer-based systems, and (like most MDA staff in those days) he was involved in most aspects of this work, including extensive travel to advise and train museum staff.

He is currently Deputy Director of the MDA, and has particular responsibility for system development and computer-related aspects of the Association's work.

JONATHAN MASON
Chapter 14

Joined the Registrar's Department of the Tate Gallery, London as a Museum Assistant in January 1976; Permanent Collection Registrar from 1981; Registrar (Permanent Collection and Exhibitions) from 1987. Registrar of the National Galleries of Scotland, Edinburgh from January 1988.

REBECCA MORGAN
Chapter 33

Rebecca Morgan is a computer consultant with Touche Ross who has specialised in the application of computer techniques to large records management problems. Having qualified as a Textile Technologist she transferred to the computer field. Prior to entering management consultancy, she held a variety of analysis and management positions, in both the public and private sector.

Her involvement in records management systems has spanned a wide range of application areas. In additon to work in the museum environment she has also reviewed record keeping and management techniques for a national library, a patents retrieval system, the maintenance of clinical trial records, and also determined the records management requirements for central government departments.

In addition to the work in the specialised field of records management, she also carries out strategic consultancy assignments, determining how information technology can be used to improve competitive edge and to ensure that the information requirements of large complex organisations can be met effectively.

PROFESSOR BRIAN R. MORRIS
Chapter 24

Principal Saint David's University College, Lampeter, since 1980; born 4 December 1930; married 1955, Sandra Mary James, JP; one son, one daughter. Education: Cardiff High School, Worcester College, Oxford (MA, DPhil). National service with Welch Regiment, 1949–54.

Taught English Literature (especially Shakespeare and seventeenth-century drama) at the Universities of Oxford,

Birmingham, Reading and York, before becoming Professor of English at Sheffield University from 1970–80.

He is a Trustee of the National Heritage Memorial Fund, a Director of the British Library Board, a Trustee of the National Portrait Gallery, Vice-President of the Museums Association, Vice-President of the Council for National Parks, etc. He has served on the Museums and Galleries Commission since 1976, and the Prime Minister appointed him Chairman of it in 1985.

He has published books on Shakespeare, seventeenth-century poetry, and Elizabethan drama, as well as three volumes of his own poems.

Long, long ago he played badminton for Oxford, rugby for anyone's extra-B fifteen, was Welsh Junior quarter-mile champion, and (briefly) earned his living boxing in a fairground. He now cycles, walks over the mountains and runs long distances across country rather slowly. He has ambitions to run at least a half-marathon before senility sets in.

JOANNE M. NERI
Chapter 30

Born in 1955, with joint British and American nationality. Currently a graduate student in the documentation of collections. BFA, San Francisco Art Institute, 1984; MA, Center for Museum Studies, John F. Kennedy University, anticipated 1988. Joy Feinberg Scholarship recipient, 1986.

Specific research projects on computer collections management issues and system design features included work with the Seattle Art Museum, the Fine Arts Museums of San Francisco and the Art Museum Association of America. Her practical work experience is primarily associated with academic requirements. As an intern/assistant registrar at the Fine Arts Museums of San Francisco, she held responsibility in manual and automated inventory, accessioning and other information handling activities. Past experience includes responsibilities as cataloguing and research assistant at the San Francisco Art Institute, working with their slide, film and video collection. In addition

she has worked with the York Archaeological Trust as an excavation and recording assistant.

CHRISTOPHER NEWBERY
Chapter 31

Attended University of Leicester 1968–72, and awarded a Degree in History and a Graduate Certificate in Museum Studies. Commenced employment as a Research Assistant at the London Museum, Kensington Palace, working specifically on the creation of the new Museum of London in the Barbican which opened in 1976. Subsequently became a Senior Assistant Keeper in the Modern Department of the Museum of London before leaving to gain management experience as curator of two Local Authority Museums: firstly at Chichester in West Sussex and secondly at Newport in Gwent. Returning to London in 1983, became the first London Museums Officer for the Area Museums Service for South-East England, providing advice and assistance to some 200 non-national museums in the Greater London area.

Presently Deputy Secretary and Head of the Museums and Grants Section of the Museums and Galleries Commission. Particular responsibility for liaison with non-national museums, for funding and monitoring the work of the English Area Museum Councils and the Museum Documentation Association and for a number of project-based grant schemes. Over the past two years, has also been responsible for negotiating transitional funding arrangements for museums directly affected by the abolition of the GLC and Metropolitan County Councils, and for the publication of reports on the Registration of Museums and the Museum Professional Training and Career Structure.

RICHARD ORMOND
Chapter 16

Born 1939; educated at Marlborough College, Brown University, USA and Christchurch, Oxford.

Assistant Keeper, City Museum & Art Gallery, Birmingham, 1962–65; Assistant Keeper, National Portrait Gallery, London,

1965–75; Deputy Director, National Portrait Gallery, London, 1975–83; Head of Pictures, National Maritime Museum, Greenwich, 1983–86; currently Director, National Maritime Museum, Greenwich.

Author of books and catalogues, chiefly on nineteenth- and twentieth-century British art, including *J. S. Sargent*, 1970; *Early Victorian Portraits in the National Portrait Gallery*, 2 vols, 1973; *Lord Leighton*, with Leonée Ormond, 1975; *Face of Monarchy*, 1977; *Sir Edwin Landseer*, 1982; *The Great Age of Sail*, 1986.

Married to Leonée Ormond, senior lecturer in English, King's College, London; two sons.

PHILIP W. PHILLIPS
Chapter 18

Philip joined the staff of the then City of Liverpool Museums in 1972 after graduating with a geology degree from University College Cardiff. He became Assistant Keeper of Geology in 1973. His geological interests are mainly in Lower Carboniferous palaeontology and palaeoecology of the north of England and north Wales. He has been president of the Liverpool Geological Society 1980–82 and is currently their Hon. Archivist. He was also a Vice-president of the Geology Section of the British Association in 1981. Museum interests include improving the accessibility of the reference collections through computer documentation and projects such as the Natural History Centre at Liverpool Museum. Currently he is working on combined computer videodisc systems for use in public displays.

D. ANDREW ROBERTS
Chapters 1, 5, 34 and 36

Andrew Roberts married and joined the MDA within a short period in 1977. Ten years later, both decisions continue to seem wise. After an initial MDA appointment as Research Officer he became Secretary in 1979 and Director/Secretary in 1987.

Born and brought up in Newport, South Wales, he read a BSc in Geology/Archaeology at Leicester University (1969–72) and an MSc in Information Science at The City University, London (1973–74), with an intervening interlude as a Library Assistant in Cardiff. He transferred from City to become a Research Assistant on a research project at the Sedgwick Museum, Cambridge, with initial responsibility for establishing the parameters for a national survey of cataloguing practice then acting as secretary of the IRGMA committee chaired by Geoffrey Lewis and Philip Doughty.

Early roles with the MDA included the continued development of data standards, record cards and control forms and providing field advice. Undertook an Office of Arts and Libraries funded research project in 1981–83 to investigate the state of documentation procedures in museums (published as *Planning the documentation of museum collections*). More recently involved with a survey of documentation and automation practice in museums in South-East England. Current responsibilities include consultancy, publications and conferences.

LENORE SARASAN
Chapters 9 and 35

Lenore Sarasan is President of Willoughby Associates, Limited, a company specialising in automating museum collections. Ms Sarasan started her university study in nuclear physics and radioastronomy at the University of Illinois, Urbana, completing advanced work in Mathematics and Computer Science at the University of Illinois, Chicago. She is a prolific publisher of articles, papers, and books in her field, is a frequent speaker, and conducts seminars for major museum-related organisations in the United States and abroad.

KAROL A. SCHMIEGEL
Chapter 12

Karol Schmiegel is the Chairman of the Registrars Committee of the American Association of Museums. She received an AB degree from Smith College and a MA degree from the University of Delaware, both in art history. She is also an alumna of the Museum Management Institute. Ms Schmiegel is the Treasurer of the Mid-Atlantic Association of Museums and the Registrar at Winterthur Museum, where she is currently implementing a computerised Collections Information

Management System for 83,000 decorative and fine art objects. Her responsibilities include inventory control and object movement. She is the author of several articles on American painting and museology.

JANE E. SLEDGE
Chapter 3

I was once caught off guard by an interviewer who asked me to describe myself in a word. The word is serendipitous. I was lucky enough to be hired by the National Inventory Programme, later renamed the Canadian Heritage Information Network (CHIN), while in the middle of writing a Master of Museum Studies' thesis on Ontario gardens. Without background in computers, I quickly found myself learning about 'fields and databases' and acting as intermediary with other museum professionals struggling to understand the nuances of new technology. As Assistant Director for Museum Services I had the opportunity to experience first hand the trauma of new technology, the impact of change, and the joy of surviving the transition. Ten years later, with experience in museum consulting, collections' insurance, and museum security, I now find myself at the Smithsonian Institution contributing my experience to the development and implementation of an automated collections information system, as Collection Information System Administrator in the Office of Information Resource Management.

FREDERICKA SMITH
Chapter 14

Joined the National Maritime Museum, Greenwich, London in 1979 as a Museum Assistant working first in Information Retrieval and then in the Ships Department. Later appointed Loans Officer to coordinate and control loans from the collections, this was the first such appointment. In January 1986 appointed as the first Registrar of the Victoria & Albert Museum, the National Museum of Art & Design with collections in excess of four million objects and 11 curatorial departments. It is hoped that an internationally recognisable registration system can be set up.

ROGER SMITHER
Chapter 15

Roger Smither was born in Istanbul, Turkey on 13 April 1948. After obtaining a BA degree in History from Cambridge University and a year's postgraduate research, he joined the Imperial War Museum as a film cataloguer in July 1970. From 1973 to 1976, he was responsible for the development and implementation of the computer system APPARAT, which handled both cataloguing and collections management in the Museum's film archive. Since 1977, he has been Keeper of the Department of Information Retrieval, with a staff of five and responsibilities extending over documentation work in all the Museum's seven collecting departments. He has supervised the transfer of the Museum's computerised cataloguing work, including the APPARAT files, to the Museum Documentation Association's bureau service, and is currently overseeing the introduction of PCs into a number of Departments for both data entry and collections management implementations. He has worked with various national and international organisations involved in the cataloguing and documentation of museum and audio-visual archival collections, and published several pieces on cataloguing practice and procedures and the application of computers to them, including the second *FIAF study on the usage of computers for film cataloguing* (FIAF, 1985). He is married with two (twin) children.

KATHERINE P. SPIESS
Chapter 19

A native of Portsmouth, New Hampshire, Katherine P. Spiess holds a Bachelor of Arts in Mathematics/Computer Sciences from the University of New Hampshire and a Masters in Museum Studies from the New York State University, Cooperstown Graduate Program.

In 1973, Mrs Spiess became the first Registrar of Strawberry Banke, an historic preservation maritime community in Portsmouth, where she developed the organisation's first registration and cataloguing systems. In 1975, Mrs Spiess assumed the position of Registration Specialist at the

National Museum of American History. In that capacity, she was responsible for developing the Museum's initial independent acquisition and accession program and for managing its automated collections information system. From 1982–84, while serving as Chief of the Computer Services Center, Mrs Spiess oversaw the selection and installation of the Museum's first inhouse computer system. In her current position, Mrs Spiess continues to manage the Museum's automated collections information system and assists in formulating and implementing the Museum's policies and procedures for proper management of the collections.

Mrs Spiess is an Adjunct Professorial Lecturer in the graduate Museum Studies Program at George Washington University, where she teaches a course in collections management. She participates in several seminars annually, conducting sessions in the development of cataloguing systems and the use of computers by museums.

MARGARET STEWART
Chapter 14

Registrar, National Gallery, London.

JANE SUNDERLAND
Chapter 9

Jane Sunderland is Vice President of Willoughby Associates, Limited, a company specialising in automating museum collections. Ms Sunderland directs the company's West Coast operation and supervises the design and development of custom systems. Her undergraduate university study was in Biological Anthropology at Harvard University and she is currently pursuing graduate study in film production at the University of California, Los Angeles.

SONJA TANNER-KAPLASH
Chapter 13

Sonja Tanner-Kaplash has a background in Fine Art History and Business Administration, and was awarded the 1985 National Museums of Canada Fellowship in Museum Studies to complete a PhD at the University of Leicester. She teaches and lectures

extensively and was seconded to the University of Toronto to teach the Graduate Programme in Museum Studies in 1984. She is active in both provincial and national museum associations, and is the current President of the Ontario Museum Association.

In 1980 she was appointed Registrar of the Royal Ontario Museum; she had been with the institution since 1974 in other capacities. The ROM is perhaps the third largest museum in North America, with 19 curatorial departments; the Registrars Office, with a staff of 10, is responsible for all aspects of documentation on the collections, including an active loans programme. In conjunction with a major building and renovation project the Museum began to computerize collections documentation, using the services of a federal agency; the Registrar was responsible for planning and implementing this initial stage of computerisation, which has provided the foundation for the Museum's current computerised documentation system.

Dr LYNNE TEATHER
Chapter 28

Dr Teather is the Graduate Co-ordinator of the Museum Studies Masters Program at the University of Toronto where she has been a full-time faculty member since 1984. Before that, she worked at the Canadian Heritage Information Network, National Museums of Canada and at a small historical society museum in Niagara-on-the-Lake, Ontario and was a part-time Instructor in Museum Studies. In 1984, Dr Teather became the first graduate of the Doctor of Philosophy in Museum Studies at the University of Leicester with a thesis entitled *Museology and Its Traditions: The British Experience, 1845–1945* and continues her research on the historical roots of museum work now looking at the Canadian scene. She is also active in the museum profession and is the author of the Canadian Museums Association study *Professional Directions for Museum Work in Canada: An Analysis of Museum Jobs and Museum Studies Training Curricula, 1978.*

CONTRIBUTORS

STEPHEN TONEY
Chapter 10

Stephen R. Toney is the acting director of the Office of Information Resource Management, Smithsonian Institution, where he supervises 90 staff who plan, develop, and operate Smithsonian computer systems and data and voice communications systems. Previously, Mr Toney headed the Information Management Division of OIRM; the Division is responsible for the Smithsonian's IRM policy and planning, including data administration.

He worked in a number of libraries, both as systems analyst and also in traditional library positions. He was responsible for planning and procurement of the Smithsonian's bibliographic system, used by the Smithsonian libraries, six archival repositories, and several research projects. Previous to the Smithsonian, Mr Toney was a programmer and systems analyst with the Library of Congress.

Mr Toney owns Systems Planning, a firm which assists cultural institutions in planning and developing information systems. He holds a Master of Library Science degree (British Columbia), a Master of Computer Science (Virginia Tech), and a BA in Studio Art (Antioch College).

DAVID WATSON
Chapter 23

Born in 1954 in Perth, David Watson graduated from the University of Western Australia in 1976 with a Bachelor of Psychology. He joined the Australian Public Service as a Psychologist in 1977, where he had his introduction to computers by using them as a tool for data analysis. In 1979, he joined the Department of Veterans Affairs in the role of a statistical computing consultant for departmental medical researchers.

Over the years David had maintained an active spare-time interest in films, and largely as a result of this was appointed to a position in the National Film Archive of Australia (later to become the National Film and Sound Archive) in 1982. His initial appointment was head of acquisition of film and television material, but he also was given responsibility for the film archive's manual accessioning

system. Within a short time, he realised the futility of maintaining a manual system and started work on what eventually became the film and television collections management system, FLICS.

In 1985, he became the head of the film and television cataloguing and access unit. As a result of the Archive's increasing use of computers, David eventually took on the task of coordinating computer work for the entire Archive. In 1987, he moved into the newly created position of Information Systems Coordinator for the entire Archive. Current responsibilities include managing the conversion of FLICS from ADABAS to Oracle, coordinating the planning and development of a Sound & Radio collections management system (called SONICS), purchasing new computer equipment and software and supervising the operation of the Archive's computer facilities.

ANNETTE WELKAMP
Chapter 22

Cataloguer, University Gallery, University of Melbourne, Melbourne, Australia. Previously Curator of the McClelland Regional Gallery, Langwarrin, Victoria and Assistant Curator of Monash University Gallery, Clayton, Victoria. She has a Bachelor of Economics from Monash University, Victoria, and a Graduate Diploma of Museum Studies from Victoria College. She was Secretary of the Art Museums Association of Australia in 1986 and is currently a committee member of the Victoria Branch of the Museums Association of Australia.

PETER WILSON
Chapter 11

Peter Wilson was born in 1947 and educated at Eltham College and Pembroke College, Cambridge, where he read Natural Sciences. He is married and has a son and two daughters. He lives in Strawberry Hill, Middlesex.

After a brief career in the surface coatings and chemical industries he won a Department of Education and Science four year studentship in the conservation of easel paintings at the Tate Gallery. He was

awarded the Gallery's Diploma in Conservation in 1976 and immediately joined the permanent staff of the Conservation Department with special responsibility for environmental control and monitoring.

In 1980 he moved to be Head of Technical Services in the then newly-formed Department of Exhibitions and Technical Services. A major concern has been the introduction of computer-based collections management procedures. He is a member of the Tate Gallery Planning Group for which his recent responsibilities have included the lighting and environmental monitoring systems for the new Clore Gallery, the technical briefs for the proposed redevelopment of the main building and the development of the remainder of the Queen Alexandra Military Hospital Site to provide a Museum of New Art, Sculpture Museum and Study Centre. Another area of responsibility is the transport of works of art and he is working on a computer-based specification system for the use of the Registrar's Office.

Apart from his work at the Tate, he has managed to find a little time for a postgraduate research project on Gallery Lighting Conditions at the Bartlett School of Architecture & Planning, University College London. He is currently serving as an MDA Executive Committee member and is the Co-ordinator of the ICOM Committee for Conservation's Working Group 12: 'The Care of Works of Art in Exhibitions and in Transit'.

TOSHIO YAMAMOTO
Chapters 20 and 28

Toshio Yamamoto completed the requirements for a BSc in Biology at the University of Toronto and a MSc in Entomology from the University of Illinois. In 1966, he returned to the Royal Ontario Museum as a Curatorial Assistant in the Department of Entomology and Invertebrate Zoology.

In May of 1978, he was seconded by the Museum to assume the position of Coordinator of Collections Management. This term appointment was created to ensure a safe and orderly movement of all the collections in conjunction with the ROM Renovation and Expansion Project.

This position became a permanent part of the Museum administration in 1982 with the incumbent reporting to the Associate Director — Curatorial, and, as needed, to the Senior Management Team. Toshio Yamamoto's responsibilities now include the development, implementation and coordination of collections management-related plans and the scheduling of activities in concert with the demands on personnel, time, and space resources imposed by museum-wide programmes.

COLLECTIONS MANAGEMENT FOR MUSEUMS

D. ANDREW ROBERTS

The phrase *collections management* has become fashionable as museums work to redefine their function and focus on the need for the effective care of the collections in their charge.

As Richard Light and Geoffrey Lewis independently note in their respective contributions (Chapters 8 and 27), collections management 'means different things to different people'. Perhaps because of my documentation background, I consider it to encompass the policies and procedures concerned with the accessioning, control, cataloguing, use and disposal of enquiries, acquisitions and loans while in the care of the museum or at an outside agency, together with related issues such as exhibition management and object transportation. I do not consider that it embraces physical collection security, environmental control or conservation, detailed aspects of each of which are better regarded as a separate ramification of *collections care*, nor of collection research, which is surely a separate issue.

This philosophy tends to accord with that adopted in the United States and Canada, where the role of registrars and collections managers is far more influential than in other countries (Chapters 3, 12, 13 and 19). It was an implicit prejudice when drawing together the programme for the *International Conference on Collections Management for Museums* and this resulting publication.

The accelerating awareness of the importance of collections management is exemplified by a series of reports on the state of American museums undertaken during the mid 1980s (American Association of Museums, 1984a and 1984b, and Slate, 1985), which placed an emphasis on the need to invest in this area:

> While some major collections are adequately cataloged and organized, most are in need of massive reorganization. Many small museums are without even a basic inventory. Almost all museums need to make an increased commitment to a comprehensive collections management program involving inventorying, cataloging, photographing and storing collections data in some retrievable form. The adequate organization of collections and the full documentation of the associated information on provenance, related research, technical analyses and exhibition history are key to gaining intellectual control of these irreplaceable resources. (American Association of Museums, 1984b)

One of the triggers in the United States and elsewhere has been outside pressure on museums to demonstrate accountability for collections. In the United Kingdom, government influence over the major national museums has concentrated since 1974 on the implementation of a series of management objectives (discussed in Chapter 5 and Roberts, 1985):

> routines for the registration and location of every significant item in the hands of the institution;

> the adoption of a practicable routine for checking the presence of items in their appointed places, so as to prevent or detect losses, and to check their condition to forestall deterioration;

a long-term programme for the scholarly description and cataloguing of the collection as a background to its study and display;

periodic reviews to ensure that the collection was effectively organised for the purposes determined by the Trustees.

A more recent UK development has been the introduction of a museum registration scheme, the guidelines for which require museums to have an acceptable collections management policy and to fulfill specific documentation standards, or to agree to attain such standards within an agreed timescale (see Chapter 31).

External pressures such as these, together with internal changes within museums themselves, have resulted in the appointment of specialist staff, the development of collections management policies and the adoption of new systems. Although the pace and degree of change varies in different countries, the impact of these developments on museums is now becoming apparent around the world.

Historically, museums in the United States were first to appoint significant numbers of collections managers and registrars (Chapter 3), with the conventional role of the latter being defined in *Museum registration methods* (Dudley and Wilkinson 1979). A selective survey of United States museums showed 64% as having full-time registrars (Slate, 1985). In contrast, a selective survey of non-national museums in the United Kingdom identified only a handful with a registrar and only 11% with a documentation specialist (Chapter 5 and Roberts, 1986b).

Despite the low base level in the UK, there is now a growing trend towards establishing registrar, collections management, documentation or automation positions, particularly in the larger national museums (see Chapter 16, for example) and more innovative local museums (see Chapter 18). There is also possibly a greater awareness of the importance of collections management among junior and middle-grade curatorial staff than in north American museums. The development of a professional focus and the recognition of the need for specialised documentation training (Chapters 27 and 31) will undoubtedly make the underlying trend more apparent to the broader museum community.

At a professional level, the United States and Canada registrar groups have active meetings programmes (Chapters 12 and 13) and have begun to publish ethical guidelines (American Association of Museums. Registrars Committee, 1985 and 1986), while an incipient UK group is struggling to become established (Chapter 14).

The development of codes of ethics for registrars by groups such as the American Association of Museums Registrars Committee has followed the earlier drafting of broader codes by the International Council of Museums and national bodies (such as Museums Association, 1987). One pressure that is most apparent in the United States is the legal constraints on museums, outlined in impressive detail in *A legal primer on managing museum collections* (Malaro, 1985). The legal issue is far less well recognised in other countries, except in specific areas such as new data protection legislation (for example, Jones and Roberts, 1985).

The legal primer referred to above (Malaro, 1985) includes guidance on the contents of a collections management policy for an individual museum. Malaro (1979) was one of the first to articulate the value of such a policy, following the crisis of confidence that faced the American museum system in the 1960s and 1970s (see Chapters 3 and 19). More recent brief descriptions have been given by Porter (1985 and 1986). The case of the Royal Ontario Museum has now become perhaps the

COLLECTIONS MANAGEMENT FOR MUSEUMS

Table
1.1

Collections management policy outline

Museum function	Statement of the purpose, aims and priorities of the museum, with reference to the scope, use and development priorities of its collections
Professional standards and accountability	Reference to established professional standards, registration schemes and the need for the museum to demonstrate accountability
Documentation policy	Guidelines concerning the scope, construction, priorities and use of the museum's documentation system
Receipt of items	Guidelines governing the receipt of items into the museum
Acquisition policy and accessioning and inventory control procedures	Criteria for determining whether an item should be added to the collection and the procedures for processing it into the collection
Location/movement control policy	Procedures for locating and tracking the movement of items within the museum
Item documentation and location control policy	Guidelines governing the methods and standards to follow when documenting (cataloguing) acquired items
Catalogues, information retrieval and publications	Guidelines concerning the required scale of collection catalogues, indexes and other retrieval facilities, and the documentation strategy to adopt when producing collection publications
Supplementary information resource policy	Guidelines concerning the maintenance of other sources of information (such as biographic files) and their relationship to the object collection documentation
Documentation and collections audit policy	Procedures for checking the maintenance of documentation and the selective checking of the collection
Conservation, storage and handling	Guidelines for the identification of conservation hazards and the proper storage and handling of items
Security, confidentiality and access	Guidelines for the care and control over access to items and documentation in the museum
Insurance	A definition of the scope of insurance cover provided for items in the care of the museum, including retained enquiries, acquisitions and loans-in
Loans-out policy and procedures	Criteria for deciding upon the suitability of an item for loan and controlling its subsequent movement
Deacquisition policy and procedures	Criteria for determining whether an item should be disposed from the collection due to decay, etc.

classic study of the role of a collections management policy (Royal Ontario Museum, 1982 and Chapter 20). Stansfield (1985) provides a British interpretation based on teaching experience at Leicester. Orna (1987) relates specific collections management issues to the broader topic of information resources management and policy.

Table 1.1 consolidates some of the ideas on collections management policies in an outline which is used as a model when advising UK museums (Chapter 34).

A number of Area Museum Councils – such as the Scottish Museums Council – are encouraging local museums to develop such policies as part of an overall strategic planning exercise.

Information about policy and practical developments in a number of museums is given in Chapters 16–23. Other case studies have also been published in recent years, notably Light, Roberts and Stewart (1986), Orna and Pettitt (1980) and Roberts (1985). General procedural advice on collections management is provided by introductory guides (such as Ambrose, 1987 and Paine 1986) and texts (such as Thompson, 1986), while documentation advice is given in MDA publications (Museum Documentation Association, 1981 and Roberts, 1985). One discipline which has made particular progress in identifying its collections management needs is the natural sciences, where conference reports (Waddington and Rudkin, 1986 and Genoways, Jones and Rossolimo, 1987) and a number of procedural guides (such as Brunton, Besterman and Cooper, 1985 and Cato, 1986) have been produced.

A strong focus in most recent initiatives has been on the automation of collections management procedures. As shown in the systems exhibition associated with the conference (Chapter 36), we appear at last to have reached the point where reasonably priced and viable systems are now available for adoption by individual museums. The situation in the early 1980s where museums were making faltering steps to automate (Sarasan, 1981 and Sarasan and Neuner, 1983) has now been superseded by the release of relevant tailored packages for inhouse use. The growing maturity of museum automation is demonstrated by a spate of in-depth papers and reports about the fundamental issues (such as Bearman, 1987a and 1987b, Orna, 1987, Sarasan, 1986 and 1987, Williams, 1987 and Chapter 9).

Despite the scale of interest in collections management and automation, relatively little literature has appeared about the subject in recent years. With their emphasis on development in three continents, the following chapters go a long way towards rectifying this omission. Whether you are planning to automate, considering a revised departmental structure or concerned about introducing new procedures, the contributions should act as a valuable guide to collections management principles and practice.

SURVEYS OF
COLLECTIONS MANAGEMENT SYSTEMS
AND PRACTICE

2 SURVEYS OF COLLECTIONS MANAGEMENT SYSTEMS AND PRACTICE

PHILIP S. DOUGHTY

In the early 1970s I became Chairman of the Information Retrieval Group of the Museums Association. I arrived in that Chair with a genuine interest in museum documentation but no techical knowledge to speak of. At my first meeting two issues emerged with startling, almost frightening, clarity. The first was that information scientists inhabit a world of their own with self imposed limits, conventions, rituals and an obscure vernacular. The second was that the curators drawn to this field were in fact curators no more. They had lapsed following their seduction by new technology — the computer in particular. One often had a feeling that people were playing with computers employing museum data whilst trying to convince themselves and others that this exercise met a genuine museum need. My association with that Committee was an interesting exercise in education, and it proceeded in both directions.

The rigorous examination of procedures and practice in museum collections management has progressed significantly since then but the problems of effective communication and clarity of objective remain the same and bad habits are a perennial feature of newly initiated generations. This should never be regarded as a minor problem.

Collections management is a topic so broad that it presents some of the most daunting of all museum challenges. The reasons are all too obvious and here are just a few:

perceptions of what constitutes collections management are often radically different, rendering a foundation for general debate difficult;

no two museum disciplines present the same problems;

the problems of large and small museums are of a different kind and on different scales;

national traditions and standards of practice have evolved in different ways;

solutions and strategies at all levels from individual museums and disciplines to national schemes and networks show extremes of contrast;

the expectations of curators and administrators are frequently at variance;

the identity and needs of categories of users of curatorial data are ill-defined, pointing to a fundamental flaw in most systems.

Dialogue at all levels is essential. Within a small area like the United Kingdom it is possible for most groups of interest to meet and discuss common problems. The same is true of most European countries where travel within national boundaries is relatively straightforward. Perhaps it is less true when distance becomes a major factor and this is a matter that may be developed later. The papers in this report offer a unique opportunity to examine the international position and with the calibre,

experience and geographic spread of contributors and delegates to give a useful indication of current practice worldwide.

We must be clear that our conclusions and experience are communicated effectively. We are adding important and potent weapons to the curators and manager's armoury at a time when museums world-wide seem to be under increasing pressure to give a service expected to expand rapidly whilst offering more variety, increased complexity and bigger throughput. This is usually against static or contracting public funding. Recent experience shows an ever quickening pace without hint of respite. Demand is growing and all projections reinforce this trend.

To embark on a new course we must know our starting point. In collections management terms that means current practice, procedures and expectations. The papers will lay that foundation.

3 SURVEY OF NORTH AMERICAN COLLECTIONS MANAGEMENT SYSTEMS AND PRACTICE

JANE E. SLEDGE

Traditonally stories of life in North America are somewhat exaggerated: the streets are paved with gold, the world's craziest people live in California, and everything in North America that can be automated is automated. An exemplary North American philosophy is: 'Whatever you vividly imagine, ardently desire, sincerely believe, and enthusiastically act upon . . . must inevitably come to pass'. The expectation is that museum collections management systems follow in the same grand tradition. If you believe this, there is a very interesting bridge in Brooklyn that's for sale.

This paper is about the search for the Holy Grail of collections management information systems, the ensuing misconceptions and expectations, and the way in which collections management systems seem to be evolving in North America. It also focuses on the people who use collections management systems and the data processed by the systems. The actual physical care and conservation of collections is not addressed. This paper only references collections management systems in Canada and the United States. The author is abysmally ignorant of progress in collections management systems in Mexican museums.

An often asked question is 'How does your computer system do collections management?' Collections management systems are automatically, forgive the pun, associated with computer systems. The 1970s saw the rise of auditors, the expansion of museum buildings, and the beginning of collections inventories. Automated audit control of museum collections by means of an inventory was an early view of a collections management system.

While computers provide for increased accountability and accessibility, they do not 'do' collections management. Museum staff do collections management, with and without computers, both systematically and unsystematically.

A second misconception is that collections management is done by 'the' anointed individual or department. With increasing professionalism, resulting from accreditation programmes offered by both the Canadian and American Museum Associations (CMA and AAM) and the increase of museum studies programmes among other things, came a staking out of territory — or a stating of boundaries in terms of roles. The establishment of museum special interest groups, such as Registrars Committees, again within both the CMA and the AAM, is part of a general trend towards role specialisation (Chapters 12 and 13). Conservators, interpreters, museum administrators, educators, everyone seems to have a special interest group to represent their particular concerns.

Writing on the nature of role specialisation and collections management, Dan Gallacher, Curator of History at the British Columbia Provincial Museum, suggests that the tendency among museum workers to role specialisation creates problematic narrow loyalties:

specialties are deeply ingrained in museums, they can greatly limit staff effectiveness . . . we need a new approach to collections management if specialization is to serve ourselves and our clients. (Gallacher, 1982)

Gallacher lists the problems role specialisation creates: increased separation between specialists, with occupational languages becoming the equivalent of foreign languages; increased geographic separation brought about by new space requirements for specialised equipment, such as that needed for conservation; demands for recognition and prestige resulting from advanced degrees and training; and, finally, wider gaps being created between museum staff as new intermediary management positions, such as assistant directors and department chiefs, mediate disputes between divisions. In many museums, a new level of middle management directs day to day activities.

Museums now host so many activities that there is much pressure on middle management to handle crises and problems and to effectively supervise complex projects. Public programmes, loans, block-buster exhibitions, research, new construction, security, and collections care require dedicated professionals. Role specialisation is a necessity and a challenge faced by many professions. Just like any change, it takes time to understand the impact and develop methods to maximise the potential. Effectively using and supporting specialists requires a change in management style.

The change is to collaborative working relationships. A report to the Director of the National Museum of Natural History at the Smithsonian from a Task Force on Collections, charged with examining the role of collections within the mission of the Museum and with recommending strategies to enhance the Museum's capability to fulfill its collections management responsibilities, pinpoints teamwork as the hallmark of a collections management system:

> The collections management team including NMNH administrators, the curators, specialists and technicians within the scientific departments, exhibits and education staff, and the staff of affiliated agencies must work toward these common goals ... The Museum's two greatest strengths are the professional highly dedicated collections management team and the comprehensive, well documented collections themselves. (Gomon, Bright, Cairns, Collier, Greene, Hevel, Lellinger, Melson, Springer, and Thorington, 1987)

Mary Case, Director of the Office of the Registrar at the Smithsonian Institution, notes how collections management is the responsibility of all museum personnel:

> Collections management is conducted by people who direct, control and use objects, specimens and related data. Foremost among collections management personnel is the museum director, followed by the curator, scientist, historian, registrar, conservator, and, where applicable, collections manager. (Case, 1987)

Collections management transcends individual specialities. The term collections management indicates a proactive attitude towards the management of the collections. This is a new management style for museums. Unsolved past problems force the re-examination of museum goals and activities and require creative solutions. The problems result mainly from a lack of resources and an increased demand for museums to be more responsive to the communities they serve: to support more research, to house more objects, to produce more exhibitions. In North America there is a new and growing group of museum managers who are graduates from

Masters of Business Administration programmes or who hold advanced degrees in Public Administration. These new managers use business management tools, set business goals, and plan business activities. The collections are a resource that must be managed efficiently to support the business. As a result there is a shift in the traditional roles of all museum personnel, but most importantly within the roles of curator and registrar, the people producing, using, and controlling collection information.

Within the curatorial domain, in addition to pressures to align research activities with museum management priorities, there is a refinement of curatorial research methods to encompass broadening aspects of collections management. Gregg Finlay, a past Chief Curator of the New Brunswick Museum, suggests that notions of collections management as limited only to inventory control and physical access must give way to include the sphere of idea management and intellectual access:

> Yet, if basic descriptive data is required for the physical management of the collection, contextual data is required for the intellectual management of the collection. There are vital linkages between the artifact record and museum scholarship, and between object and idea. (Finlay, 1985)

Dr Margery Halpin, Curator at the Museum of Anthropology at the University of British Columbia expands on the changing relationship between the object and the idea:

> One result of the transformation in the relationship between the knower and the known, or the observer and the observed, is the reformulation of the relationship between the signifier (the text, painting, image, exhibition, etc.) and that which is absent and signified (meaning, culture, reality itself, etc.). (Halpin, 1987)

The provision of intellectual access to collections, the ability to hold and make accessible changing and uncertain relationships within an increasingly complex knowledge base, is one of the challenges faced by museums. As museum professionals admit that they are not all knowing, that what is being recorded is a point of view, or a cultural perception of the way things are, or even that things may be unknown, new requirements are placed on collections management systems.

These new requirements are visible in the design and development of computer systems that support layers of access by different levels of museum staff. Having met the mandate from Congress to complete an inventory of its collection holdings, the Smithsonian is now migrating physical inventory data from an older computer system and building conceptual models from which to design databases to support collections-related activities inclusive of management and research. Many museums which pioneered automated collections inventories are now expanding older database structures to encompass a burgeoning and different knowledge base. The data itself is an 'object'.

There is tension between the modern curatorial role of content specialist and researcher and the traditional role of cataloguer and keeper of the collection. Finlay's views stress the importance of documenting specific groups of objects within a research or exhibition context. Collection documentation in general requires a systematic approach and rigorous control. Objects should not wait for inclusion in research projects or exhibitions before receiving proper physical and intellectual documentation.

A major problem is that curators collect, study, and exhibit the objects with which they are familiar. Whole sections of the collection, not acquired during a specific curator's tenure, may be unknown, or ignored. Another problem is that curators tend to develop their own records, neglecting to share new or revised information. This results in confusion when automating museum curatorial and registrarial records. The root of the problem is access to a single central information source that will support different views, both research and management, of the same data.

Efficient collections management information systems require multiple points of access. The 'Master Mall Raceway' at the Smithsonian will support the flow of information between several large computer systems and many small personal computers. When asked to guesstimate the number of computers at the Smithsonian an ADP manager said there must be at least 1200. The Royal Ontario Museum (ROM) has approximately 150 machines, including both terminals and microcomputers, that tie into the Canadian Heritage Information Network to query against the ROM's institutional databases and to upload and download data to micro databases. Museum staff who have long understood the importance of interpersonal communications networks begin to recognise the importance of telecommunications networks. They are becoming familiar with Local Area Networks and data over voice telephone networks.

North American museums are getting 'wired' and the number of computers and terminals in a single museum is increasing. Cost efficient minicomputers, super-micros, the 386 multi-tasking micro with greatly increased storage capability, a wide variety of applications and operating systems software, and proven communications software, packaged and sold by vendors familiar with the museum marketplace give even the middle and small size museums choices in automating collections management information.

As the keeper of the collection records, the registrar plays a critical role in information access, balancing the curatorial focus on research, ensuring systematic documentation, and providing care for all objects in the collections. The responsibility for the collections management system and the task of project manager for museum automation usually rests in the Registrar's Office. This creates an unusual set of circumstances. Women outnumber men at least ten to one in the registrarial profession. High level museum management positions are usually held by men. High technology also tends to be a masculine profession. Women gain a significant and hard fought foothold in this territory by a recognition of the importance of automation for the museum and the registrar's ability to manage automation projects and understand technology. Over the course of the last ten years registrars have become an important part of the museum's senior management team.

Besides computer systems, registrars also manage other complex collections management tasks such as the maintenance of legal accountability for the fiduciary care of collections and the preparation of disaster and risk management plans. Museum management has only recently recognised the importance of the role of the registrar in maintaining accountability for the museum's collections and the implications of liability for poor museum practices.

In North America, one of the main ways museums manage collections systematically is through the development and application of policy. Registrars often author these policies, and at a minimum play an important role in their implementation. Marie Malaro's book *A Legal Primer on Managing Museum Collections* (1985) sits

on almost every registrar's bookshelves. This text and the American Bar Association's annual course on Legal Aspects of Museum Administration helps registrars to maintain fluency in the changing legal embroglios. The case of *Lefkowitz v. The Museum of the American Indian: Heye Foundation* was a turning point in the recognition of the importance of the legal aspects of collections management.

Among the charges listed by the Attorney General were the following:

1. A failure to keep complete and contemporaneous records of all collection objects;

2. The permitting of questionable accession and deaccession practices;

3. Self-dealing by the trustees and the director of the museum (it was alleged, for example, that trustees obtained artifacts and other benefits from the museum and that gifts to the museum were valued at inflated figures for income tax purposes).

(Malaro, 1985)

If the Museum had followed a collections management policy, the situation might not have occurred. Museums across North America are beginning to recognise that collections management policies provide significant benefits. A 1984 survey of collections management practice and the use of technology in Canadian museums determined that some 52% of Canadian museums had a written and approved collections policy and that another 17% planned to write one within the next 12 months (Price Waterhouse Associates, 1985).

The instigation of collections management policies, the upgrading of manual documentation systems, better record-keeping methods, the provision of appropriate access to the documentation system by all levels of museum staff, and the now frequent use of computers combine to create what is referred to in the vernacular as collections management systems.

Besides a top level museum management commitment to teamwork, a second ingredient needed for successful collections management systems is resources, both financial and human. The 1984 survey also asked respondents:

what factors 'constrained (their) institution's ability to effectively manage its collections' ... results show that the overwhelming majority, 90% of the respondents, indicated that inadequate financial resources and lack of staff were constraints. (Price Waterhouse Associates, 1985)

Specific funding for documentation is available to museums in both the Canada and the United States through programmes sponsored at federal or national levels. In Canada the federally funded Museums Assistance Programme, now under the auspices of the Department of Communications, provides about $800 000 a year for a competitive grant programme entitled Registration Assistance Programme (RAP). Funding is given to some 20 different museums, many of which are pursuing long-term documentation projects. To give an idea of just how expensive and long term a documentation project can be, the Montreal Museum of Fine Arts received about $900 000 over the course of the last ten years to document a collection of approximately 25 000 objects. This funding does not include hardware, software or communications. RAP only funds certain positions, such as assistant registrars, cataloguers, and data entry personnel.

In the United States, the National Endowment for the Humanities provides $5 000 for planning documentation projects and up to $25 000 for the actual projects. The

3

Biological Research Resources Program, sponsored by the National Science Foundation, provides funding for the refurbishment and operational support of systematics collections among other programmes. Between 1972 and 1984 systematics collections received $35 795 000, but only $425 000 was given directly to the creation of catalogues (Edwards, 1985).

Traditionally seen as passive stores of information, museum records received little attention and few resources. Museum management considered everything to be in order and priorities placed elsewhere. In 1972, to assist in the initial design of the Canadian National Inventory Programme, Canada's largest museums were surveyed to gather information about the state of museum record keeping. Museum staff said that records were in perfect order and that the data could easily be automated. Time, experience, and analysis proved this assumption wrong both in Canada and the United States. Lenore Sarasan, a museum automation consultant, writes:

> The documentation systems of many museums provide as little ease of access to information as overcrowded storerooms provide to specimens. Object records may be incomplete, they may be incorrect, they may even be non-existent. (Sarasan, 1986)

The naïve assumption, that the automation of existing information leads immediately to the goal of a collections management system, proves the misdoing of many automation projects, as museum management assumes that the project is 'done' when the data is in the computer. The American Wing of the Metropolitan Museum of Art is in the middle of a three year redocumentation project to correct, compare, and correlate its sources of information. This project received about $250 000 of funding from the National Endowment for the Humanities and other grants to redocument 12 000 objects. Years of neglected funding and the lack of priority for the activity of documentation now haunt museums. For a long time people like Stephan de Borhegyi were voices crying in the wilderness:

> It is appalling to find that in many natural history museums in the United States important specimens and even entire collections are only spottily documented. Too often catalogue entries carry only a few fleeting remarks concerning the history of an object, inadequate even for the type of information required for accession cards. This deplorable state of record keeping not only indicates bad housekeeping, but also seriously impedes research. (de Borhegyi, 1965)

Data clean-up and reconciliation work goes hand in hand with the use of collections management information systems, and this time people want 'to do it right'. The search for shared standards is increasingly important in North America as museum staff understand that collections management systems not only depend on internal teamwork in museums but external collaborative solutions. The operative words are enlightened self-interest. A recent conference sponsored by the National Museum of American History entitled 'History Museums in the United States: Identifying a Common Agenda' highlighted collaborative efforts (Taylor, 1987). Pre-conference discussion papers set the stage for an intensive three days of meetings and resulted in a successful grant proposal to the National Endowment for the Humanities. The establishment of common databases and data standards for history musuems lies at the heart of the proposal. Throughout the conference, references were made to the Humanities and Natural History Data Bases of the Canadian Heritage Information

Network (CHIN). Canada has two national indices to Canadian museum collections holding some four million museum records. Through the development and use of the CHIN system, *de facto* standards evolve for the exchange of information between 150 museums. Museums in the United States acknowledge the value of shared information and data standards. While Canadian and American museum professionals hate the thought of imposed standards, they request the establishment of standards.

Standards are beginning, just like museum objects, to be interpreted in context:

> Standardization is an administrative technique for coping with diversity. It reduces the opportunities for confusion and it facilitates the replication of results. Standards are generally introduced when a human activity has grown in size to a point where it can no longer be controlled on an ad hoc basis. (Martin, 1984)

In the discussions about common databases and data standards, compatibility plays an important intermediary role. Lancaster and Smith define compatibility as:

> a property that governs the extent to which two or more organisms can communicate and exchange data ... compatibility is not the same as identity. Two individuals may be compatible; they certainly are not identical. (Lancaster and Smith, 1983)

In efforts to promote data sharing among art history projects, the development of authority files for vocabulary control received considerable backing from the J. Paul Getty Trust. One project, the Art and Architecture Thesaurus, stands out as a significant contribution. Initially conceived in 1979 as a project to create a comprehensive, controlled vocabulary capable of handling existing or future visual image systems, the Art and Architecture Thesaurus Project has developed a hierarchial vocabulary list of some 35 000 terms.

Museums eagerly welcome such tools, but just as there is a debate on the imposition of national data standards, there is a discussion about the value of terminology controls. Tendencies towards too much cleanliness, which might prove not to be next to Godliness, must be carefully reviewed. Just like objects, languages also need preservation. Regional and historic must not be blindly weeded out. Collections management information systems must be capable of preserving and permitting access to a rich vocabulary as well as allowing conflicting authorities equal space. Experts caution against the wholesale adoption of controlled vocabulary:

> Perhaps somewhat surprisingly, while controlled vocabularies tend to promote internal consistency within information systems, they also tend to *reduce* intra-system compatibility. Systems based on natural language are inherently more compatible than those using controlled vocabularies. (Lancaster and Smith, 1983).

There are many different automated object documentation systems in North America with various types of file structures and organisation: flatfile, hierarchial and relational. *De facto* data dictionary standards cannot be imposed on system designs, as the fields in a relational system will not be the same as those in a flatfile system. There is little possibility of establishing a 'winning' system. The game 'my system's better than your system' offers no prize in a cooperative effort. Museums are beginning to look instead for data standards which are not hardware or software dependent.

The types of information needed to provide physical and intellectual access are more important than the computer systems themselves. As a by-product of the action of sharing data, museum professionals realise that museum information is a collection they govern and create. While the primary collections of most museums are the objects, the information about these objects is increasingly given importance as museums spend money on documentation systems. Mary Case drew this theme out in a position paper on Collections Management Issues, defining collections management and collections as:

> the deliberate development, maintenance, use and disposition of objects and specimens as well as related documentation. Collections comprise both intellectual material and physical objects and specimens. (Case, 1987)

Total programme funding given by the Canadian government over the course of the last 15 years to museum documentation (through CHIN, RAP, and documentation projects under job creation schemes funded by Employment and Immigration) with additonal funds allocated by museums, inclusive of hardware, software and communications costs, for the purposes of researching and reviewing existing documentation, creating new documentation, and data entry is roughly $25 000 000. Information is a valuable resource and a significant investment in the future.

A second aspect of external collaborative efforts to create accessible databases is a trend towards the creation of resource information databases. CHIN supports resource databases, two of which are the Repository of Stolen Art (ROSA) and the Conservation Information Network. ROSA, a database made public to the Canadian museum community through CHIN and the Royal Canadian Mounted Police, provides information about art and cultural history objects reported stolen in Canada. The Conservation Information Network provides the conservation profession access to online databases with information on pertinent technical literature, materials used in conservation treatment, and observations regarding the practical application of such materials. Other resource databases are maintained by the Smithsonian Institution, two of which are the National Museum of American Art's and the National Portrait Gallery's Inventory of American Paintings to 1914 and the Catalog of American Portraits.

The Common Agendas Conference suggested that the Smithsonian Institution, the American Association of Museums, and the Association for State and Local History consider establishing databases for museum facilities, museum training programmes, seminars and conferences, and professional resources. There is a strong impetus for collaborative efforts and more use of shared experience and resources.

Will there ever be an ultimate collections management information system? We move from a state where:

> We build systems like the Wright brothers built the airplane — build the whole thing, push it off a cliff, let it crash, and build it over again. (Graham, 1984)

to an intermediate state in which our aspirations are better understood as context and experience are provided:

> The uncertainty principle in physics says that the act of observing subatomic events changes those events. There is an uncertainty principle in data processing. The act of providing an end user with what he says he needs changes his perceptions of those needs. (Martin, 1984)

SURVEYS OF SYSTEMS AND PRACTICE

We learn that simply saying 'all I want to do is push a button and see the universe' does not provide exactly what we expect. We see the universe, but do we understand it? What do we do with our data and how do we turn it into knowledge? The answer is not in the computer system, but in the use of the tool and the sharing of its results. In North America we are beginning to understand ourselves and work together to use the tools at hand.

4 OVERVIEW OF COLLECTIONS MANAGEMENT PRACTICE IN AUSTRALIA, NEW ZEALAND AND PAPUA NEW GUINEA

JENNIFER GAME

Introduction

My interest and awareness in museum documentation systems began in 1982 when I was appointed the first Registrar at the Australian War Memorial. At that time the Memorial, one of Australia's largest museums, had a collection estimated at over one million items.

A government review of the Federal collecting institutions — known as PAC 196 (Public Accounts Committee Report 196) — had found that the Memorial's collections management systems, like those of many other collecting institutions, were inadequate. The general problem was that it was not possible to locate easily, or in many cases at all, material from written records and, once inside storage areas, it was not possible to find the written records through a unique number or any other system. In short, without an adequate collections management system, no institution can know exactly what it has or where it is.

Over a period of time, the staff of the Memorial's Registration Section conducted physical stockchecks which established the link between objects and records. Objects without records were catalogued and records without objects were listed and the objects written off. The physical stock check alone could not ensure a better future. At the same time as the stock checks were conducted, new procedures and systems were introduced.

In 1984, I was given the opportunity to visit a number of museums in North America. Correspondence with these museums indicated there were a handful happy with the systems they had developed. Notable among them was the Detroit Institute of Arts: a true collections management system.

Apart from the fact that I wanted to see a successful system in its environment, I hoped to find, in another institution, a system which could be transported back to the Memorial. A system tried and proven elsewhere was the best option. The risk of failure would be minimal.

I felt that such a system might exist and this belief was related in part to the experience of libraries. Libraries, unlike museums, had access to off-the-shelf software packages. Why shouldn't museums have the same? Libraries operated in similar ways and so vendors developing a system could expect to sell many copies of the software and thus not only recover the development costs but also bringing in a profit. If I could find a museum which was similar to the Memorial then I could expect their system to be useful to us.

I could not find any comparable institution with a successful system. I was impressed with the Detroit Art Registration Information System (DARIS) (Schulman, 1986) and the Detroit Institute of Fine Arts but their system could not be migrated and adopted.

The Canadian Heritage Information Network had begun a national inventory but was far from providing an individual museum with an integrated collections management system. The CHIN data dictionary was however, very useful and later led to renewed interest in developing a museum information standard in Australia.

During my investigation I found that the Society of American Archivists had looked at the library experience and discovered that the existence of library standards allowed for the exchange of information and that shared or exchanged information provided the economic incentive for automation and the by product was a shared catalogue. Museums, like archival repositories, did not have equivalent information standards and the sharing of cataloguing information was not as relevant to institutions with unique material.

In 1985, the Memorial installed a system using a Hewlett Packard 3000 Series minicomputer and the software known as MINISIS. The system is still working successfully.

In 1986, I joined a new museum, the Australian National Maritime Museum. The Museum is still being built and will open in Sydney in 1988. It had recently installed a collections management system using a local area network and multiuser RBASE.

Collections management: What is it?

The term 'collections management' is often used and rarely defined. I use it in the sense that it is the sum of all the activities which result in the preservation of the collection, the physical and intellectual control of the collection and the exploitation of the collection.

The experience in Australia is that museums rarely attempt an integrated computer assisted collections management system, but rather opt for a system to meet a limited requirement. Within the one museum, many systems may operate, using different information standards, different hardware and different software. This lack of standardisation is seen as undesirable but unavoidable. Some large institutions have introduced and maintained standards, such as the Australian National Gallery.

Collections management survey

In June 1987, the Australian National Maritime Museum (ANMM) sent a questionnaire to some 70 museums in Australia, New Zealand and Papua New Guinea. The sample was based on museums listed in the *World of learning* and some additional museums listed in the *Directory of museums and living displays*. I must gratefully acknowledge from the outset the assistance I received with the survey from Mark Berndt, a technical officer at the Museum.

Some 41 responses were received. Two museums returned two questionnaires as separate sections within each museum had different systems. Other questionnaires returned detailed several separate systems operating in the one institution.

The questionnaire was not designed to elicit large amounts of information which could be used to produce statistics. Staff size, number of objects and percentage of objects for which there is a machine-readable record was all the quantitative information sought. It was designed to explore the use of computers to assist with collections management.

Table 4.1 summarises the overall responses while Table 4.2 expands on the information about computer systems.

Table 4.1 Institutions responding to the ANMM collections management survey

Institution name	Type of institution	Number of full-time staff	Collection size	Computer-assisted?	Comments
Australia					
Albury Arts Centre	Art gallery	2			Expect to have access to a mainframe computer in the near future
Art Gallery 'A'	Art gallery	79	12 000	Yes	
Art Gallery 'B'	Art gallery	10	1 500	Yes	
Art Gallery 'C'	Art gallery	3	1 808	Yes	
Art Gallery of New South Wales	Art gallery	102	13 000	Yes	
Australian National Gallery	Art gallery	255	75 000	Yes	Replaced earlier system based on a WANG Minicomputer
Australian War Memorial	Other museum	5	1 000 000	Yes	HP3000 Minicomputer based MINISIS system
Australian National Maritime Museum	Other museum	60	4 600	Yes	Now using barcodes and barcode software for inventory control
Birdwood Mill: National Motor Museum	Other museum				Recently purchased a Macintosh Personal Computer for administrative use
Geological and Mining Museum	Natural science museum	21	106 000	Yes	
Illawarra Folk Museum	Other museum	1			Local History Museum with Honorary Curator
Melbourne Maritime Museum	Other museum	5	762		
Museum 'A'	Other museum	32	1 500	Yes	
Museum 'B' (History Dept)	Other museum	169	30 000	Yes	
Museum of Victoria, Natural History Division	Natural science museum	190	9 000 000	Yes	Information Retrieval System (not DBMS)

Institution	Type	Staff	Collection	Computerised	Notes
Museum of Victoria, Science and Technology Division	Other museum	3.5	36 000	Yes	Batch input system with periodic production of a microfiche catalogue
National Film and Sound Archive	Other museum	61	629 400	Yes	
National Gallery of Victoria	Art gallery	170	70 000	Yes	Recently introduced central control over location of works; expect to purchase new system through the Victorian Ministry of Arts (Victorian Public Galleries catalogue system)
Queensland Art Gallery	Art gallery		6 000		
Queensland Herbarium	Natural science museum	30	420 000	Yes	Likely conversion from Fortran-based programes to UNIFY database system
Queensland Museum	Natural science museum	140	2 000 000	Yes	17 different sections each with separate processes and systems
Queen Victoria Museum and Art Gallery	Art gallery	50			Currently investigating a computer system (manual system based around MDA)
South Australian Maritime Museum	Other museum	13.8	10 000	Yes	
South Australian Museum	Natural science museum	95	3 500 000	Yes	Use Australian Biological Information Standard
Tasmanian Museum and Art Gallery	Art gallery, Natural science museum	40	330 200		Investigating TITAN system for natural science collection
The MacLeay Museum	Other museum	6	650 000	Yes	Australian Photograph Access Network standards used
The MacLeay Museum, Invertebrate Section	Natural science museum	1	750 000	Yes	
Wollongong City Gallery	Art gallery	4.5	810		

Table 4.1 *Continued*

Institution name	Type of institution	Number of full-time staff	Collection size	Computer-assisted?	Comments
New Zealand					
Algantighe City Gallery	Art gallery	2	1 000	Yes	Investigating replacement system operating under UNIX
Art Gallery 'D'	Art gallery	29	10 022	Yes	Research Librarian acts as system manager
Auckland Institute and Museum	Natural science museum, Other museum	80	800 000		Currently investigating computing systems
Canterbury Museum	Natural science museum				
Dunedin Public Art Gallery	Art gallery				
Gisbourne Museum and Arts Centre	Art gallery				
Nelson Provincial Museum	Other museum	3	595 000	Yes	Large photographic collection investigating REVELATION-based system
New Zealand Academy of Fine Arts	Art gallery	3	0		A Society which conducts exhibitions but is not a collection-based museum
Robert McDougal Art Gallery	Art gallery	15	3 764		The position of registrar recently created
Southland Museum and Art Gallery	Art gallery, Natural science museum	6	500 000		
Theomin Gallery	Other museum	4			Family collection in original home setting
West Coast Historical Museum	Other museum	2	7 500		Local History Collection
Papua New Guinea					
Papua New Guinea National Museum and Art Gallery	Other museum	58	30 000	Yes	

Table 4.2 Computer-assisted collections management systems

Institution name	Year of installation	Software packages	Hardware configuration	Number of work-stations	% of collection machine readable
Aiganthighe Art Gallery		Assets Register (custom, internal)	Mainframe	15	100
Art Gallery 'A'	1981	AGWA (custom, internal)	Micro	1	100
Art Gallery 'C'	1986	Victorian Public Galleries Catalogue System (custom, external)	Micro	1	98
Australian National Gallery	1978	IMAGES (GALLERY)	Mini	45	100
National Gallery of Victoria		DBASE II	LAN		28
Geological and Mining Museum	1972	Data Manager	Mini	2	5
Museum of Victoria, Division of Natural History	1979	Cardbox, Titan (custom, internal)	LAN	17	3.6
Queensland Herbarium	1969	Herbrecs (custom, internal)	LAN	4	100
Queensland Museum	1987	RBASE, DBASE III +, DATAFLEX, MINARK	Micro	1	2.5
South Australian Museum		DAM (custom, external)	Mainframe	0	1
The MacLeay Museum	1983	PEACHTEXT, Microsoft Word, DOS 2.1	Micro	1	7-8
Australian National Maritime Museum	1986	RBASE, DBASE III	Micro/LAN	3	24.5
Australian War Memorial	1985	MINISIS	Mini	14	20
Birdwood Mill Motor Museum	1987		Micro	1	0
Museum of Victoria, Science and Technology Division	1978	WORDSTAR, CARDBOX	Micro/Mainframe	2	45
Museum 'B' (History Dept)	1983	ICL STATUS	Mainframe/LAN		70

Table 4.2 *Continued*

Institution name	Year of installation	Software packages	Hardware configuration	Number of work-stations	% of collection machine readable
National Film and Sound Archives	1984	FLICS, RBASE III	Mainframe/LAN	16	90
Nelson Provincial Museum			Micro	1	0.1
Papua New Guinea National Museum and Art Gallery	1984	MICROSOFT FILE	Micro	1	
South Australian Maritime Museum	1987	INMAGIC (experimental)	Micro	1	0
The MacLeay Museum	1985	FRAMEWORK, DBASE III, EXCEL, HISTORIA	Micro	3	1

Returns from art galleries
In the survey, art galleries and like institutions were characterised by relatively high staff to the size of the collection, adoption of cataloguing standards, and the use of computers to record cataloguing information.

The Australian National Gallery has recently developed an integrated collections management system (GALLERY) which allows locations to be recorded and changed for individual items and groups of items (see Chapter 21).

GALLERY is implemented on the McDonnell-Douglas Sequel range of mini-computers. The structure has been developed by AWA (Amalgamated Wireless A/Asia Ltd) Computers in response to the needs of the Australian Art Gallery. It is based on the PICK query language named ENGLISH. The relational database allows all records to be tied together such that objects can be seen as individual items or as parts of a collection in any other way which has been defined, including keyword searches. Full details of storage locations are held and external loans are catered for. An automatic register of loans, storage, restoration, etc., is prepared.

The Australian National Gallery using a minicomputer with 45 terminals and one microcomputer are very happy with the performance of the system. They are working closely with AWA Computers to develop standardised art gallery data dictionaries. AWA Computers are developing a museum system for release in 1988.

In the State of Victoria, the Victorian Ministry for Arts has been active in a project which involves several public galleries. The system based on a software package known as Revelation is essentially a cataloguing system. There are three main files in the system: public information; academic information; and collections management information. There is an artist name master file which ensures consistency of entry of names. The other authority files include institution name and media category.

A limited number of fields of information are recorded and include donor name, location of object, value of the object, accession number, title, artist's name, exhibition history, inscription, media category and credit line. Standard reports can be produced and limited *ad hoc* enquiries on specific fields is available.

Returns from natural science museums
Natural science museums are characterised by low staff to collection size ratio, by the imposition of taxonomy nomenclature and by the need for fast information retrieval rather than database management.

The Queensland Museum is typical of natural science museums. The size of the collections make it almost mandatory to use computers, however, each area develops its own system for very specific needs.

The information retrieval system known as TITAN developed in the University of Melbourne is now used by a number of museums. A single screen is used for data entry and for information retrieval. Report generation and enquiries are limited.

Returns from other museums
The third category of museums is really all those which are not art galleries or natural science museums. The diversity of systems is greatest, as would be expected. The systems are generally standard database management packages which have been used to develop specific applications.

Emergence of new information standards

One of the most interesting developments in Australian museums is the development of new standards for information categories.

Museum Standards Committee
As part of the Australian Government commitment to the arts, the Department of Arts, Heritage and Environment sponsored a Museum Standards Workshop in Melbourne in 1985. Workshop participants represented major institutions throughout Australia.

The purpose of the workshop was to bring museum and other related professional groups together to consider the development of a nationwide data dictionary which may be the first step in the establishment of an Australia-wide computer-based network of museums and like institutions holding museum-type collections.

The workshop recommended to the Cultural Ministers that a committee be established to develop a national multidisciplinary dictionary based on the Canadian Heritage Information Network model.

In 1986 this Committee met for the first time. Its terms of reference were to pursue the development of a national multidisciplinary data dictionary based on the Canadian model; to encourage the development of information systems by arts authorities at all levels; and to investigate and advise the Cultural Ministers Council on the feasibility of a National Arts Information Database.

The work of the committee is not widely known among museums in Australia. To date museums have been asked to provide data sheets. The Committee found that there was a significant degree of commonality in the data sheets and that collecting institutions were willing to comply with standards when available.

The Committee has made little progress towards a national data dictionary, but rather decided to concentrate on the compilation of a set of data elements, although no date has been set for the completion of this task.

Australian Photograph Access Network (APAN)
APAN was formed in May 1985 and now comprises the following institutions:

Archives Office of New South Wales;

Art Gallery of New South Wales;

The Australian Museum;

Historic Photograph Collection, McLeay Museum, University of Sydney;

Museum of Applied Arts and Sciences;

New South Wales Government Printing Office;

State Library of New South Wales;

Australian National Maritime Museum.

APAN aims to raise the standard of service to the public by the adoption of data standards for photographs; seeking funds for a shared computer system which would make records and visual material available to the public; and discussing and, where possible, solving curatorial problems.

SURVEYS OF SYSTEMS AND PRACTICE

The membership has been deliberately confined to Sydney based collections until a draft standard was formulated. A working standard has now been developed and circulated. There are three mandatory, twelve recommended and seven defined data elements.

In February 1987 the first APAN conference was held. It was very well attended.

The New South Wales (NSW) Government Printing Office

The NSW Government Printing Office is not a museum, but it has begun to catalogue, conserve and present to the public its photographic collection. The collection of some 200 000 images is to be reproduced and stored on new technology. It will be the first time that such an extensive project has begun, using laser discs to preserve and present a photographic collection in Australia. From this project grew a second project, which is now known as the Laser Picture Studio. In effect the technology and expertise developed by this institution is being made available to other collecting institutions.

The Laser Picture Studio is a pre-production facility. A computerised slide animation camera produces colour and black and white images from originals of different sizes. The film is then sent to a laserdisc production house for transfer to disc. Only the frame number appears on the disc. Indexing is done through software and a personal computer.

The Government Printing Office has in partnership developed software known as JUST IMAGINE, based on a product called TCR — The Corporate Retriever (MS-DOS IBM compatible). There are two levels of access offered: professional and public.

The software for professional access allows the user to search a large database which contains detailed descriptions of the photographs. The user searches the database using words, phrases, dates and so on, and is provided simultaneously with images from the videodisc and descriptions of the images from the database.

The search language is easy to learn, with commands consisting of common English words, such as FIND and VIEW. Complex combinations of words and phrases may be used together with logical connectors, such as FIND Sailing Ships AND Sydney Cove AND 1895.

The database, now close to 50 000 records, has been built up from all known information about the photographs. This includes descriptive details from the original registers, physical details such as format, size and condition, and very specific subject descriptions derived from an examination of the images themselves. To provide the subject analysis, the indexing team has developed a thesaurus containing nearly 3 000 searchable subject terms. A similar number of New South Wales place names may also be searched.

As well as this controlled searching, the software allows for the retrieval of the images by searching any word in any part of the description, such as from the title, notes of associated images or any other field. The user has the facility to obtain an immediate reference print of any image which is displayed.

The software for public access is based on the professional access software, but operated through menus rather than through commands entered by the user. This is to allow casual users at exhibitions or in other public places to browse through parts of the collection which interest them. Operation is in a specially designed booth using a simple keypad.

The public presentation begins with a short motion picture introduction after which the user is invited to press the START key to view photographs. The first menu allows the user to select one or more topics, for example:

1. Sydney Harbour and harbourside
2. City of Sydney
3. Sydney suburbs and surroundings
4. New South Wales country and islands
5. Buildings
6. People and activities
7. Sport and other events
8. Transport
9. Animals and plants

Once the selection is made, the user will be given a second menu to choose from. As an example, after choosing 1 above, the choice might be:

1. Darling Harbour and harbourside
2. Circular Quay
3. Sydney Harbour Bridge
4. Sydney Opera House
5. Harbour islands
6. Harbour beaches
7. Boats and ships
8. Wharfs and piers
9. Middle Harbour and North Harbour

A third level of choice may also be provided, allowing the search to be narrowed down by date. At this stage the user is informed of the number of captions of the photographs available and invited to browse through them, using the VIEW key.

As in the professional system, a description of the image will appear simultaneously with the image.

Pioneering a new collections control system for the Australian National Maritime Museum (ANMM)

The first Museum staff commenced duty in mid 1986. With an opening of 5 000 square feet of exhibition space planned for late in 1988, it was necessary to have a system for collections management in place almost immediately.

A decision was taken that collections management procedures would exist to support them. Prototyping commenced in July 1986 using a Hewlett Packard VECTRA personal computer and the software package RBASE 5000.

The first collections management module to be developed was an Acquisition Control System (known in our nautical environment as NEPTUNE). Via the RBASE data entry screen curators record details of proposed acquisitions (single items or groups of items) including brief description, source details, method of acquisition, costs (conservation, packing, transport). This data is manipulated to generate acquisition proposals for endorsement and approval by the relevant approving mechanism within the Museum.

SURVEYS OF SYSTEMS AND PRACTICE

These records are subsequently updated with details of the approval process, receipting details (number of Incoming/Interim receipts, dates issued and signed copies received) and any subsequent dispersal of material within the Museum other than to the National Maritime Historical Collection. For example, material may be acquired in part for the Education Section's educational resource material collection or for the staff or public library.

Earlier this year the Museum upgraded its collections management system to a Hewlett Packard VECTRA PC Local Area Network, comprising a file server with 40 megabyte disk and three user stations each with 20 megabyte hard disk. All collections management data files are shared from the server. The collections management software has also been upgraded to the multi-user RBASE SYSTEM V. RBASE modules developed to date to supplement the Acquisition Control System are described below.

A movement control system (modules in RBASE are called 'tables') records the movement of acquisitions from the source location to one of the two Museum storage areas. Details recorded include material description, details of carrier pick-up and delivery, costs, dates, special handling instruction, Museum staff involved in the move, etc. This module enables movement scheduling and monitoring and provides important information on the methods used for complex moves and related costs. Notification to curators and conservation staff of pending moves and arrivals is speedily generated.

A carrier module records details on all external carriers (specialist or non-specialist, including government agencies) used by the Museum. Full details are recorded only once in this database and linked via a code to the movement control system. Details include carrier name, address, contacts, services offered, payment, service assessment, etc.

A master inventory control module is used, in which each physically unique item is registered individually via a brief description and an eight digit registration number and associated barcode label. There is often a one-to-many relationship between the acquisition control system and the inventory module, as one record at acquisition stage can result in many (sometimes hundreds) of separate inventory records (for example, a large collection of paintings). The inventory module also records item dimensions, weight, value, insurance provisions and related registration numbers.

Loan modules (Incoming and Outgoing) record details of material loaned or borrowed plus associated loan documentation (for example, file number, details of loan request, loan approval dates, loan agreement numbers, loan period, loan condition, loan tracking numbers for incoming loans, etc.). The Museum will necessarily maintain a large incoming loan programme.

The lenders module records details of all proposed, current and non-current lenders. Names, addresses, contacts are recorded only once and can be linked to the incoming loan module by the incoming loan file numbers as many times as required.

A conservation module is to be developed.

A full item cataloguing module is also to be developed to enhance the basic level description.

Exhibition contents modules are available for each of the Museum's five opening exhibition themes RBASE tables record details of all historic collection material and a wide variety of non-collection items, such as reproductions, graphic supports, interactives, dummies supports, etc. It is intended that all exhibition components be

4

physically numbered and recorded to enable exhibition installation and planning to be facilitated.

The presence in each module of an element of common data from another module enables one museum object to be tracked through each process as represented by an RBASE table. Modules can also be linked either physically using the RBASE join facilities, or logically through the software's reporting facilities.

The development, implementation and maintenance of the collections management system in RBASE has been undertaken in a relatively short time by museum registration staff with little ADP experience or training. RBASE application programs are quick and easy to develop and result in multilevel menu systems which are extremely user friendly, effective and very simply modified as required.

To date, system performance has satisfied both user and system management expectations. The system already maintains several thousand records, regularly accessed and modified. The rate of data capture will continue to increase, as it must if our opening deadline is to be met. A few months down the track we will be better able to assess the suitability of both hardware and software to meet our ongoing and ever changing requirements. Immediate pleas are for a further system upgrade to increase our LAN to 11 user stations, including a 'desktop publishing' station principally for in-house production of exhibition labels. Only ten stations can simultaneously access the file server.

Other important features of the collections management system at the ANMM include object numbering and, where possible, the attaching of a barcode representing the unique registration number.

Object record photography is also covered. Each item is routinely photographed as part of the Registration Section work flow. Printouts of items awaiting photography are regularly produced from the inventory control module. Each item is photographed in colour slide with a colour match scale indicator and registration number included. A viewing print collection of the items is maintained on a 5 × 7 in. cibachrome, filed in a RETRIX photographic filing system where each registration number is coded and retrieved by dialling in the number required.

Object storage and location/movement recording is a fundamental museum process. At the ANMM a Holding Management System has been developed parallel to the RBASE system in DBASE. The barcode label is an essential part of this location control system. Each object (through its registration number) has a record in the Holdings Management System where its 10-character location code is recorded together with the date it was issued to that location. A brief 100 character description identifies the object. Initially, registration numbers and description were related into the Holdings Management System but recently a routine has been developed for the automatic transfer of relevant data (registration number and short descriptive text) from RBASE to the holdings module.

When a new location is entered for an object, the previous location is automatically moved into the location history area. The system allows for easy update of location information either by entering information on the keyboard or by uploading information from a portable barcode reader. Stocktaking is speedily performed using the portable unit and barcode reader and uploading data. A number of specially designed reports can be produced following a stocktake.

The incorporation of barcode technology into our collections management system is an exciting development which is resulting in radical changes to some traditional

SURVEYS OF SYSTEMS AND PRACTICE

museum processes. The system is still in its infancy and is constantly being reviewed and enhanced. We do use specialist consultants in this area, and of course, there are problems. For example, we are using commercially produced, relatively large, laminated labels which are adhered to plastic luggage labels. Barcode labels cannot be fixed to the objects themselves and a proportion of our material does not happily wear our luggage labels (such as works on paper). There are conservation implications with any labelling process. Items on display may need their luggage labels and barcodes removed.

However, despite the problems the system works well and as with RBASE, has to date more than met our expectations. The system commenced as single user but has recently been networked. We are currently investigating the barcoding of locations as well as the items themselves. A laser wand will make scanning easier: at present we have one only portable unit and contact scanner.

5 COLLECTIONS MANAGEMENT SYSTEMS AND PRACTICE IN UNITED KINGDOM MUSEUMS

D. ANDREW ROBERTS

In examining the state of collections management in United Kingdom museums, I will concentrate on an historic perspective. Further background is given in two reports on documentation in museums (Light, Roberts and Stewart, 1986 and Roberts, 1985).

After two papers from young museum communities, the first point to stress is the long history of many United Kingdom museums and their collections. As just one example, the British Museum began to compile records of its acquisitions over 230 years ago: records which are still relevant today, but whose own longevity presents museum staff with serious problems in managing the collections.

In the rest of this paper, I will tend to distinguish between the National Museums and non-national or local museums. There are around 25 major national museums based in London, Cardiff, Edinburgh and Belfast, with branches around the country such as the Imperial War Museum outstation at Duxford. These museums are funded by a variety of government departments. Administratively, they are semi-independent of the government, with Boards of Trustees and Directors who are in theory accountable directly to Parliament.

The non-national museums include institutions funded by local government agencies such as county and district councils, university museums (of which Cambridge has among the finest examples), regimental museums and a growing number of private or independent museums.

The national museums funded direct by central government departments have come under pressure to demonstrate accountability for the collections in their care for over 100 years, with a first Treasury directive on the importance of auditing and the maintenance of an inventory having been drafted in 1886. The recently renamed National Audit Office and Parliament's Public Accounts Committee (PAC) have been concerned about the accountability of museums since a first investigation in 1912, following losses from some national collections. The manual for government accounting indicates that the national museums should record the acquisition, holding and disposal of their collections in an inventory and should check the status of the items in this inventory on a regular basis.

A second significant event almost exactly 100 years ago, was in 1888, when leading museum directors and curators agreed to establish a Museums Association. The proposal for its establishment referred to its primary objectives as including a compendious index of the contents of all provincial museums. The subsequent half century saw a steady growth in the number of museums (from 200 in 1900 to 900 in 1963) and the gradual development of documentation procedures, such as the innovative Leicester system (Chapter 17).

During the 1960s and 70s there were further critical reports by the government auditors on the effectiveness of the audit and inventory procedures in the national

museums. However, it also became appreciated that the idea of a comprehensive itemised inventory and comprehensive rolling audit programme for each of the national collections was unrealistic. In 1974, the Department of Education and Science instead established a series of management objectives. These referred to the need for the registration and location of every significant item, checking the presence of items, a long-term programme of cataloguing and periodic collections management policy reviews (Chapter 1).

At the same time, local government in the UK was being reorganised into new county and district units. Two papers issued in 1973–74 referred to the importance of collections management and the potential of computerisation. The first — a government circular — encouraged the local authority funded museums to review their facilities and examine the need for specialist services in connection with the storage and retrieval of records, using the computer departments of the new county councils. The second — the Wright report on provincial museums — identified the availability of detailed and accurate information about the objects in a museum's collection as a primary requirement for the effective interpretation and management of those collections. The report actively encouraged non-national museums to improve the effectiveness of their documentation systems. During this period, the Information Retrieval Group of the Museums Association (IRGMA) was actively developing documentation standards. IRGMA itself and a handful of national and local museums were also exploring the use of the early generation of computers, with the Sedgwick Museum in Cambridge being one leader.

In parallel with changes in museums themselves, the regional Area Museum Councils were being established and beginning a phase of rapid growth. On the training side, the post graduate course at Leicester was also being strengthened, and was producing a new generation of young museum curators, who saw the professional management of their institutions and the development of a museum ethic as a high priority.

Despite these positive developments, very few museums had staff specifically employed to manage their collections. Unlike the experience in North America, the concept of a specialist registrar or collections manager was only found in a handful of major art galleries and in departmental museum assistants in the largest national museums. The overall idea of the importance of collections management only really came into focus in the late 1970s. The work of the Museum Documentation Association (MDA) illustrates the trend. Formed in 1977, its initial emphasis was on cataloguing facilities and advice, and it was only at the end of the decade that it became conscious that collections needed to be managed much more dynamically than in the past.

In the national museums, a further government audit investigation was undertaken in 1981. The audit officers and the PAC reviewed progress towards achieving the management objectives, paying particularly rigorous attention to the situation in the British Museum, Science Museum and Victoria and Albert Museum and the role of the Office of Arts and Libraries in overseeing this work. The British Museum's evidence of the progress it had made in inventorying parts of its collections did much to reassure the investigators that the national museums as a whole were conscious of the importance of accountability and audit. The report of the 1981 review reiterated the importance of inventories, while acknowledging the magnitude of the problems facing museums. It recommended that each museum establish the work still to be

done to bring its inventory records to a satisfactory state and draw up a programme for their completion within a reasonable period. It also considered that each museum should determine what types of audit checks were required for different types of object.

Since then, the majority of the major national museums have recognised the need to employ specialist staff, introduce revised procedures and invest in new systems, sometimes as part of a broad reassessment of their overall management and functional structure. The current scale of investment in staff and systems will almost certainly attract the continued attention of the audit bodies and result in another rigorous examination of the national museums.

In some ways, non-national museums have been slower to react. Despite a number of major projects, usually funded by job creation schemes, few of these museums have progressed from an emphasis on conventional cataloguing to the identification of a collections management policy, the introduction of new procedures and the appointment of specialist staff. There have however been encouraging developments in the last few years, with a noticeable increase in the number of new posts and requests for procedural advice. The MDA has also been reacting to the trend, such as by introducing new manual control systems in the early 1980s (Museum Documentation Association, 1981). The low price computer packages which it is releasing will also extend the range of automated collections management options available to musuems. Taken together with the important developments by other vendors, we appear to be about to cross a threshold beyond which usable and cost effective computer systems suitable for a wide range of museums will be more readily available.

I do not want to dwell upon the work of the MDA. The one point which is worth stressing is the role of IRGMA and the MDA in developing and promoting documentation standards, including the maintenance of a wide ranging data standard or data dictionary. An upgraded version of this standard is supported by the new computer systems. The manual systems based on the standards are currently used by around 500 museums, while MODES, the first new generation computer system, was installed on 80 micros in nearly 60 museums in the six months following its release. These facilities have resulted in *de facto* standardisation between a large proportion of the museums in this country at the basic level of data fields.

I should also refer at this point to the Museums and Galleries Commission. This is the recently strengthened independent body which advises government on museum policy. Its roles include funding the English Area Museum Councils and the MDA. It has just carried out a major training review and another current priority is the development of a registration scheme for museums (Chapter 31). The Commission is taking a growing interest in the importance of collections management and may well encourage national and non-national museums to direct resources into this area in the future.

Part of my evidence for the statements about practice and trends comes from three surveys with which I have been involved. In the mid 1970s, IRGMA was able to carry out a review of the state of cataloguing practice in UK museums. In the early 1980s, I undertook an in-depth examination of documentation procedures and policy in a selective range of national and local museums (Roberts, 1985). More recently, in mid 1986, the MDA was commissioned by the Area Museums Service for South Eastern England to investigate the state of documentation in 900 non-national museums

Table
5.1

Standard of documentation procedures in museums in south-east England

The figures refer to the percentage of respondents to the 1986 survey %

		%
Entry control over:	enquiries	55
	short-term loans-in	66
	acquisitions	82
Accessioning of:	permanent acquisitions	80
	long-term loans-in	73
Accession record coverage (current standards):	under 100% coverage	87
	under 75% coverage	61
	under 50% coverage	48
Location control:	written details of location	53
	collection in logical order	28
	no details of location	19
Movement control:	internal movements logged	43
Exit control:	external movements logged	89
Preparation/maintenance of catalogue records:	permanent acquisitions	73
	long-term loans-in	64
Catalogue record coverage (current standards):	under 100% coverage	92
	under 75% coverage	68
	under 50% coverage	57

Information retrieval:	Object name	Subject	Donor
under 100% coverage	86%	85%	92%
under 75% coverage	76%	75%	79%
under 50% coverage	62%	70%	74%

		%
Collection audit:	internal audit	33
	external audit	16
Documentation security:	duplicate register	38
	duplicate catalogue	33
	duplicate location list	20

in the south-east (Roberts, 1986b). This most recent survey produced valuable evidence of the collections management problems facing museums. The main survey technique was the distribution and analysis of a questionnaire. We also absorbed evidence from a general Museums Association survey of the overall UK museum situation.

The questionnaire included five main sections on:

external support;

documentation and collections management procedures;

computerisation and system change;

audit, access and security;

staff and training.

In the case of documentation, the overall picture was of an extremely disturbing level of practice and coverage in many museums (Table 5.1). To take a few illustrative examples, only 55% of the respondents prepared a written record of items left as an enquiry, only 80% produced separate accession records and only 73% produced

**Table
5.2**

Current and anticipated computer use by museums in south-east England

A. Time perspective

Do you use or plan to use computers in the museum?

Already use	55 (18%)
20 introduced more than two years ago	
35 introduced in last two years	
Intend to use in next few years	110 (35%)
No current plans	147 (47%)
	312 responses (out of 312)

B. Uses

If you do use computers or plan to use computers, for what purposes will they be used?

	Already in use	Planned use	Total
Object collection management	15	67	82 (26%)
Object catalogue record	24	100	124 (40%)
Object catalogue record indexing/retrieval	21	107	128 (41%)
Library records	13	63	76 (24%)
Archaeology sites and monuments record	5	18	23 (7%)
Biological or geological site records	2	21	23 (7%)
Financial planning and management	15	28	43 (14%)
Shop stock control	5	31	36 (12%)
Environmental monitoring	5	11	16 (5%)
Word processing	32	61	93 (30%)
Mailing lists	22	44	66 (21%)
Gallery display	9	25	34 (11%)

catalogue records for each significant item in the collection. The standard of the records that were available usually fell far below the expectations of current staff. Similarly, just 53% of respondents kept specific location records and these were rarely comprehensive. (It should be added that another 28% noted that their collections were in a logical order.) Only 43% claimed to keep a written track of internal movements. More encouragingly, 89% logged external movements. The survey indicated that the state of indexing and retrieval facilities was also very poor, with only around 25% of the museums having a reasonable coverage of primary object name, subject and donor indexes.

Despite the pressure for accountability, in this sample of non-national museums, just 33% referred to an internal audit programme and only 16% to an external programme. In the related case of security, less than 40% had a duplicate copy of their registers or catalogues.

The evidence does forcefully illustrate the rate of build up of computer use, with over 50% expecting to be using computers for cataloguing and retrieval by the end of the decade, compared with just 18% in mid 1986 (Table 5.2).

It is indicative of the interest in computerisation that every respondent answered the question on this subject. The impression that 50% already expect to computerise

SURVEYS OF SYSTEMS AND PRACTICE

Awareness of the need for system change

	%
A. System change	
Museums with procedures under development	
entry control	41
accessioning	40
location control	40
item/cataloguing procedures	56
information retrieval	56
B. Retrospective projects	
Museums with retrospective projects	
inventorying/registration	54
cataloguing	60
information retrieval	57
C. Computer adoption	
Overall plans to adopt computers	53
Primary intended uses	
collections management	26
catalogue record	40
information retrieval	41

in the next three to four years is probably a low estimate. Falling system prices or — most crucially — the availability of more effective low-cost software, might well encourage some of those that do not at present anticipate computerising into the active camp. Of the museums that referred to the intention to computerise, 75% indicated that documentation was a priority area.

At the time of the survey in mid 1986, there was a wide diversification of hardware and software being used by the active respondents. The inclusion of an appreciable number of very small and non-standard systems would suggest that many of the current users will be looking for a new generation of machines within the next few years. The concentration on generic building-block applications packages such as dBaseIII was very noticeable. The duplication of effort being devoted to applying these generic systems in individual museums is a matter of concern, and one of the reasons for encouraging the availability of more tailored packages specifically for museum purposes.

The details are of course already out of date. The MDAs new data entry system (MODES) has itself made an impact in the area and has overnight become probably the most widely used package for documentation purposes.

As with computer use, appreciable numbers of respondents referred to the recent or planned introduction of new procedures or a retrospective documentation project (Table 5.3).

Another area reviewed was that of staffing and training (Table 5.4). In the case of responsibility for documentation and collections management policy and pro-cedures, the main emphasis was on the role of general managerial and curatorial staff. Only a handful of museums referred to the availability of a documentation specialist. The implementation of procedures also fell mainly on non-specialist

Table 5.4 Documentation staff

		%
Policy managed by:	director or designated curator	74
	documentation specialist	11
	other	3
	no one person	12
Procedures managed by:	director or designated curator	65
	documentation specialist	6
	other	14
	no one person	15
Work carried out by:	curatorial/assistant staff	69
	documentation specialist	15
	job creation staff	16
	volunteers	44
Training:	attended seminar or course	47
	relevant degree	21

curatorial staff, although job creation employees and volunteers played an important role. There is separate evidence from the UK as a whole that documentation projects are the major users of temporary staff and volunteers in museums.

Finally, there was little evidence of more than cursory pre-service or in-service training of these staff in documentation and collections management principles.

I mentioned earlier the *de facto* standardisation of data fields among MDA users. There has been far less progress in introducing standard terminologies and vocabulary control facilities in disciplines outside the natural sciences. We are currently piloting a new survey on terminology control practice, with a post-graduate student carrying out a review of the situation in Yorkshire and Humberside on our behalf. These survey results are being accumulated in a national database of collections management practice which the MDA is building up as a long-term non-confidential resource.

Returning to the south-east survey, we see little reason to expect that this evidence from one geographic area is atypical, although the large number of volunteer staffed museums may be affecting some of the figures. Despite all the depressing evidence of the scale of undone work inherited from previous generations, it is encouraging that so many museums are involved in positive planning and change.

Looking to the future, I would expect the speed of change to continue to accelerate. I have referred to the management changes in hand in the largest national museums. In both national and local museums, we are seeing the upgrading of collections management being identified as a high priority for the future, with the cost of new posts and systems being taken into account in planning proposals. The recent Museums and Galleries Commission report on training has identified documentation and automation as key areas for the development of new courses and in-service programmes (Museums and Galleries Commission, 1987). Perhaps most significantly, museum managers and trustees are recognising that there needs to be a shift of resources into the management of collections if the museums in the country are to perform effectively in the 1990s.

6 COLLECTIONS MANAGEMENT SYSTEMS AND PRACTICE IN MUSEUMS IN THE NORDIC COUNTRIES

CARSTEN LARSEN

This paper will give a view of what is going on in the museums in the Nordic countries when talking about collections management. But the task to present a full account upon this item is too huge, so I have decided to concentrate upon stating the level of automation used in the museums in the Nordic countries and at the same time try to answer how and why automated documentation is one of the major tasks.

Planning and cooperation in collections management

As in so many other places in the world, in the Nordic countries it is normally the curator who decides what to collect. But it is far more interesting to know how (or why) the curators plan the collection.

There are many answers but roughly they can be put together in four groups: because the individual curator thinks it is a nice object; because the museum has been ordered to do it, for example, by government (local or national); because the museum has a long term plan (and this of course is by far the best reason); or because the museum has available storage.

Which director can truly say that the collection in their museum has a homogenity which is the result of long term planning? Perhaps some of the recently founded museums can make that claim, but most older museums have collections of special objects which are not, and never will be, representative for the subject in question.

Many museums have devoted themselves to special topics, but for the curators it becomes increasingly difficult to have an overview of their own collection, let alone the collections in other museums with the same topic. If this overview cannot be established, then it most certainly is hard to talk about representativity or long term planning.

What is needed are better tools for collections management in order to serve as an instrument when collecting, researching and making exhibitions. In several of the Nordic countries this situation led to the formation of pools of related museums. Museums with special interest in textiles, maritime matters, etc., sat together and discussed the possibility of forming national pools of museums. The most obvious result, besides the vital contact between colleagues in the same field, should be sharing the 'market' in order to be able to establish specific local collections, which in total would be one collection, representative for the nation.

At the same time, the dawn of automation had arrived in the Nordic countries. And as documentation is the cornerstone of overviewing a collection, the idea of local databases hooked up with a national database took form. The plan is to keep the information of each museum at the museum, in a local or regional database, and to deliver the information worth sharing to the national database. In this way you

would have access to the national database to see whether it is a good idea to buy or receive a certain object for your collection. Instead of buying an object which is present in ten other museums, you may want to direct your attention to objects which are not present anywhere.

The time has come where numbers of museums, numbers of items held in the museums and especially number of different collections management systems used in the country, can tell you whether the country has been cooperating in the task of preserving its common heritage.

National databases

This is no new idea, as it has already been implemented in other places in the world. But all the Nordic countries have through the various museum associations made reports stating that this would be the best way of doing things. And all the governments in the Nordic countries find it a splendid idea, but so far it has only been made law in Denmark.

In Denmark two automated offices have been established since 1982 and 1984 and they have been placed at the two biggest state museums. The office to hold the national database of the arts is called Art Index Denmark and is situated at Statens Museum for Kunst (national gallery) in Copenhagen. Art Index Denmark will be responsible for the scientific standard and homogenity of the database, performing input routines and maintaining and expanding the lists of preferred terms and the thesauri. The museums are responsible for presenting to Art Index Denmark a minimum of data to be entered in the national database. The national database for cultural history (archaeology, ethnology and history) is called Det kulturhistoriske Centralregister (The Central Cultural-Historical Archive) and is situated at the National Museum in Copenhagen. Since 1982 the archaeological museums have been reporting on new finds to this archive and simultaneously the archive is transforming the old register, kept since 1872, into machine-readable form. In total there are about 150 000 archaeological sites registered and about 35 000 of these are now computerised. The archive is, in cooperation with the museums, planning to establish an ethnological/historical register. These two registers together with data-bases for objects will be the main task for the archive in the next five to ten years.

Both offices are funded by the state (Ministry of Cultural Affairs) and have staff like curators, computer scientists and administration officers. The museum act stipulates that every museum has to share its data with the national database and in return every museum can perform searches of the national databases.

The reason why Denmark, as opposed to the sister countries, has succeeded in establishing a national database is the infrastructure of the Danish museum system. The majority of museums in the Nordic countries are funded by state or local government. Museums related to each other have gathered in museum associations, the art museums having their association, etc. However, Denmark is the only country in which there is a gathering of all the museums in a council which is embedded in the government. This council of museums consists of colleagues from museums elected every third year and their job is among other things to prepare the revision of the museum act.

Being a council of all museums and being embedded in the government, this council carries a lot of weight. There has been a total agreement to stipulate in the Danish museum act that all museums must report to the two national databases.

This does not mean that Denmark has come very far in the automation of museums. It only suggests that the Danish view so far has been top-down: first establish the national body with guidelines for automation and secondly establish ional or local databases.

Sweden, a working party published a report in 1981 on the documentation of museum collections of objects and pictures. In this publication it was suggested stablish a working party which was to produce the guidelines for a collections management system. This working party (SAMOREG) published a proposal for a common collections management system in the Swedish museums in 1985. The system is based on paper, but at the same time it was suggested that the working party was established permanently as a national office for coordinating the use of computers.

In Finland, the government in 1984 set up a committee to make a thorough study of the ways in which museums can make use of information technology. This Information Technology committee concentrated on the use of computers as an aid to cataloguing. To coordinate the transition to a computerised system, the Finnish Museums Association in 1985 set up a committee, which deals with general practical questions relating to the changeover from manual systems to automation.

In Norway, the five archaeology museums have participated in a committee for automation since 1980. In 1982 a report was published and since then the committee has been working on developing a system for archaeological objects and sites.

The art and cultural historical museums have for more than ten years been dealing with plans to automate their collections management systems. One of the major problems within these museums is that more than half of the objects in the collections are not catalogued. In 1986 a project to coordinate the different automation plans was ended and one of the main results of this work has been a proposal for a national database.

Local databases

If instead of looking at national databases, we take a look at the local ones, the Swedish museums dominate the field of automated collections management.

The *Etnografiska museet* in Stockholm had a few years ago an online system to a service centre, but have now on account of prices a batch-system. They are now seriously thinking of buying their own computer.

Kulturarvet in Falun has for several years worked with the documentation of text and pictures on a computer basis. The data capture is mostly done on micros and the data is then transmitted to a private service centre in Gothenburg. Photographs of the objects are stored on videodisc. First the picture is recorded on a 35 mm camera and then scanned to video-film which is used in producing the videodiscs.

Naturhistoriska riksmuseet uses only 80 characters per object in the computer registration. This is of course an advantage as the collection contains around 15 Million objects and the system is mostly used in scientific research projects.

Nordiska museet in Stockholm is the museum in the Nordic countries with most machine readable data. It is in the process of developing an integrated information system, which first of all is for the benefit of professional museum people.

The museum started approximately 20 years ago and now has its own computer, where information is recorded in data fields without the possibility of free text. The information was standardised from the ledgers and each object was classified

according to the *Outline of Cultural Materials* and the museum's own classification system.

Not only the objects from the Nordic Museum itself, but also objects from about 15 other museums are registered in this database (around 700 000 objects in total). These huge figures mean that the computer cannot handle all the objects online and most data is kept on tapes and the museums receive sorted lists of their inventory. This approach could be called the start of a national database.

A matter worth noting is the way the data entry is conducted in this project. As in all countries, there is a level of unemployment in Sweden. This is particularly the case in the north of the country and the museums can get their data entry done free of charge in a little town up north. Nineteen unemployed persons took 18 months to enter the data from the Nordic Museum and they can do another six smaller museums every year.

Statens konstmuseer has developed and tested a system for administrating the depositions of works of art. Around 10 000 deposits are registered and can be used online or to print sorted lists.

In Norway, the museum association for art and cultural historical museums conducted a survey in the form of a questionnaire. It showed that nine museums used computers and that they had information on about 40 000 objects, which is the equivalent of approximately 12% of the total number of objects in the museums. Fifty out of 120 museums had plans to automate.

Unlike most other countries, Norway has provided a great deal of money and effort to establish nomenclatures of the collections from after the reformation. Since 1981 a project has been conducted which has developed nomenclatures for several classes of museum objects, all beautifully published.

The archaeologists have for many years used computers in different research projects and *Tromsø Museum* has been the leading partner in this respect.

The *Arkeologist museum* in Stavanger has also made progress, concerning the documentation of archaeological sites and locations. All information has been automated in cooperation with a private database host, but has now, on account of rising prices, been implemented on their own machine. Also *Universitetets Oldsags-samling* in Oslo is conducting an automated registration of sites and locations.

In Finland the most extensive project is the one conducted at *Lahti city museum*, where the aim is to embrace as much data as possible. The system is still in its development stage.

Other Finnish museums, among them *Ateneum* (the main art museum), are planning to use micros in collections management.

In Iceland, four museums have gone partly computerised, among which is the *National Museum of Cultural History and Art*. The level of ambition is somewhat modest, as everything is based on micros with software like dBaseII, spreadsheet programs and filing systems.

In Denmark only a few museums have begun to automate their collections management system. This is the result of the Museum Council policy of trying to work out a system which will run both on micros and minis and which is to be implemented at local museums at very low price or free.

The *Nationalmuseet* in Copenhagen has been gifted with approximately $10 million to be used before 1994 in the field of documentation. After 1994 there is approximately $0.75 million to maintain the databases and to continue developments.

The National Museum consists of many different departments (several archaeologic departments, the ethnographical department, the ethnological department, etc.). Each of these departments has through the last 175 years had their own specialised collections management systems, and it was early recognised that all these manual systems should be contained in several databases, which are to be looked upon as one integrated collections management system.

Also, it was recognised that not only new data from new objects should be registered but also most of the data from the existing collection.

The automated collections management system should consist of a text database with the textual, cultural historical information about the objects (this database is called GENREG) and a picture database containing pictures of most of the museums artefacts. The two databases should be integrated with other more specialised databases, like a database for conservation (to be implemented in 1988 and called KONREG), a database for scientific analysis like C14-dates, etc.

The first step regarding the databases was taken early in 1987, when a proposal for the database GENREG was published. The main idea is that the information about one object can be logically separated. The top level in the separation could be called the data groups. Within the data groups there is some information which logically can be grouped together and these sets can be termed data sets. The data fields are the bottom level where the actual information is registered.

The data groups are called identification, accession, provenance, description, determination, administration, references and system information.

Identification contains the information used for a quick identification of an object.

Accession is the information which is added to the object when it is received at the museum. One data set in this data group is information about how and when the object was found and brought to the museum. Another data set contains the data fields relating the information to the source (i.e. archive, date of manual registration, etc.).

Provenance is the information which accompanies the object when the museum gets it into custody. One data set contains data fields about objects found in the earth (i.e. from what type of structure does the object come, name of the structure, number on maps, etc.).

A vast amount of information can be deducted by just looking at the object and this information is contained in the data group *description*. Data sets are information about quantity, measurements (length, height, weight, etc.) and material (including pointers to the planned database for C14).

The information derived from studying the objects is contained in the data group *determination*. Data sets are classification, dates, etc.

Information which is formed by handling the objects is put into the data group *administration*, which embrace such data sets as location (where is this object physically stored) and conservation (pointers to special database about conservation).

All other information regarding the objects is considered *references* to other archives. This data group of references also contains the reference to the picture database.

Recently this system has been implemented in two departments, the ethnographical and ethnological. For the time being, certain data about all objects in these two

departments is registered in the text database and in 1988 a system for the picture database will be implemented.

The software used is the relational database management system Oracle, which runs on micros (DOS) and minis (Unix). All machines will in principle be able to communicate through a local area network.

SYSTEM DESIGN

7 SYSTEM DESIGN
PETER HOMULOS

The three papers that follow on the subject of system design approach the subject from distinctly different points of view, all of which are relevent.

Richard Light's paper on the scope and design of collections management systems deals with how to relate activities and processes in a museum to the physical implementation of a system designed to support those processes. Jane Sunderland and Lenore Sarasan provide a more formalised approach to the selection of a system to meet collections management needs. They deal with measuring the characteristics of systems in an objective fashion. Stephen Toney discusses the tools and methods available to manage the process of the development and implementation of a system in a museum.

Without a clear and precise understanding of the functions or activities a system is expected to support, it is highly unlikely that the system will succeed. It is equally unlikely that today's set of activities will remain unchanged over time. The importance of expressing needs and the variability of those needs have created a reluctance in some museum professionals to actually commit to a particular system. The importance in Light's message, beyond the model he puts forward, is the process by which he arrives at the model. Understanding how to develop an expression of needs removes the fear of changing that expression in the future.

Following a statement of requirements one begins the process of selecting a system. Based on the extensive work they have done in museum automation, Sunderland and Sarasan have developed, in their paper, a good method of objectively assessing the characteristics of systems. The selection of a system represents a considerable investment on the part of the institution and it takes a long time to recover from a poor decision. Given the importance of this decision it is essential that one sees through the smoke and mirrors and evaluates candidate systems on their merit. No 'off the shelf' system will provide for all of the needs of an institution. Each will have to be customised, but hopefully as little as possible. The time spent selecting a system can greatly reduce the cost and time of customisation.

Establishing a specification of needs and selecting a system that meets those needs is only part of the story. The remaining part deals with planning and managing that system within the museum. In his paper on planning techniques, Toney discusses many of the issues and considerations that are vital to the successful implementation of systems. He deals with the planning process, tools such as software engineering and data administration and issues such as strategy and stakeholder representation.

Collectively the papers that follow give the reader a good introduction into many of the considerations essential for the design, selection and implementation of an effective collections management system.

8 THE SCOPE AND DESIGN OF COLLECTIONS MANAGEMENT SYSTEMS

RICHARD LIGHT

While the term 'collections management' is generally understood by museum professionals (although it may mean different things to different people), it is perhaps less clear what is meant by a 'collections management system'. How can you 'systematise' the wide range of jobs which come under the broad heading of collections management? This paper offers a starting point in this discussion by providing a general view of what a collections management system is. It outlines the scope of a collections management system and provides a generalised model on which the actual design of a working system might be based.

The role of a collections management system might be defined as:

> to handle *information* relating to *activities* which impinge on the *collections* held or managed by a museum. This information should be *organised* to facilitate the *control* of current and future activities and the *recording* of information about all activities, past, present and future.

Thus a collections management system is an information handling system. It reflects what is happening in the real world, but cannot directly control events. It needs to be 'fed' with accurate, up-to-date information if it is to function properly. This information will take a variety of forms: letters, contracts, museum control forms, etc. In an automated collections management system some, but not all, of the information will be held and manipulated electronically.

A collections management system organises this information by providing files (manual or automated) which group similar forms, etc., together and which arrange them in a useful order. It ensures that links are maintained between different files so that related information can be found quickly. In general terms, the organisation of a collections management system should closely reflect the working practices of the museum within which it operates.

As mentioned above, a collections management system itself cannot actually control events in the real world, but one of its primary purposes is to support collections control. It does this by providing museum staff with pertinent information so that they can make informed decisions when working with the collections. It also helps to ensure that the museum's agreed procedures are followed for each activity undertaken. Finally, a collections management system should provide an audit trail showing what actions have been carried out, and by whom.

Scope of a collections management system

A collections management system should document and control any activity impinging on objects in the collection itself. Examples of such activities are:

accessioning;

loans management;

store management;

temporary exhibitions;

insurance/indemnity.

For each activity undertaken, the collections management system should support a number of different aspects, as follows.

It should aid the implementation of museum policy on issues such as the scope of the collection, acquisitions, disposals and loans-out. This involves the provision of pertinent information on museum policy to decision-makers, and the incorporation of controls to ensure that policy guidelines are followed and appropriate authorisation given.

It should seek to establish a secure legal position by ensuring that the museum's rights (for example, title to objects in the collection) and responsibilities (for example, honouring reproduction rights and having enforceable loan-out agreements) are discharged. The collections management system should provide information sufficient to bring or defend a legal action where necessary.

A collections management system will provide some measure of financial control in relation to the collections. As a minimum, it should organise information on valuations for insurance or indemnity purposes, but it might also deal with purchase funds or storage/conservation costs.

It should help to ensure the physical well-being and security of the collections. This is achieved by numbering the objects and linking these numbers to documentation on activities concerning them, by effective movement control procedures, by appropriate packing and shipping guidelines, and by routinely monitoring the condition of objects and undertaking conservation where necessary.

An important role of a collections management system is the provision of information about the collections. This might take the form of storage or display labels, systematic catalogues and *ad hoc* responses to enquiries. In each case the type of information and its layout should be appropriate to the purpose for which it is being provided. Defining a collections management system in this way means that the museum's cataloguing work should be seen as an integral part of its collections management system, and not as a separate activity.

To summarise, the scope of a collections management system is to aid the controlled and effective use of a museum collection. It covers activities such as display, temporary exhibitions, loans-out and research on the collections. The more actively a museum's collection is being used, the more it will need an effective collections management system.

Design of a collections management system

As noted above, a collections management system is an information handling system. The information that it holds relates to objects in a museum collection, and to actual and potential activities which affect those objects.

The system is 'driven' by inputs of information (for example, letters or forms received and data entered by museum staff into a computer) which reflect events in the real world. An input may, for example, indicate that a curator wishes to carry out a certain action, that permission for an activity has been granted or refused, or that an action has been completed. The system will organise these inputs so as to support the subsequent stages in the process. It will also update other files as necessary to provide management information and to avoid contention for a specific object.

Table 8.1

Step	Aspects
1. Loan-out initiated by external request	
2. Approve/reject request in principle	policy
3. Check availability of object(s) for period requested	scheduling
4. Check condition of each object	physical care
4A. Conserve object if necessary	
5. Approve loan	authorisation
6. Notify borrower of decision/arrangements	information provision
7. Pack object(s)	movement control, physical care
8. Prepare loan agreement, shipping paperwork	information provision, authorisation
9. Loan agreement signed & returned by borrower	authorisation
10. Loan shipped	movement control, scheduling

Breakdown of a typical collections management activity (a loan-out)

On request the collections management system will provide outputs. These may be worksheets summarising tasks to be carried out, donor or loan agreement forms, specimen labels, management reports, etc.

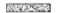 A data model for activities

Although a collections management system includes (and makes active use of) information about objects in the collection, this is an area which has been extensively discussed elsewhere. For example, the Museum Documentation Association has produced a wide range of publications and systems related to the documentation of museum objects. Accordingly, the rest of this paper will concentrate on the outline of a model for the activities associated with collections management.

Examples of activities have been given above, and it has been pointed out that each activity should take account of a number of aspects. Each activity can be seen as a sequence of steps. Table 8.1 shows a possible sequence of steps for a loan-out.

The sequence is started by someone requesting that a given activity should take place. This might be a member of the museum staff, someone outside the museum, or even the collections management system itself. (For example, it might provide the information that, say, ten years had elapsed since a given object's condition had been checked.)

Each step will normally be carried out by an agent, and that person will usually be a member of the museum's staff. However, any activity involving people or institutions outside the museum (such as a loan-out) will contain some steps that have to be carried out externally.

The overall activity, and hence each step within it, will be (or certainly should be) subject to time constraints. For example, a short-term loan-out will have a start date and a finish date. In turn, the start date will impose deadlines on all the preliminary work that has to be done before the object(s) can be shipped out.

The number of steps to be carried out will depend on the level of detailed control which the museum wishes to exercise over each activity. The precise nature of each step, and the sequence in which they are carried out, will be determined by and will closely reflect the museum's policy and working procedures. For each type of

activity there should be a standard sequence of steps reflecting the 'default' procedure to be followed.

However, not every activity of a certain type will actually go through the standard sequence of steps. Some requests will be refused, causing the whole process to stop. Some steps may be conditional on others: for example, conservation may only be undertaken if a check on condition shows it to be necessary. Normally one step will lead to the next, but it may be possible for some steps to be carried out in any order, so long as they are all completed. For example, steps 2, 3 and 4 in Table 8.1 could in theory be carried out in any order, but all must be completed before the loan is approved (step 5). In order for each step to be carried out, both information and access to the object(s) concerned may be required by the agent concerned.

The information required to carry out a step should be held by the collections management system. Ideally, relevant information should be organised and presented to the agent who has to carry out the step as their notification that the step needs to be carried out. This may take the form of a worksheet detailing tasks to be done. As a minimum, the system should have organised the relevant information so that the agent can quickly find the information they require.

Access to objects will normally preclude their use for any other purpose at the same time, whether it is for a brief examination of condition or for the loan-out itself. The scheduling procedures within the collections management system should ensure that objects are available where necessary for each step in the activity, not just the 'main' step.

Finally, it should be noted that each activity may relate to a number of objects and that each object may consist of multiple parts. Some steps will need to be recorded separately for each distinct object (and part): some objects requested may not be available, while others may not be in a condition to be lent. While some steps (for example, shipping out the loan), clearly apply to all objects concerned with the activity, it is probably more straightforward within the collections management system to continue to hold separate records for each object.

When an activity is initially requested, it may not be clear exactly which objects are required. For example, a request for a loan of 'a Victorian carriage clock' might be satisfied by any one of the three clocks in a collection: the museum or borrower will need to select which one to lend.

Features of an 'activity record'

From the above discussion it is clear that the collections management system needs some sort of record to pull together all the information relating to each activity. This activity record should be given a unique number, quite distinct from the numbers given to the object(s) involved in the activity. It may be convenient to have a separate number sequence for each type of activity.

The activity record should hold (or point to) existing relevant background information about the object(s) concerned. For each such object it should then, where appropriate, provide the information required to carry out each step of the activity. After a step is complete, it should record the results of that step for each object concerned (Figure 8.1).

On completion of an activity, the detail held within the activity record will no longer be required, although the full record may well be kept for archival purposes. However, it is valuable to copy back a brief summary of the overall activity into the

Fig. 8.1 Structure of an activity record

records of each object concerned. This might record, for example, that an object was loaned between certain dates to form part of a particular exhibition. This summary should include a cross-reference to the number of the full activity record, so that further details can be traced if required. In addition, it is important to record any new information about an object that might come to light as the result of an activity.

In order to schedule the use of objects, the proposed and actual start and finish dates for each activity need to be linked to a central scheduling file (Figure 8.2). This records the actual and proposed use of each object (or part of an object), with the aim of preventing 'clashes' between two or more activities.

Fig. 8.2 Links between activity record and scheduling file

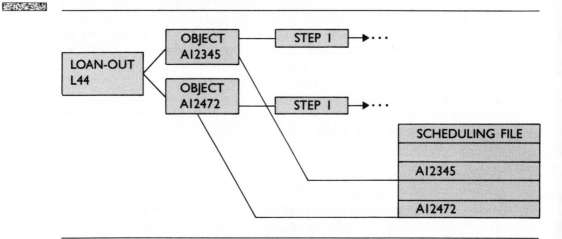

In theory it is possible to have a link from each step requiring access to an object to the scheduling file, but for most practical purposes it should be sufficient to log the earliest start date and latest finish date for the overall activity.

Use of the activity record

When an activity is started and the object(s) concerned have been identified, the collections management system should create a 'standard' activity record containing all the possible steps for each object, with proposed agents and start and finish dates for each step. This draft activity record can be checked against the scheduling

file to see if there are any clashes with existing commitments. Clashes can be resolved either by withdrawing the objects concerned or by re-scheduling one of the activities.

Once the schedule for the activity has been approved, the system should 'trigger' the first step for each object mentioned in the activity record. The actual dates when each step was carried out should then be recorded, along with other details of the step.

In a manual system this might be achieved by the use of a job card for each object noting its progress and being passed on to the agent responsible for each step. This file can only offer a single point of access (for example, by date due, by object number or by type of operation), and additional files will be needed if different points of access are required. The operation of an effective manual system will thus involve a significant amount of hand-copying. Cross-references will have to be maintained by hand, and any cross-checking or management reports would have to be prepared manually.

In an automated system the cross-referencing between files can be maintained automatically: for example, the central scheduling file can be kept up to date from details in the activity records. Worksheets and reports can be generated by the system itself. It can provide active support for collections management by warning of overdue deadlines, producing management overviews and helping plan the effective use of staff resources.

Summary

An effective collections management system should not just reflect a museum's working practices: it should be totally integrated with them. This means that the system must support all the activities carried out by the museum that affect its collections. Furthermore, the component steps of each activity in the system should be modelled on the museum's practice. A museum should find that a collections management system is actively supporting its current policy and procedures, rather than imposing new ones.

The organisation of work by a system relies on activity records which separately record the involvement of each object in the process. The effective scheduling of work and allocation of objects rely on a central scheduling system that encompasses all collections management activities relating to the collection itself.

Where collections management systems currently exist, they are likely to suffer from one or more of the following design errors:

lack of a central 'time allocation' mechanism;

insufficient analysis of activity records so that they track progress of individual objects;

lack of cross-references, and inadequate transfer of information from the collections management system back to the main object records

A collections management system is a documentation system that controls and records the active use of a museum collection. Historically (at least in the United Kingdom) there has been an emphasis on cataloguing the (passive) permanent collections. Increasing pressure on museums should result in an increasing demand for collections management systems which can help them make effective use of their holdings.

9

CHECKLIST OF AUTOMATED COLLECTIONS MANAGEMENT SYSTEM FEATURES OR, HOW TO GO ABOUT SELECTING A SYSTEM

JANE SUNDERLAND AND LENORE SARASAN

How can you even begin to select an automated collections management system for your museum? If you are like most of the museum professionals put in charge of selecting a system, chances are you do not even have a background in computers. How can you know what is possible, let alone what is appropriate for your museum?

For starters, you need to educate yourself and determine in which areas your museum could best profit from automation. Talk with or visit museum professionals who are involved in automation projects. Sign up for seminars and workshops on museum automation. Read as much of the published literature on the subject as you can find. Take advantage of conference exhibition halls to collect literature, see demonstrations, and talk with other people investigating automation. As you continue to investigate museum automation, collect names of systems and vendors at every opportunity.

If it seems like the field is getting more and more complicated, that's because in reality there are more choices these days. More 'off-the-shelf' packages and more developers of custom systems are available than ever before. The range of functions and activities addressed by collections management software is broadening as well and user expectations are increasing at a tremendous rate. While a few years ago, most museums would have been more than thrilled with a simple retrieval system that answered routine questions and did little more, museum staffs now look toward systems that can address complex collections management functions, help plan exhibitions, provide access to images, and eliminate the need to ever produce a report by hand again.

Still, for all the technological improvements and the increased number of systems being offered, selecting a system to fit your particular needs is no small task. In spite of being called the same thing, automated collections management systems are not alike. Each system has a different philosophy, a different perspective, and a different way of doing things. Some do what they say they do and some do not. The selection is a serious one for any museum not only because of the financial investment involved, but also because of the potential impact on the management and account-ability of the objects in the collection. If you pick a bad system, you will likely be stuck with it for quite awhile.

How, then, do you acquire the best system for your needs? First, you must determine what your needs are before you can decide whether a particular system fits them (Sarasan, 1986). The more precisely you do this, the better chance you have of acquiring a system that meets your requirements and expectations. Next, you need to gather information about different systems in a systematic way so that you

can more easily compare them. At first, all systems may seem to do the same things but as you learn more about them and examine them more carefully, the significant differences between them will become apparent. Finally, you need to compare your particular needs with what a particular system provides. A system might be wonderful and contain all sorts of dazzling features, but if it doesn't satisfy your needs, it is not the system for you. By approaching the problem systematically and investigating museum automation as thoroughly as possible, you increase the probability of acquiring the right system for you.

This paper will help by providing guidance on a checklist approach to selecting a system. It is complemented by a separate article on what to look for in an automated system (Sarasan, 1987).

The checklist

We have developed a checklist approach to help you optimise your time and efforts investigating automated systems. Our Checklist of Automated Collections Management System Features lists the features found in systems along with a convenient means of gathering information systematically so that comparisons are more easily made. The Checklist also assists you in collecting information about the vendors offering these products. More than with other kinds of software systems, the quality and integrity of the vendor will be pivotal to the success of your project.

The Checklist may be used in three phases of the selection process. First, it assists you in determining your museum's needs. Because the Checklist is very detailed, it provides you with an overview of the universe of possibilities in museum automation. Second, when you have prepared yourself adequately to evaluate specific systems, it provides a means of methodically recording information about each system you review. Finally, it can provide a good portion of the system requirements definition for a Request for Proposal when you are ready to seriously entertain competitive bids.

The Checklist consists of two sections. The first is a System and Vendor Profile on which to collect basic information about an automated collections management system and its vendor. The second section is a Checklist that categorises system features into eight separate categories for you to examine in determining whether a software system fits your needs:

what collections management functions are addressed?

what are the general features of the system?

what data structuring features are there?

what is the user interface like?

what query features are provided?

what are the reporting capabilities?

what special features does the system support?

what training, documentation and support are available?

How to use the checklist

Before contacting vendors, read through all parts of the Checklist. Each investigation of an automated system will result in a packet of information which should include the following:

System Profile (Table 9.1);

Vendor Profile (Table 9.2);

System Checklist (Tables 9.3–9.10);

System Checklist Log Sheet (Table 9.11).

The System Profile summarises general facts about a particular software system, while the Vendor Profile summarises its vendor's background and services. The System Checklist itemises system features. Use the System Checklist Log Sheet to record the progress of your review of each system.

1. Prioritise System Features. Start with a clean copy of the System Checklist. Work down the Checklist, prioritising each feature for your museum as 'Must Have', 'Might Need', 'Don't Need', or 'Frill'. It is easy to say, 'We want it all!' but the truth of the matter is that very few systems actually provide even half of the features in the Checklist. Museum automation is still in its infancy (in spite of having been around for almost 25 years) and user expectations have grown at a faster rate than the sophistication of the systems on the market. Remember, the system that best fits your needs is not necessarily the one with the most 'YES' answers, but rather the one which most closely matches your priority profile.

You may want different departments or different people to complete separate prioritisations to see how different users perceive their individual needs.

2. Collect System Literature. Contact vendors and request written literature and brochures on systems. Prepare a file for each system.

3. Complete Profile Sheets. Review the system literature you have collected. Fill out a System Profile Sheet and a Vendor Profile Sheet for each system that you wish to investigate further. Initially, draw this information from the literature you have received from the vendor. Next, contact each vendor to gather additional information onto the Profile Sheets.

4. Complete System Checklist. For each system that seems interesting, make a photocopy of your prioritised System Checklist. Initially fill out the Checklist from the information included in the printed literature. Next, arrange for a mutually convenient time for the vendor to have a lengthy telephone conversation with you to discuss the system. Avoid having a detailed demonstration of a system before you have filled out the Checklist as completely as possible. Record each vendor contact on the System Checklist Log Sheet.

5. Create Short List. Review and compare the Checklists for the systems you have investigated. Evaluate each system against the priorities you have set and your perceived needs. Note that as you learn more about systems, your priorities may change. Draw up a short list of systems that should be investigated further.

6. Arrange Initial Demonstrations. Call the vendors of the systems on your short list and arrange for detailed demonstrations. This type of demonstration differs in style and form from those in an exhibition hall that are aimed at a crowd of people. Anticipate a minimum of two separate demonstrations before you purchase any system. You will be amazed at how many things about the system you notice the second time that you missed the first time. Select only those systems for demonstrations that you truly believe you may purchase; avoid exploiting vendors.

Ideally, the initial demonstration should be at an installed site with the vendor present. This way you will see the system working on real data in a real museum environment. Arrange a mutually convenient time with the vendor, the site user,

SYSTEM DESIGN

and yourself. In this initial demonstration it would be better not to bring a large committee from your museum or the focus of the demonstration will become diffused. The demonstration should last several hours and cover most, if not all, of the points in the Checklist. You should be prepared to cover your own travel and incidental expenses at this point in the investigation, but not those of the vendor.

7. Write-up Impressions. After each demonstration, carefully write up all notes and impressions as soon as possible. Review the previously prepared Checklist with the information gathered during the demonstration. Record any questions or points of confusion that may have arisen and submit this list as soon as possible, in writing, to the vendor. Ask the vendor to respond in writing.

8. Prepare Request for Proposal. At this point you have narrowed the field enough to move to the Request for Proposal (RFP) stage. A formal RFP will allow you to get competitive bids from vendors on hardware, software, customisation, and database construction fees. The information you have collected with the help of the System Checklist will assist you in describing your system requirements. In addition, the RFP should include a brief description of your museum, the function areas to be automated along with activity levels (such as number of loans per month), the departments involved, and the numbers and types of collections. The more complete your RFP, the more specific and accurate the vendor proposals can be.

You may feel that you already know which system you want and it will be tempting to avoid this formal request process. However, issuing a Request for Proposal gives your museum an overwhelming advantage in selecting the right system and avoiding a very costly error. First, it requires that your perceived needs be articulated in writing. No matter how much advance work you have done, you may find that articulating your requirements in writing — and getting input from all parts of the museum — significantly expands and changes your understanding of the museum's needs. And second, an RFP requires the vendor to place in writing those system specifications and claims that have been given orally. An RFP protects the museum against any possible misunderstanding between it and the vendor as to what is needed, what a particular system provides, and at what cost. Further, an RFP will help you gain a broader picture of everything that is involved in the installation of a system — hardware, software, data entry and implementation — including expenses that may not have been covered earlier.

Allow vendors an adequate time to respond. At least six weeks, and preferably two months, should be allotted. During this period you should be available to answer any questions raised by the RFP and to provide additional materials the vendor may need to prepare a proposal.

9. Review Proposals. When the Proposals have been received, read them all carefully. You may wish to hire a consultant to assist you in evaluating the proposals or ask someone from your accounting firm to help. Do not just compare the bottom line figure of the Proposals; a vendor may not respond to all parts of the RFP.

10. Arrange On-Site Demonstrations and Vendor Presentations. Based on the first round of demonstrations and the Proposals, reduce your short list further to two or three systems. Invite each vendor to visit your museum and give a presentation of the product at your site. As many staff as are interested should be invited to this presentation. The vendor should pay for all costs involved in such a marketing demonstration including travel, equipment and other incidental expenses. Again, select only those systems for on-site demonstrations that you are truly interested in.

11. Make Final Selection. Select a system for purchase and notify the vendor. Return all materials to the other vendors. Sign contracts, making the Proposal a part of the contract, and begin to implement your new system.

Summary

Selecting an automated collections management system does take some time and effort. Plan on spending from several months to a year on the process from start to making a final decision. Remember, that unless you have an overwhelming need to automate immediately (such as a pressing need to take a physical inventory due to a rash of missing items or the arrival of a huge collection that needs immediate cataloguing), there is little lost in waiting. Systems are becoming more sophisticated every day and hardware prices are falling.

As a final note, if an administrator, trustee or donor offers you a sum of money to spend by the end of the month on automation, don't just leap into a system without looking very carefully. In most cases the money would be better spent on a consultant to help you analyse your needs and review possibilities or on travel money to allow you to visit museums currently automating.

SYSTEM DESIGN

Table 9.1 System profile

System Name

Hardware system(s): _____
Operating system(s): _____
Language written in: _____
Memory requirement: _____
Disk storage: _____
Pricing: _____

Originally developed for:
Institution name/contact _____

Type of collection _____ Year installed _____ Records in database _____ Users _____

System orientation: _____ Registrarial _____ Curatorial _____ Scholarly _____ Other: _____

Total Installations: _____
Site name/contact _____

Type of collection _____ Year installed _____ Records in database _____ Users _____

Comments:

Table 9.2 Vendor profile

System name: _____
Contact: _____
Title: _____
Phone: _____

Vendor name: _____
Address: _____

Principals: Name Title Museum experience
_____ _____ _____
_____ _____ _____
_____ _____ _____

Number of years in museum automation business: _____
Number of non-clerical staff full-time on museum automation: _____

Customisation fees: _____

Data conversion services: _____

Cost: _____

Other software available: _____

Copyright 1987 by Willoughby Associates, Limited

SYSTEM DESIGN

Table 9.3 Collections management functions features

Must have	Might need	Don't need	Frill	Features	Yes	No	Planned	Can't tell
__	__	__	__	System supports pre-acquisition activities	__	__	__	__
__	__	__	__	Automatically assigns temporary numbers	__	__	__	__
__	__	__	__	System supports accessioning activities	__	__	__	__
__	__	__	__	Automatically assigns accession or catalogue numbers	__	__	__	__
__	__	__	__	System supports cataloguing activities	__	__	__	__
__	__	__	__	System supports loan processing activities	__	__	__	__
__	__	__	__	Outgoing loans	__	__	__	__
__	__	__	__	Incoming loans	__	__	__	__
__	__	__	__	Automatically assigns temporary numbers	__	__	__	__
__	__	__	__	System supports shipping activities	__	__	__	__
__	__	__	__	System supports exhibition planning activities	__	__	__	__
__	__	__	__	System supports physical inventory activities	__	__	__	__
__	__	__	__	System supports location control activities	__	__	__	__
__	__	__	__	System supports insurance activities	__	__	__	__
__	__	__	__	System supports conservation activities	__	__	__	__
__	__	__	__	System supports deaccessioning activities	__	__	__	__
__	__	__	__	System supports move or reorganisation activities	__	__	__	__
__	__	__	__	System supports rights and reproductions activities	__	__	__	__
__	__	__	__	System supports scholarly research	__	__	__	__
__	__	__	__	System tracks conservation/restoration history	__	__	__	__
__	__	__	__	System tracks exhibition history	__	__	__	__
__	__	__	__	System tracks loan history	__	__	__	__

Table 9.3 *Continued*

Must have	Might need	Don't need	Frill	Features	Yes	No	Planned	Can't tell
___	___	___	___	System tracks location history	___	___	___	___
___	___	___	___	System tracks ownership history	___	___	___	___
___	___	___	___	System tracks photographic history	___	___	___	___
___	___	___	___	System tracks publication history	___	___	___	___
___	___	___	___	System tracks value history	___	___	___	___
___	___	___	___	System tracks crates	___	___	___	___
___	___	___	___	System tracks frames and other supports	___	___	___	___
___	___	___	___	System supports whole/part relationships	___	___	___	___
___	___	___	___	System provides scheduling functions	___	___	___	___

Liked: _____

Disliked: _____

Comments: _____

SYSTEM DESIGN

Table 9.4 General system features

Must have	Might need	Don't need	Frill	Features	Yes	No	Planned	Can't tell
|	|	|	|	System is multi-user	|	|	|	|
|	|	|	|	System is expandable	|	|	|	|
|	|	|	|	System is modular	|	|	|	|
|	|	|	|	System can be customised	|	|	|	|
|	|	|	|	System incorporates commercial database management system	|	|	|	|
				DBMS: _____				
|	|	|	|	System has maximum field length	|	|	|	|
				Maximum field length possible: _____				
				Maximum field length defined or used: _____				
|	|	|	|	System has maximum number of data fields per record				
				Maximum fields per record possible: _____				
				Maximum fields per record defined or used: _____				
|	|	|	|	System has maximum record length	|	|	|	|
				Maximum record length possible: _____				
				Maximum record length defined or used: _____				
|	|	|	|	System has maximum file size	|	|	|	|
				Maximum records in installed database: _____				
				Maximum records in test database: _____				
				Theoretical maximum: _____				

Table 9.4 Continued

Must have	Might need	Don't need	Frill	Features	Yes	No	Planned	Can't tell
—	—	—	—	System provides multi-level security	—	—	—	—
—	—	—	—	User ID security	—	—	—	—
—	—	—	—	User function profile security	—	—	—	—
—	—	—	—	Password security	—	—	—	—
—	—	—	—	File security	—	—	—	—
—	—	—	—	Field security	—	—	—	—
—	—	—	—	Program security	—	—	—	—
—	—	—	—	System has remote site capability	—	—	—	—
—	—	—	—	System is operating system-independent	—	—	—	—
—	—	—	—	Recommended operating system: _____				
—	—	—	—	System is hardware-independent				
—	—	—	—	Recommended hardware: _____				
—	—	—	—	System can run on microcomputers	—	—	—	—
—	—	—	—	Microcomputer(s): _____				
—	—	—	—	System can run on microcomputer networks	—	—	—	—
—	—	—	—	System can run on minicomputers	—	—	—	—
—	—	—	—	Minicomputer(s): _____				
—	—	—	—	System can run on mainframes	—	—	—	—
—	—	—	—	Mainframe(s): _____				
—	—	—	—	System is accessible through microcomputers as workstations	—	—	—	—

SYSTEM DESIGN

___ ___ System can import ASCII file

___ ___ System can export ASCII file

Liked: _____

Disliked: _____

Comments: _____

Table 9.5 Data structure system features

Must have	Might need	Don't need	Frill	Features	Yes	No	Planned	Can't tell
				System uses relational file structure				
				Number of pre-defined files: _____				
				Maximum possible: _____				
				System uses hierarchical file structure				
				System uses network file structure				
				System uses flat file stucture				
				System uses other file structure				
				Structure: _____				
				System provides a variety of related files				
				Maker file				
				Culture file				
				Source file				
				History files				
				Bibliography file				
				Other file: _____				
				Other file: _____				
				Other file: _____				
				Other file: _____				
				System stores data variable-length				
				System supports sub-fielded data fields				
				System supports repeatable field values				
				Maximum: _____				

SYSTEM DESIGN

System provides pre-defined data fields

Number of pre-defined data fields: _____

System provides user-assignable data fields

System is driven by data dictionary

System provides fast-access paths (indexes) to records

Maximum possible: _____

Number used: _____

System supports field indexing

Indexing by entire field

Indexing by term or phrase

Indexing by word

Indexing for left truncation

Indexing for right truncation

Indexing for adjacency or word proximity

Multiple fields to one index

System automatically updates indexes

System supports authority files

System supports foreign language diacritical marks

Liked:

Disliked:

Comments:

Table 9.6 User interface features

Must have	Might need	Don't need	Frill	Features	Yes	No	Planned	Can't tell
—	—	—	—	System is menu-driven	—	—	—	—
—	—	—	—	System restricts access to confidential data	—	—	—	—
—	—	—	—	System provides formatted data entry screens	—	—	—	—
—	—	—	—	System provides multiple screens per record	—	—	—	—
				Number of screens per record: _____				
—	—	—	—	System provides sufficient carry-over from screen to screen to identify record	—	—	—	—
—	—	—	—	System supports multiple files per screen	—	—	—	—
				Number of files per screen: _____				
—	—	—	—	System provides English-like field tags	—	—	—	—
—	—	—	—	System provides online checks during data entry	—	—	—	—
—	—	—	—	System provides validation against authorities during data entry	—	—	—	—
—	—	—	—	System supports browsing through authorities during data entry	—	—	—	—
—	—	—	—	System supports automatic entry of terms from authorities during data entry	—	—	—	—
—	—	—	—	System supports recursive entry for linked files	—	—	—	—
—	—	—	—	System provides special retrospective data entry screens	—	—	—	—
—	—	—	—	System supports capture of repetitive data without rekeying	—	—	—	—
—	—	—	—	System provides formatted data update screens	—	—	—	—
—	—	—	—	System provides online checks during data update	—	—	—	—

System provides validation against authorities during
 data update

System supports browsing through authorities during
 data update

System supports automatic entry of terms from authorities
 during data update

System supports online updates

System supports batch updates

System supports global updates

System supports foreign language diacritical marks

Mark and letter appear as one character on screen

Mark and letter appear as separate characters on screen

Mark and letter appear as a code on screen

Liked:

Disliked:

Comments:

Table 9.7 Query features

Must have	Might need	Don't need	Frill	Features	Yes	No	Planned	Can't tell
				System allows every field to be searched				
				System provides multiple levels of query access				
				Query through formatted screens				
				Query by example				
				Query through formal query language				
				Other: _____				
				System provides Boolean (logical connectors) searching				
				AND searching				
				OR searching				
				NOT searching				
				EOR searching				
				Nested expressions				
				System provides range searching ($=, >, <$)				
				On numerical fields				
				On date fields				
				On character fields				
				System provides fast-access paths (indexes)				
				Accession or catalogue number				
				Attribution				
				Object type				
				Object name or title				
				Materials				

SYSTEM DESIGN

Date

Description

Geography

Source

Current location

Other: _____

Other: _____

Other: _____

Other: _____

Other: _____

System supports wildcard searching

Right truncation wildcard

Left truncation wildcard

Wildcard on index terms

System supports phonetic ('sounds like') searching

System supports full text index retrieval

System supports full text non-index retrieval

System supports adjacency or word distance searching

System supports online linked vocabulary for retrieval

Thesaurus

Lexicon

'ANY' file

Other: _____

System supports presence/absence searching

System allows indexed and non-indexed fields to be combined in single query

Table 9.7 *Continued*

Must have	Might need	Don't need	Frill	Features	Yes	No	Planned	Can't tell
				System allows indexes to be reviewed during query				
				System provides query hitlist				
				System provides intermediate query results				
				System allows query to be modified				
				System allows review of query results without changing modes				
				System allows query to be saved				
				System allows query results to be saved				
				System supports approximate searching				
				System allows query results to be viewed in alternative formats				
				System allows forwards and backwards browsing through query results				
				System allows query results to be sorted by various fields				

Liked:

Disliked:

Comments:

SYSTEM DESIGN

Table 9.8 Report features

Features	Must have	Might need	Don't need	Frill	Yes	No	Planned	Can't tell
System provides pre-defined printed reports								
Number of printed reports: _____								
Unique term lists								
For every data field								
For selected data fields								
Object summary sheet								
Object worksheet								
Collection in accession or catalogue number order								
Accession or catalogue numbers sort correctly								
Collection in artist/maker order								
Collection in object class order								
Collection by source								
Collection by method of acquisition								
Collection by medium/material								
Collection by object date								
Summary reports of values								
Location shelf lists								
Other: _____								
Other: _____								
Pre-acquisition reports								
Acquisition reports								
Accessioning reports								

Table 9.8 *Continued*

Must have	Might need	Don't need	Frill	Features	Yes	No	Planned	Can't tell
—	—	—	—	Cataloguing reports	—	—	—	—
—	—	—	—	Loan processing reports	—	—	—	—
—	—	—	—	Location tracking reports	—	—	—	—
—	—	—	—	Life history reports	—	—	—	—
—	—	—	—	Deaccessioning reports	—	—	—	—
—	—	—	—	Visiting scholar reports	—	—	—	—
—	—	—	—	Move reports	—	—	—	—
—	—	—	—	Conservation reports	—	—	—	—
—	—	—	—	Other:	—	—	—	—
—	—	—	—	Other:	—	—	—	—
—	—	—	—	Other:	—	—	—	—
—	—	—	—	System allows reports to be displayed on the screen	—	—	—	—
—	—	—	—	System allows reports to be saved to a file or diskette	—	—	—	—
—	—	—	—	System supports reports on special forms	—	—	—	—
—	—	—	—	Object receipt	—	—	—	—
—	—	—	—	Accession record	—	—	—	—
—	—	—	—	Deed of gift	—	—	—	—
—	—	—	—	Accession or catalogue card	—	—	—	—
—	—	—	—	Accession label	—	—	—	—
—	—	—	—	Object tag	—	—	—	—
—	—	—	—	Photograph label	—	—	—	—
—	—	—	—	Specimen label	—	—	—	—

- Loan form
- Deaccession record
- Slide jacket label
- Other: _____
- Other: _____
- Other: _____
- System provides report generator
- Report generator can link together multiple files
 - Number of files: _____
- Report generator can include or exclude any field
- Report generator provides full Boolean searching
- Report generator can select on any field
- Report generator has limits on number of selection criteria
 - Maximum: _____
- Report generator can sort on any field
 - Number of sort levels: _____
- Report generator has limits on levels of sorting
 - Maximum: _____
- Report generator can calculate totals
- Report generator can produce columnar reports
- Report generator can produce stacked reports
- Report generator allows user to specify print positions
- Report generator limits number of lines per record
 - Maximum lines per record: _____
- Report generator can provide header information

Table 9.8 *Continued*

Must have	Might need	Don't need	Frill	Features	Yes	No	Planned	Can't tell
——	——	——	——	Report generator can redefine field names for report	——	——	——	——
——	——	——	——	Report generator has automatic page numbering	——	——	——	——
——	——	——	——	Report generator has automatic word wraparound	——	——	——	——

Liked: _____

Disliked: _____

Comments: _____

Copyright 1987 by Willoughby Associates, Limited

SYSTEM DESIGN

Table 9.9 Special features

Must have	Might need	Don't need	Frill	Features	Yes	No	Planned	Can't tell
				System provides visiting scholars/public access system				
				System provides online help				
				System provides context-sensitive help				
				System supports user-defined help				
				System provides online syntax controls				
				System provides online documentation				
				System automatically converts measurements				
				On screen				
				On reports				
				System interfaces with other software packages				
				Word processing				
				Desktop publishing				
				Spreadsheet				
				Statistical package				
				Graphing				
				Charting				
				Mapping				
				Accounting				
				Membership/development				
				Mailing list				
				Scheduling				
				Other:				

CHECKLIST OF SYSTEM FEATURES 77

Table 9.9 *Continued*

Must have	Might need	Don't need	Frill	Features	Yes	No	Planned	Can't tell
				System supports visual access to images				
				Digitised images				
				Videodisc				
				System supports bar codes				
				System supports optical scanners				
				Hand-held scanners				
				Page scanners				
				System supports linked vocabulary structures				
				Thesaurus				
				Multi-lingual thesaurus				
				Lexicon				
				'ANY' file				
				Other:_____				
				System provides software for developing linked vocabularies				
				Thesaurus				
				Multi-lingual thesaurus				
				Lexicon				
				'ANY' file				
				Other:_____				
				System provides software for updating linked vocabularies				
				Thesaurus				
				Multi-lingual thesaurus				

SYSTEM DESIGN

Lexicon

'ANY' file

Other:

System provides structured printed listings of linked vocabularies

System provides pre-built linked vocabularies

System provides pre-built authorities

Attribution authority

Classification authority

Materials authority

Other:

Other:

Other:

Other:

Liked:

Disliked:

Comments:

Table 9.10 Documentation and support

Must have	Might need	Don't need	Frill	Features	Yes	No	Planned	Can't tell
				User manual provided				
				System documentation provided				
				Data dictionary provided				
				License fee includes training				
				Number of hours: _____				
				License fee includes support				
				Number of months: _____				
				License fee includes source code				
				Support includes bulletin board service				
				Support includes direct access service				
				Customisation is available				
				Cost: _____				
				Users group is available				

Liked: _____

Disliked: _____

Comments: _____

Table 9.11 System checklist log sheet

| System Name | | Title: |

Primary investigator: _____

Dates of investigation: _____

Received brochure: ___/___/___

Other materials: ___/___/___ Type: _____

Other materials: ___/___/___ Type: _____

Other materials: ___/___/___ Type: _____

Spoke with vendor: ___/___/___ Contact: _____

Spoke with vendor: ___/___/___ Contact: _____

Spoke with vendor: ___/___/___ Contact: _____

Spoke with vendor: ___/___/___ Contact: _____

Saw demonstration: ___/___/___ Site: _____ Demo by: _____

Saw demonstration: ___/___/___ Site: _____ Demo by: _____

Saw demonstration: ___/___/___ Site: _____ Demo by: _____

Saw demonstration: ___/___/___ Site: _____ Demo by: _____

Comments: _____

10 PLANNING TECHNIQUES FOR COLLECTIONS INFORMATION SYSTEMS

STEPHEN TONEY

This paper describes lessons learned from the Smithsonian's Collection Information System development efforts, both past and present. It will discuss three topics that can dramatically improve the way museums develop systems and the quality of the systems themselves:

the need for a planning process, and what one is;

what data administration is, and how it can help you; and

the discipline known as software engineering and its value in systems development.

Data administration and software engineering are similar in purpose and even overlap in specific techniques used. Both provide a systematic way to look at the needs of the organisation and a systematic way to document those needs.

The paper will also discuss the phenomenon of technology diffusion, and what it means for museums looking at new technologies.

Introduction

Automated collections management at the Smithsonian began in the early 1960s, when computer and collections people collaborated in the development of a system called Selgem (an acronym for Self-Generating Master, a name rooted in the system's batch origins). This system served well not only at the Smithsonian, but at about 20 other museums, achieving rather high status among its contemporaries. However, it is a perfect justification of the theory that systems should be thrown out and redesigned every decade or so; it had become obsolete not only because of technology, but also because it was designed before there were good planning techniques in data processing.

It is now recognised that for a system the size of the Smithsonian's collections information system, either Selgem or the new one now being developed, techniques to organise the planning for and development of the system are essential. These techniques result not only in better planning, but in descriptions of the system and its environment that enable the system's managers to run it and improve it throughout its life. The three techniques to be discussed are a planning process, data administration and software-engineering environment.

Planning process

Planning for a system falls into the category of operational planning — that is, determining how a given strategy (such as to develop an automated system) will be implemented. (Operational planning is in contrast to strategic planning, which determines what the goals of the museum should be and what strategies will fulfill them.)

For an *operational* planning process, the following resources are needed before you begin:

Strategic direction. Planning should start with a statement of what the system should accomplish, expressed in terms meaningful to the users of the system. The main value of such a statement, since its contents are probably well understood by the planners, is to ensure that top management is supportive of the system and that the planning team has organisational location and validity.

Policy-making procedure. Any system planning process will continually point out areas in which new policy is needed or old policy must be modified. By having management sign off on a statement of strategic direction as in the previous item, they also are primed to expect requests for the necessary policy decisions.

Stakeholder analysis and representation. Stakeholders are those persons or groups inside or outside the museum who will be affected by the new system. The purpose of stakeholder analysis is to make sure that all those persons' needs are represented in the planning. It is far better to work out differences in the early stages than to discover after years of planning that significant needs have been overlooked.

Schedule and budget. One of the purposes of the planning is to establish a schedule and budget for the system. However, the planning process itself is also a major institutional commitment, and should have its own schedule and budget. Management at all levels tends to get impatient with planning that goes on longer than expected and costs more, so get the commitment up front.

Techniques. Planning techniques must be chosen. The two recommended are data administration and software engineering, which will be discussed below.

Record-keeping procedure. Provision must be made to record, update and maintain records of the work of the planners.

Information resources. When planning planning, thought should be given to availability of reference libraries, documents describing national standards, online information services and other sources of background information.

Technical consultants. By this I mean systems people, who may or may not be stakeholders; in either case you will need some of them to perform technology assessment, to help with procurement and to implement the system.

Planning consultants or facilitators. One person, not a stakeholder, should be added to the group to manage the planning process. Alternatively, a consultant can be used. This person will call meetings, run meetings, maintain records, and arbitrate, striving only to achieve good planning without any other agenda, hidden or open. Depending on the techniques you use, facilitation of brainstorming or analysis sessions may also be needed, which is best done by an impartial person.

Attention to these components will help ensure that the planning process and the resulting system will be a success.

Data administration

The discipline of data administration arose only in the early 1980s from a number of existing techniques.

Data administration is a group of techniques and approaches that can help you analyse and manage data. A large part of data administration is *analysis* of data. The justification for data analysis comes from the idea that in addition to the analysis of procedures, functions and processes — as system analysis has always done — data must also be analysed to develop optimum systems. There are four reasons for this:

First, although processes change over time, the *data elements* in any system are relatively stable. For example, at the Smithsonian Institution we are attempting to migrate our data about museum object collections to the Inquire database management system. One of the main difficulties in building the new database is the multiplicity of current systems: besides Selgem we have several different mini- and micro-based systems, 3×5 cards, punched cards, ledger books and others. But the data in all these systems are almost the same, and has not changed much in 140 years. The same cannot by any means be said of processes. These are signs of the stability of data. Because they are more stable than processes, data better reveal the underlying purposes of the organisation, and thus data analysis leads to more suitable systems.

Second, *data-flow* analysis (as described by De Marco (1978) and numerous other practitioners) leads to systems which are better designs, as they minimise the interfaces between modules of the system — and it is the interfaces that cause most of the problems. That is, as you design the system by breaking it down into its subsystems, functions and subfunctions, you do so by choosing breakdowns that minimise the data to be passed between the subsystems or functions or subfunctions.

Third, studying the data interfaces created by the data-flow analysis provides one means of *evaluating* the system design, in a way that process-analysis techniques, such as flow-charting, cannot do. The simpler the interfaces, the better the design.

Finally, data analysis will make *future* maintenance and conversions much simpler, because ten years from now, the data analysis done today will still be valid, whereas the process analysis will probably be obsolete.

At the Smithsonian, we have purchased a license to a data administration methodology with supporting software, which is assisting us in analysing both data and processes, from the top down. (Ideally, data analysis is begun outside the system under study, with an overview of data throughout the museum. Within this context, the data for the specific system can be analysed.) We have nearly completed the strategic level of analysis, and are now beginning lower levels of analysis, right down to the data structures the computer will support for managing collections information.

There are other aspects to data administration besides data analysis. Documentation of data in a data dictionary is an emphasis. Data administration also has a policy component, necessary to manage data as a resource, just as is done for money, people and buildings. A museums' data are far more valuable than any system it can install. Data administration provides a means to manage them.

Software engineering

Before discussing software engineering we have to agree that the major stages in planning a system are those shown in Figure 10.1.

Fig. 10.1 Major stages in implementing a system

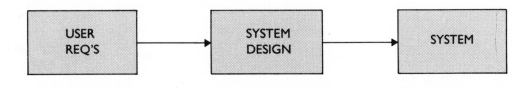

At each stage, written documents result. Software engineering consists of techniques to ensure correct systems by ensuring that these documents are correct. The idea is that if one follows the documentation procedures correctly one will be forced to do all the systems analysis correctly.

If the analysis at each stage is performed correctly, the resulting documentation will exhibit these characteristics:

completeness, in that all aspects of the system are described;

comprehensibility, so the system developers and anyone else can understand the plans;

changeability, so that new understandings of the system and new requirements can be recorded easily;

communicability, so that the documented understandings produced by each step of the planning can be translated into the documents of the next step.

Besides the value to the immediate planning process, such documents are also of future value, since it is axiomatic that a system is never finished. The documents that define the system will also be referred to in performing modifications and maintenance (of course, only if they are kept synchronised with the changes to the system).

Those are the justifications of software engineering. But what is it?

Throughout the early years of automation there were many techniques invented which were supposed to guarantee perfect systems; then it became recognised that most of them were mutually supportive. Software engineering is really only a collection of these techniques, such as graph-theoretic analysis, data-flow diagrams, simulation, provably-correct constructs, and testing and quality-control techniques. Museum professionals need not understand what all these are, since they are highly specialised, but it is important to understand the central *concepts* of software engineering.

An outstanding feature of the software engineering approach is the concentration on user requirements, with systematic techniques for the dialogue between user and systems analyst.

A second emphasis is on the correct translation of the user requirements as the design and implementation proceed — this is the communicability idea mentioned earlier. It should be obvious that a requirements statement that perfectly represents the need of the user is useless unless it gets translated with no loss of meaning to a system design, and likewise the design must be translated correctly into the resulting system. The validation of these translations is an important part of software engineering.

Fig. 10.2 Steps an invention goes through in becoming generally used.

The transition from appearing on the market to being in general use is called technology diffusion

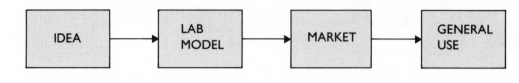

Other features of software engineering are the employment of documentation standards, of change control procedures and of quality assurance.

At the Smithsonian, we have a configuration management program to implement parts of software engineering, principally control of changes to systems, testing techniques and independent verification of documentation.

Summary

I have described briefly three approaches to managing the planning and development of complex systems. Of course it is possible to plan and design systems without these techniques, but they improve the chances of achieving a quality system. A simple system confined to one organisation with few people involved can be developed without them; but as complexity and size increase, as the number of people involved (and their various agendas) increase, as the duration of the project and turnover increase, some methodologies are required to ensure completeness, quality and stability.

Technology diffusion

The planning techniques that have been discussed are applicable not only to planning current systems, but also future systems. In other words, they enable one to plan without consideration of specific technologies that the system might be implemented on.

However, it is necessary in addition to planning to choose specific technologies and to budget for them. Thus a few ideas about technologies for museum systems of the 1990s may be of value.

Announcements in professional or technical journals about new inventions in computer hardware and software often cause anxiety in the reader, because often one has no idea how or when to begin thinking about how to use such a thing, or what variant might become the standard, or what the risks are. But understanding better how technology becomes available may help relieve this anxiety.

An invention must pass through several transitions before it can be bought and used, first from the idea to the working laboratory model, second from the laboratory to the marketplace, and last from the marketplace to general use, as shown in Figure 10.2.

The formal name for the transition to common use is 'technology diffusion'. It is a much slower process than one might expect, so little will be missed avoiding items the moment they hit the market, except high cost and uncertainty. Rapid diffusion is

SYSTEM DESIGN

that in which one-half of the potential users of a technology acquire it within the first ten years of its availability. Medium diffusion is that in which one-half the potential users acquire it between ten and thirty years, and slow diffusion takes more than thirty years (Freeman, 1986).

Slow diffusion does not mean that the technology is not significant: the tractor, the telephone and the automobile are technologies that took over thirty years to reach one-half of their potential users.

There are many factors that affect speed of diffusion (Freeman, 1986 and Rogers, 1986), but they amount to common sense. Those requiring less investment and less risk tend to diffuse faster, such as the personal headphone stereo. Technologies that are a one-to-one replacement for older technologies also tend to diffuse rapidly.

What does this mean to the museum? First, since even rapid diffusion is relatively slow, inventions still in the *laboratory* stage need not be considered in normal five- or ten-year planning. Second, for critical systems I do not recommend using technology that has just become available (the *market* stage), for the following reasons:

it may not work (this happens!);

it may be eclipsed by improved versions using different interfaces or standards;

the first vendors will probably not have good support networks right away, for training and maintenance;

vendors may go bankrupt, or withdraw the item if it is unprofitable. (The process of vendors leaving the market as it matures is called market shakeout.) In a mature market with some standardisation this is less traumatic than in a new market;

a new technology will cost a lot more in the first few years.

Thus a technology will be out a few years — that is, beginning to diffuse — before a museum really ought to be considering using it, unless the museum truly wants a research and development project.

What technologies will museums be using in the mid-1990s? Based on the above discussion, they will be technologies that are currently available, in either the *market* or the *general use* stages (of course, the general-use technology may not be common in museums but in some other market segment). The primary technology of the 1990s will, I think, be database technology, which reached the market in the late 1960s, and is an example of rapid diffusion, since by 1980 nearly every mainframe and minicomputer had a database management system installed, and dBase and RBase and others have ensured that most micros do too.

The primary *new* technology museums will be planning for in the mid-1990s, if not before, will be for image storage and retrieval. Museums will be providing their curators and public with images of their collections, linked to data about the objects. I think this technology will revolutionise museum work over the next twenty years.

One technology I do not think you have to worry about is artificial intelligence. It will be the next century before there will be products suitable for collections management systems. Of course, there is no harm in experimenting, if the money and staff are available, but artificial intelligence has been a discipline for 35 years now, with very little of a commercial nature to show for itself (but with a great deal of progress in the laboratory).

ROLE OF PROFESSIONAL GROUPS

ROLE OF PROFESSIONAL GROUPS

PETER WILSON

The three papers which make up this section serve to illustrate a crucial difference in the development of the professional museum registrar in North America and in Europe. This difference is quite evident: in North America, as the two papers from the USA and Canada show, the registrar has become a part of a multi-disciplinary team — curator, registrar, conservator — charged with the care of the cultural contents of museums. In Europe, this teamwork is at best largely underdeveloped and more frequently non-existent, to the obvious detriment of the coordination and efficiency of museums!

Whilst the UK appears to be somewhat ahead of Europe in acknowledging and making provision for the specialisation and discipline of central collections management, there is much progress yet to be made. How far there is to go can be seen from the impassioned report of Smith, Stewart and Mason which follows. Self help is obviously the order of the day and the formation of a specialist group, whether formally or informally constituted, is an essential part of the development of any emergent profession wishing to establish its identity and its standards of practice.

In this context it is, perhaps, worth taking a while to consider the desirability of collections management and to determine how the task of promoting it can be undertaken. A registrar's office, offering unified collections management at an institutional or even a departmental level, has many benefits to offer: some are clearly understood and frequently articulated, others seemingly no less obvious are rarely cited. Amongst the obvious are accountability and compatibility of approach, both of which are clearly beneficial. Why then do we not equally applaud and advocate the resultant improvements in efficiency and in the ability to provide management information? Museums are not static repositories where all that is required is to document acquisitions and keep them safe. They are dynamic organisations which need to use their resources effectively to the benefit of their clients: visitors, scholars and the public. Registrars provide the expertise not just for the well run 'culture savings bank' but also for the cost-effective, enterprising organisation with a public mission. Why is it then that collections management information and its manager, the registrar, are not so highly regarded as are management information teams in commerce and industry? Can it simply be that efficiency is of no consequence in the museum world?

We should not be surprised that this is the case. The relatively recent history of the conservation profession has some interesting parallels; it is hard today to remember that conservators were valued only for their ability to 'restore' objects which for one reason or another had become disfigured and damaged. Yet this was the case even as recently as the 1960s. Conservators had to battle to establish their role as preservers rather than restorers: it is clearly preferable to keep material in good condition, but the right to a say in how the objects are kept was hard-won. Conservators won their status and respect through the formation of professional bodies or associations such as the International Institute for Conservation and its national groups. These bodies

raised the status of conservation through discussion, representation, publication and research. Conservation became a recognised and respected discipline not because of its beneficial effects, evident though they are in retrospect, but because of its emerging professionalism.

On first consideration, this may not seem so easy to achieve for the registrar (the 'collections manager') as it was for the conservator ('the collections preserver'), as the processes and their effects are less tangible. But this is the age of information technology! No one questions the professionalism of the librarian or the information scientist and registrars must promote themselves accordingly. Formal training will become important as the discipline develops and here too registrars must learn from the conservation profession, where the best results have been achieved by building on the strength and relevance of existing educational establishments rather than by aiming for grand new institutes.

A solid professional group is the basis for, and the first step in, the development of the profession. Conferences such as this and the study and publications which they encourage are another 'growth factor'. Let us look forward to the day when Registrars meet regularly in their own international professional group! The world's museums will be the better for it.

12 ROLE OF PROFESSIONAL GROUPS IN THE UNITED STATES

KAROL SCHMIEGEL

In America many documentation activities are the responsibility of the museum's registrar, a position which has existed at least since the turn of the century.[1] The title and duties vary according to the type and size of the institution. One person holding a baccalaureate degree may be the only registrarial staff in a small museum or historical society, while the registrar in a large museum will likely hold a graduate degree and have a sizable staff. The Metropolitan Museum of Art and Philadelphia Museum of Art have had a registrar on staff since 1900, but the title has varied at other institutions. For example, at one museum the registrar was called the Museum Secretary in the mid 1950s. In the late 1970s the title collection manager was developed in natural science museums for the person who carries out registrarial duties but who works within a curatorial department.

The registrar is the accountability agent for the museum, ensuring that the museum's records indicate what collection objects it owns, the source of acquisition for each object, its current location, and what borrowed objects are in the institution's custody at any given time. The registrar usually shares responsibility for care of collections with the curator and the conservator, and these three positions should function as a check and balance for each other. The registrar is responsible for the museum's information system and maintains the central registry of the objects. Creation and maintenance of the catalogue system are usually the registrar's responsibility, as is providing access to authorised users.

The curator may control the content of the data. For example, the registrar may develop a manual catalogue card system supplemented by vertical files. One set of cards may contain confidential data which is available only to a few staff members. Some of the remaining sets of cards may be accessible to the general public, while the others may be used only by museum and academic researchers. The registrar may determine the format of the records and ensure that they correspond accurately to the data provided by the agreed upon expert, whether curator, conservator, scholar, registrar, or other. Most registrars are now investigating, planning, or implementing computerised systems.

The registrar is responsible for many collections management activities:

Exhibitions. The registrar processes the loan contracts, arranges for insurance or indemnity, transport, packing, crating, installation, customs — in short, acts as the business manager for the exhibition, often being responsible for millions of dollars for a blockbuster exhibition.

1. The titles registrar, curator and conservator are used here in the singular. In most institutions, each of these individuals would be responsible for a number of staff members, but rather than indicate throughout the registrarial staff, the curatorial staff, etc., the singular title has been used.

8

Inventory control. The registrar records objects' permanent and temporary locations, may control object movement and supervise art handling staff and carries out appropriate on-site inventory or stocktaking.

Photography of collections objects. The registrar may keep only documentation photographs or may manage all photographic activities. The registrar is responsible for rights and reproductions and grants permission for publication.

Storage. The registrar may control access and oversee organisation and maintenance in these areas.

Collection insurance. The registrar maintains appropriate coverage for the permanent collections and for borrowed objects.

Valuations. The registrar contracts with a reputable appraiser to obtain fair market values for insurance or for other museum purposes.

Accessioning. The registrar assigns a unique number to each object and records its entry into the collection, ensuring that any restrictions are noted and observed. The registrar also formally acknowledges gifts to the museum and advises donors of their responsibility for compliance with federal tax laws.

Deaccessioning. The registrar monitors the deaccessioning process to be sure that no gift restrictions, laws or ethics are violated, records what objects have been deaccessioned and what has happened to the funds realised from the sale of these objects or accessions objects received in trade.

Imports and exports. The registrar arranges for any necessary permits and sees that documentation is provided so that objects will clear customs easily.

To carry out these diverse responsibilities, it is essential that the registrar knows and keeps up to date on current standard practices. Professional organisations play a key role in this continuing education process.

The American Association of Museums (AAM) is the major professional museum organisation in the United States. It represents the museum community on a national level, lobbies the federal government for legislation favourable to museums, and liases with the International Council of Museums. AAM provides many services to the museum profession through its journal, *Museum News*; monthly newsletter, *Aviso*; a four-day annual conference for its members; and a technical information service. Museums may receive consultation through two programmes, one focusing on collections management areas, and the other on the entire institution's programmes. AAM's accreditation process for museums is carried out by a peer review process. The profession is mostly self-regulating, but the Internal Revenue Service monitors museums' monetary affairs.

AAM has offices in Washington DC, a paid staff of approximately 20, and an annual budget of $2 300 000. The organisation is over 80 years old. Members' dues and fees for services support the organisation. Its governing board is called the council. The officers and councillors at large are elected by the entire membership from their peers in the profession. Each of six regions has one regional councillor, and its president and immediate past president also serve on the council.

In the mid 1970s, recognition of the diversity and professionalism of many groups within the profession led to the formation of standing professional committees and

recognition of affiliated groups whose chairmen or presidents attend the council and may speak, but may not vote. Thus the council consists of approximately 70 representatives. The affiliated groups are separately incorporated entities, such as the American Institute of Conservation, the American Association of State and Local History and the Museum Computer Network. The standing professional committees are made up of members of AAM whose duties within the museum field bring them together. Registrars, Curators, Public Relations and Communications, Small Museum Administrators, Educators, Development and Membership, Security, Non-print Media, and the National Association of Museum Exhibition are the currently recognised committees.

In 1976, the Registrars' Committee organised and drafted its bylaws. The group was formally recognised by the AAM in 1977. There are now nearly 400 members, and a membership directory is published every second year. The Committee sponsors a semi-annual publication called *Registrar*. The current issue deals with computerisation. Past issues have published articles and professional practices statements, such as the Registrars' Code of Ethics and the Statement on Couriering. The Committee also has an informal newsletter which includes a summary of annual meeting sessions, news of interest to members, issues upon which votes must be taken, and the like.

The Registrars' Committee sponsors a number of sessions at each annual meeting of the AAM. This meeting has a Program Planning Committee, which now consists of museum staff from the host city, representatives on a nationwide basis who have been active in AAM meetings and a representative of the standing professional committees. The aim is to have a national, as opposed to local, programme planning committee. The session proposals are accepted in October, abstracts must be submitted by December 1, and approximately 100 sessions are presented.

Between 1 700 and 3 800 people attend each meeting. There are keynote speakers on a variety of topics. The sessions are one hour and fifteen minutes each, and approximately eight run concurrently. There are times allocated for committee business meetings, board meetings, sub-committee meetings, and often opportunities to visit local institutions and see exhibitions and behind-the-scenes operations. Recent sessions sponsored by the Registrar's Committee have included 'Risk Management, What Your Insurance Broker Looks For', 'Standardization of Terms for Documentation', 'Couriering Practices', and 'Purchasing Registrarial Services'.

The Registrar's Committee has an executive board which consists of three elected officers: a chairman, vice-chairman and secretary treasurer. The chairman of each of the six regional registrars' committees is also on the board, as are the standing committee chairmen for Communications, Professional Practices and Nominations. A number of task force chairmen may be appointed and attend board meetings.

The purpose of the committee is to improve professionalism through networking and sharing of information. In 1985, the committee adopted a five-year plan which outlined the committee's goals for the next five years. A task force continues to produce *Registrar*. Another group will publish *Orderly Thinking*, a book which deals with issues and areas of concern that is expected to be released in 1988. The Professional Practices statement on Couriering has been produced, and the current project deals with facilities reports. Because the committee is educational in nature, a task force is developing a prototype internship to train future registrars. A national workshop will be held in 1989 on project management within museums. An

operations manual is being prepared to explain the duties of the officers and the functions of the committee, and the schedule in which these duties must be carried out. Some of the projects are fun as well as of mutual interest, such as the contest for a logo design, which was held in 1985. A membership campaign increased our membership by twenty percent. The committee, with the approval of AAM, seeks funding for special projects, such as the publication of *Orderly Thinking*.

The regional professional committees operate with respect to their regional association in the same way as the national group works with its parent organisation, AAM. The regional groups provide sessions for their members at annual meetings and often sponsor newsletters. The regionals, however, often hold one or two day workshops devoted to a single topic. Some topics have been off-site storage, using microcomputers, proper methods for applying numbers to objects, averting disasters from earthquakes and collections management procedures. Members of the regional committees often include staff from smaller institutions who may not be able to attend the annual meeting of the national organisation. The sessions at regional meetings may be more basic and offer more nuts and bolts types of programmes, whereas the national programmes may be for more advanced professionals, cover topics which relate primarily to larger institutions, or may take more theoretical approaches.

The regional museum associations usually have a board of governors and officers with representatives from each state within the region. Two of the museum associations have full-time staff; one has part-time staff; one is about to hire staff; and the other two remain volunteer-run organisations.

In some parts of the United States, particularly in areas where the regional association covers many thousands of square miles, there are state museum associations which provide some services to their members. Some of these are extremely active, such as the Texas Museum Association and the New York State Association of Museums. They may sponsor their own programmes and have their own publications. State governments may provide some funding for these organisations and to museums as well. The attorney general in each state is the person who carries out oversight of museums on behalf of the public and is often the person with whom a state museum association will work closely on legal matters.

There are some smaller regional groups which receive state and private funding. In New York, the Regional Council of Historical Agencies and the Federation of Historical Services provide consultation and training for the staff in very small museums and historical societies. Often major cities will have their own museum organisations, such as the Museum Council of Philadelphia, which includes representatives of museums in Pennsylvania, New Jersey and Delaware, all within a thirty mile radius of the city of Philadelphia. Some of these groups may have registrars' or registrar and curators' committees which meet several times a year for programmes of mutual interest.

Often registrars have organised their own small groups on a local level. There are a number of breakfast clubs in cities such as Rochester, New York, Wilmington and Washington. There are a number of special interest groups which draw members of the museum profession who are interested in topics such as computerisation. CompuMuse is such a group in the Philadelphia area and Ciao (Computers in Arts Organization) in New York City. These hold monthly meetings devoted to the specific problems and possibilities of computerising collections information.

The Museum Computer Network is an international organisation with about 250 members and over 4000 subscribers to *Spectra*, its newsletter. The Network also holds an annual meeting of two days duration in cities in North America which are attended by registrars, curators, and other museum professionals interested in utilising the computer to improve the quality of documentation in museums.

The museum registrar in the United States has complex responsibilities. Professional groups provide on going educational programmes and a network of colleagues with whom information and ideas can be shared. Organisations of different types and scope meet the varied needs of museum staff across the country.

13 THE CANADIAN EXPERIENCE

SONJA TANNER-KAPLASH

This is the second occasion within a few months that I have been asked to address this topic; therefore you will appreciate my suspecting that registrars may have embarked upon an era of introspective 'navel gazing'. Perhaps this activity is indicative — possibly there *is* something to gaze at.

I would like to sketch out not only the basic background information concerning the manner in which the Canadian registrars' professional association evolved, but also to touch upon some of the different agents of change which have brought about the rapid development of this specialisation within the exhibiting arts, and notably within the museum profession. This area has undergone the most — and the most *profound* — changes within the past decade and a half, far more so than other specialisations within the museum field. The roles and responsibilities of the curator, the conservator, the educator and the director/administrator have not changed to nearly the same degree.

Canada is very much a victim of its geography, and this affects many aspects of life. We are the second largest country in the world, with a tiny population, approximately 25 000 000, concentrated along our southern border. Since the eighteenth century, communications and transportation have been priority issues; our tremendous differences translate into significant problems for fledgling organisations which hope to achieve a *national* rather than a regional focus without the benefit of very much funding.

Canada has a good, and for some countries perhaps an enviable, record of government support for museum work. Nevertheless, of the approximately 8 000 individuals permanently employed in the museum field, only a very small proportion are concerned with collections documentation. The figure is not remotely comparable to the number of registrars and collections managers in the United States. In the late 1970s, when the idea of an organisation of Canadian registrars first began to mature, it was painfully apparent that the likely membership was thinly spread over a wide area, and would include individuals from a wide variety of museums with different types of collections. Generally, each institution had developed collections documentation to suit its own needs, therefore, positions might easily be responsible for varying clusters of responsibilities. There were registrars with a substantial staff, and those with part-time positions, perhaps combined with a curatorial role at a seasonal museum, opened only a few months of the year — and, of course, everything in between. The size of the museum operation tends to be the governing factor.

As a generalisation, smaller institutions require a great variety of functions and skills; at larger institutions, there are more specialised staff who may (or may not) report to the registrar, who is often required to deal with contractual and legal issues that probably stay in the director's office in a smaller organisation.

Needless to add, individuals occupying these positions often had very different backgrounds and training experiences. At that time, very little was common to the

group except a desire for some element of recognition for the museum specialisation then becoming known as collections documentation, and an improvement in entry level and mid-career education and training opportunities.

Organisational structure and timing

In 1979, approximately 20 museum staff of the kind just described came together informally at the Annual Conference of the Canadian Museum Association (CMA) in Vancouver, and began to explore the options open to them in terms of organisational structure. I would like to mention here our appreciation for the assistance and advice received from our colleagues in the US, both then and later. The CMA, largely funded by grants from the Canadian government, is not a federated structure in the same manner as the American Association of Museums; in fact the CMA is completely independent of the various provincial associations of museum professionals, which are not represented on its governing body; possibly this structure will change over time. Although the fledgling Registrars' organisation might have preferred, for the sake of convenience, to work through provincial associations to develop a regional structure, there was no mechanism in place and no precedent, to accomplish this at a national level. The group also realised that we were far too thinly spread to 'go it alone' as an independent organisation — and therefore opted to remain within the CMA framework, and to work from inside to encourage the changes necessary for a broader representation within the governing authority. In the following year, at a joint CMA/AAM conference in Boston in 1980, what was initially named the 'Registrars' Committee of the CMA' was launched. Of the many special interest groups which began to form at that time, this one very quickly became formally organised with its own bylaws and structure, and is now known as the 'Registrars' Special Interest Group' of the CMA (RSIG).

Membership, representation and organisational structure

The organisational structure, which was determined at the founding meeting, provides for an executive of six members (a chairperson, a vice-chairperson, a secretary, a treasurer and two regional representatives) and identified five regions: East Coast; Quebec; Ontario; the prairie provinces of Manitoba, Saskatchewan, Alberta and the Northwest Territories; and the West Coast, including British Columbia and the Yukon. Each region must be represented within the executive, and since Ontario and Quebec are the most populous provinces in Canada, the sixth or extra member of the executive is drawn from either of these regions. This arrangement is a typically Canadian 'representation by population' solution, but one that has worked for us for several years.

Membership is now in the vicinity of 225 individuals, and is open to all museum staff interested in collections documentation; it is not open to commercial suppliers of any type, or the staff of government regulatory or funding agencies, although representatives from these groups do attend or participate in workshops and other educational activities.

Aims, activities and accomplishments

Under the general heading of the advancement and recognition of the specialty of documentation within the museum profession, there are several immediate and long-range goals espoused by the RSIG of CMA.

Some of the immediate and practical aims have been to develop regional networks and liaise with provincial museum associations: and to develop education and training opportunities at a variety of levels, including entry level, in-house or mid-career training, as well as participation in the formal educational system in place at Canadian universities, polytechnics and so on. Independently of course, the organisation offers workshops and seminars, and participates in diploma programmes offered by the various provincial professional associations.

Some long-range goals are to encourage the development of professional practices and ethics; to provide an improved forum and focus for professional concerns, notably input into policy decisions taken at both institutional and government levels; and the standardisation of terminology and other technical collections documentation issues.

In a sense, our accomplishments have been quite predictable, and the RSIG has followed the growth pattern characteristic of new and developing organisations. Meetings and seminars are 'piggybacked' with those of other allied groups, notably the CMA and the Canadian Heritage Information Network User meetings, and provincial association conferences. A Newsletter is published, albeit sometimes irregularly — and is distributed to members, usually with other CMA mailings. At the CMA annual conference each spring, the RSIG organises a one-day pre-conference seminar, which is our major opportunity to meet and recruit members and hold a business meeting. The topic of this seminar might range from the automation of loans records to collections insurance, appraisals, managing the transition from manual to computerised collections documentation and so on. The organisation also presents a session during the CMA Annual Conference, on a topic of broad general interest to the museum community, including curators, directors, conservators, and so on. The group is vitally concerned with standardisation, since this issue affects all members of the group in our day-to-day operations; in addition to participation in organisations such as the Canadian Heritage Information Network, independent ventures have been anticipated. A projected joint venture with the CMA is a development of a national database on the facilities and staff of institutions, this information usually being required by a lender when a loan request is submitted. At present, a wide variety of formats is used for this purpose, and a standardised format plus a centralised and regularly updated data bank would facilitate loans between institutions to a considerable degree. On an individual basis, members of the group participate in various advisory and policy making bodies at various levels — institutional, professional association and government.

Agents of change

Earlier I noted that a number of specific factors had encouraged the development of registrars' organisations in the United States and Canada during the 1970s; very clearly the impetus is quite different in the UK today.

Early museological educators, such as John Cotton Dana, had a tremendous influence; for example, Dorothy Dudley and Irma Wilkinson, the authors of what for many years has been *the* definitive text in the field, *Museum registration methods* (1979), were both students of Dana. Clearly the enthusiasm and need of a new country to establish and authenticate its national identity and heritage encouraged the direction of certain resources towards the documentation of public collections.

ROLE OF PROFESSIONAL GROUPS

However, to take a quantum leap into the 1970s, Richard Porter (then Chair of the Registrars' Committee of the AAM and Registrar at the Penn State Museum of Art), identified a major factor in the changed role of the Registrar as the increased volume of 'blockbuster' exhibitions, which emphasises the increased values and risks for which registrars were becoming responsible, not to mention the increasing logistic complexity of such special exhibitions (Porter, 1984). Certainly there was a similar phenomenon in Canada during the 1970s; however, I would identify this increased volume of programming as a sub-set of a much larger issue — the agent of change with which we all have a love/hate relationship — the concept of accountability.

At this time in North America, the exhibiting arts woke up to the fact that they were responsible for major public assets. The climate of the times, later reflected in 'Watergate', saw that no public institution was safe from scrutiny, and the museum community took several specific steps towards increased accountability. By coincidence perhaps, there were several highly publicised scandals involving museum abuse at this time; the subsequent response was a flurry of 'ethical activity' and the ensuing development of internal museum regulations and external government legislation, and finally, the application of this legislation and its attendant procedural regulations.

There were no shortage of scandals in the early 1970s, which involved more than just poor management, but concerned transactions such as illegal imports and exports, disposals of museum collection to finance new acquisitions, conflict of interest situations, over-valued appraisals for tax purposes, and so on. The level of concern was much more broadly based than the museum field, and interestingly enough, the academic community, the legal profession, and to a large extent, the popular media were involved. Perhaps Karl Meyer's *Plundered past* (1973) became the most widely-known publication of its type, but a good deal of the background for this book was provided by academics like Clemancy Coggins (1969). The article entitled 'In the public interest', written by then Assistant Attorney General for New York State, Palmer Wald (1974), was a first of its kind.

In this climate, museum directors began to realise how helpful it might be to have someone close at hand who was familiar not only with the collections and their records, but also with the prevailing legal environment. For, to a large extent, this was becoming the territory of the registrar, except at the very largest museums which retained in-house counsel.

Given this situation, the timing for computerisation as a tool for more effective records management and a means to achieve accountability was ideal. The very purpose of this conference is testament to the significantly increased importance of this aspect in the collections management field. It should be noted that the situation a decade and a half later, particularly in the UK, has a very different flavour and focus than the experiences of North America in the early 1970s. Now, it would seem that the availability of significantly improved information handling systems, especially designed for *museum* collections documentation, is a more significant factor for the interest of registrars in professional associations.

Some years ago, I was part of a panel at a conference in Vancouver at which questions arose as to the most important qualities for a prospective registrar. Perhaps my answer was a trifle flippant, but I still think it contained the essential ingredient — at that time I replied 'a vivid imagination and a sense of impending doom'. I qualified this by explaining that if someone could imagine the worst

possible thing that might happen — and then be able to *plan* out of it — the makings of a good registrar were there. I still believe that the major responsibility of this specialisation within the museum profession is 'troubleshooting'; it is not research, it is not preservation in the conservator's sense of the word, it is not the management of a large organisation or the preparation or exhibits. It is foreseeing and forestalling 'trouble', trouble for museum collections — in short, a very specialised form of risk management.

It is essential that the professional associations do not lose sight of the forest due to their contemplation of specific trees in it. The role of these professional organisations is to achieve a balanced overview, and to be constantly vigilant for new and unexpected demands (from whatever direction they may arise) that pose new risks to museum collections. This might encompass new, complex or even inappropriate legislation, escalating insurance costs, new advances in information technology, or government policy that requires a coordinated response. The role of the professional organisations is to prepare their membership to deal with these changes in the most effective manner.

14 THE UK REGISTRAR: A FUTURE IN THE BALANCE?

FREDERICKA SMITH, MARGARET STEWART AND
JONATHAN MASON

The model

The strengths and successes of organised central registration methods in the USA and Canada are well-known; the experiences of some of the Australian museums and galleries tell a similar story. There can be no doubt that in these countries registrars are influential members of the professional museum community, and groups such as the American Association of Museums Registrars Committee (Chapter 12) have defined the role of the registrar, produced a Code of Ethics and are constantly working towards establishing and refining professional practices and standards. Within the museum community they can defend their work and have representation at a high level.

There is a pressing need to assess what progress has been made in the UK in recent years towards central registration systems and the creation of registrar posts. It is time to consider the problems that must be faced in order to allow the proper management of museum collections.

The start

The appointment of registrars in UK museums and galleries is a comparatively recent development: until the early 1970s there were none. As recently as five years ago there were only three registrars in the UK — all in national government-funded art galleries in London. This, perhaps, gives a clue to the reasons behind creating central coordinating posts of this sort, for it was in the fine art galleries that exhibitions and loans to temporary special exhibitions first became a major factor in how staff time and resources were spent.

A high degree of organisational skill and specialist knowledge is required in order to stage an exhibition. It also requires discipline, sensitivity to the objects, proper procedure and documentation in order to be able to lend large numbers of works of art every year to special exhibitions, without incurring unacceptable levels of risk. It is hardly surprising that the number of highly competent and experienced exhibitions officers has always been greater than the number of registrars. However, many of the skills that were developed by exhibitions officers have been used profitably by registrars in creating their own posts. Whilst few exhibitions officers have any responsibilities towards their institutions' permanent collection, many registrars have amongst their duties the control and organisation of packing and transport for temporary special exhibitions.

In the last five years there has been a significant growth in the number of registrar posts: there are now ten such posts. The Museums Association Database lists 1330 museum services or groups within which there are 2131 separate museum or gallery entities in the UK. In contrast, the AAM Registrars Committee has 204 individual

and 119 associate members drawn from a community of about 6 500 museums and galleries. It is clear that registrars in this country are a very long way from being as well represented.

The group

The UK registrars do have an informal group that meets, so far in London only, to discuss common problems, working practices and procedures. In order to make the group work, and in acknowledgement of the fact that there are many other museum professionals who have a degree of involvement and experience in registrars' work, the Group also includes exhibitions officers, loans administrators, documentation and records officers, curators and administrators. It is open to anyone who feels they might benefit from attending our sessions. The Group began when there were only two or three registrars who met to discuss predominantly practical problems — particularly shipping, packing, liaison with shipping agents — in other words the things that worried them most — the responsibility being theirs when often they worked in isolation without colleagues who understood their work. The Group was founded as, and still is, a support group, providing an opportunity to meet others experienced in the same type of work, to share stories of successes and failures and to present a united opinion when required.

The Group has grown and now has a mailing list of about 25 participants. The intention is to make the sessions informative, by inviting guest speakers to deal with specialist topics, but also to try and retain the informal exchange of news and views that is found so valuable. Unfortunately, some members further from London are finding it difficult to obtain the necessary funding to attend the meetings. This is particularly hard on those new appointees who need the contact with others more experienced in the work, as there are no specific training courses available and learning is of necessity from in-post experience.

The role

Whilst some UK museums and galleries have made the positive step of appointing a registrar, there is little agreement or similarity in job definition, the position of the postholder within the museum or gallery, grading or salary. Each institution is interpreting the role for its own purposes, with little or no regard for the need to establish registration systems and a profession that is internationally recognisable. Dealings with institutions and individuals across the world can be facilitated by a recognised job title and description, one that accurately conveys the scope and responsibilities of the post-holder.

Some museums, choosing not to appoint a registrar either for fear of antagonising staff opposed to the innovation, or because they are unable to identify exactly what they need, have instead appointed documentation or records officers, collections managers, curators in charge of the collection, information retrievers, loans officers and so on, with the intention of re-asserting central care, custody and control of the collections. Such a decision might only have been made in the face of the problem of introducing new technology. The creation of a Registration Department maintains the care and control of the collection as a joint responsibility, but with one central section particularly responsible for ensuring that proper procedures and document-ation are upheld. It also ensures that auditors are provided with proof of adequate management of the collections, that museum managers are provided with the

information on which to base their decisions and planning, as well as providing for the day-to-day care of the collections as they move within the museum or between museums, either at home or abroad.

The task

There are a number of choices open to an institution considering a new initiative in collections management but with limited resources, in particular the number of staff that it can employ to tackle the job. The new technology has made an enormous difference to planning the future management of collections. Faced with this, and the knowledge that most staff in museums did not join because they had any affinity with computers, it may be the answer for management to appoint a computer or documentation specialist to oversee the change and to review procedures. This should not be seen as the alternative to the appointment of a registrar; both will be needed. A Registration Department will be needed in order to complete the whole picture of collections care or management.

To look at the other side of the problem, management might decide to ask the registrar to oversee the introduction of the new technology and to take responsibility for the choice of system and equipment. With a small, well-documented collection and with the help of systems houses and consultants, this may be possible. However, in the UK it is almost certain that the registrar will not have had any formal training or background in computing and it may not be wise to expect them to commit the museum without the help of a specialist, employed by the museum, to bring a higher level of understanding to the venture. Registrar and computer specialist can co-exist peacefully and profitably. The intention in the long term should be that once the system is up and successfully running, it should be left for the Registration Department to maintain and caretake. The computer specialist, who because of market forces will be an expensive animal to have around, will be able, after the termination of an agreed contract, to pass on to fresh challenges. It would be prudent for the management of any museum to remember the long term plan when establishing working relationships between registrar and computer specialist within the museum hierarchy.

The future

What does the future hold for the small group of museum registrars, in this country? It is hoped that the numbers will grow and, with it, an open acknowledgement of the benefits that central registration can bring to any museum or gallery, whatever the size of its collections or the complexity of its internal structure. A society of museum registrars, or similar body, might help work towards defining and strengthening the role of the registrar. Although a small group in terms of numbers, the members already help to care for some of the largest and most important collections of fine and applied art in the UK. As the institutions vigorously promote research and interpretation of these collections, so the registrars have an important role, in facilitating public access to the collections and helping to care for them in perpetuity. It is a network that has gained influence, but only by a huge growth in numbers can it hope to achieve what can be seen in the USA, Canada and Australia.

A museum accreditation scheme would help establish the registrar's position by requiring museums to look more closely at how they manage their collections. In the USA, the AAM Accreditation Scheme, coupled with the Museums Assessment

Programs (MAP), have encouraged and assisted many museums to analyse their performance and to develop the means for improvement. MAP II, with its emphasis on long term care and management of the collections, has helped to establish central registration systems in the USA. A similar scheme could do the same in this country. The Museums and Galleries Commission is on the point of introducing a register of museums, which may help in this respect. The position of the registrar within the instititition needs to be improved, salary and grading need to be commensurate with levels of responsibility. The scope of activities needs to be understood and accepted, staffing levels need to reflect workload and size of collections. The fears of curatorial colleagues who might see moves towards central collections management in terms of loss of power need to be allayed. Support should be provided for Trustees and Directors in fulfilling their responsibilities as custodians of the collections. Museum management can be helped to make decisions and choices in this difficult era of dwindling resources and mounting costs. Conservation colleagues can be assisted with the physical care and protection of the collections. A society of museum registrars might be able to organise short courses or administer practical training in approved museums, in a similar way to the AAM Registrars Committee Internship Program.

Registrars must always be prepared to deal with the unexpected — odd jobs and problem solving often fall to the registrar, who needs to be flexible in approach. An active campaign is needed to maintain and extend the standards of collections management and to work towards the recognition of the registrar's central position within the museums of the United Kingdom.

PROCEDURAL AND POLICY
DEVELOPMENTS IN INDIVIDUAL MUSEUMS

15 PROCEDURAL AND POLICY DEVELOPMENTS IN INDIVIDUAL MUSEUMS

ROGER SMITHER

Museums are not identical: they operate on different scales, with different perceptions of their role and their audience, and in different economic, political and social climates. This is self-evident, and members of the museum profession are repeatedly warned — and always quite justifiably — against assuming that a course of action adopted by one will be appropriate for another to follow merely because both their institutions call themselves museums. Despite such warnings, and in full awareness of their correctness, the experiences of other museums are a source of endless fascination for members of the profession.

This phenomenon is not difficult to explain. Although museums are not identical, they have more in common with each other than they have with other institutions. The precise circumstances of two museums may differ, but they will share common perceptions of common problems. Take, for example, the conflicting priorities among designers, conservators and security consultants in determining lighting levels in exhibitions. However such conflicts are resolved in individual cases, museum professionals collectively will share the perceptions that such issues can be problems and that museums' terms of reference for resolving them will be closer to each other's than to those of institutions such as department stores or banks. In very much the same way, the manner in which museums perceive their documentation needs can differ widely — how much common ground is shared between collections of geology and militaria or between a small local museum and a large national gallery? — and yet still reveal more identity of interests than would necessarily be found in comparisons with cataloguing methods in libraries or stock-control procedures in warehouses.

In spite of the acknowledged dangers involved, there is also a habit, occasionally mixed with a hint of anticipatory schadenfreude, of expecting to profit from the example of certain pioneers and innovators among museums, many of which are represented among the papers in this section. Why should an institution choose a particular moment to introduce a new system or to abandon an old one? Was the decision purely a matter of theory, or a response to pressures internal or external, direct or indirect (audit requirements or financial constraints), or to a specific opportunity? What are supposed to be the merits of one combination of hardware and software over another? What exactly is intended to be the benefit of a major overhaul of the staffing establishment? Have such benefits materialised, and what are the feelings of the staff concerned: what are the reactions of a previously autonomous keeper or head of a curatorial department on losing control over their acquisition records or being absorbed into a new function-based structure? Those who may have to face such questions in their own institutions in the future must welcome any auguries from the unknown or progress reports from pioneers.

In the papers which follow there are several examples of museums' realising the need for changes of direction in policy and staffing to accomplish significant

9

improvements in collections management. The relationship between undocumented collections, old documentation and new systems, procedures for the erosion of documentation backlogs, and the implications of different levels of ambition, purchasing-power and self-sufficiency in introducing computers to collections management are also widely discussed and illustrated. There are demonstrations of the interaction between museum documentation and all other aspects of museum administration, exemplified by case studies in gallery projects and risk management. The experiences detailed in the papers conform to the pattern of usefulness suggested earlier. Nobody — least of all the authors — would pretend that the procedures described are universally applicable. The thinking behind those procedures, however, will be found to cover ground which readers in the profession will recognise, and the conclusions reached will offer valuable material for those readers' own thoughts on the subject.

THE NATIONAL MARITIME MUSEUM: PLANNING FOR THE FUTURE

RICHARD ORMOND

The National Maritime Museum is a large multi-media historical and technical museum of the traditional type. It occupies a sprawling group of buildings in one of the most famous architectural sites in Britain. The famous Queen's House, built for Henrietta Maria by Inigo Jones, is linked to two later side wings by colonnades. Up the hill in the Park lies the Old Royal Observatory which is also run by the Museum. Buildings are in the news at the moment, because the National Museums and Galleries are about to assume responsibility for their own property from the Property Services Agency of the Department of the Environment. This is a radical, far-reaching change, putting museums for the first time in charge of all their resources. Museum buildings have been under-funded for years and there is a heavy pro-gramme of essential maintenance work in the pipeline. With limited resources, it remains to be seen how effective museums are in managing their estates.

The National Maritime Museum was founded in 1934. To begin with, its collec-tions grew modestly in the more traditional museum spheres — pictures, ship models, instruments, weapons and antiquities. A huge expansion came in the 1960s and 70s, particularly in the archive and records field. The Museum holds approxi-mately 800 000 ship plans, 100 000 charts, 60 000 prints and drawings, 500 000 historic photos, 40 000 books, and two miles of manuscript holdings and the archives of shipping companies.

Looking after these huge collections requires heavy expenditure in terms of accommodation, staff and conservation facilities. This is the hidden iceberg, the raw materials of history which the public never sees, and which is the most difficult aspect of the Museum to promote. Some of the larger collections are poorly documented, inadequately stored and in less than perfect condition. Curators have begun to realise that the Museum can no longer be a passive, catch-all repository for everything to do with the sea. A subjects and collections policy is required, and this is now in course of preparation.

More than anything, the Museum must be very clear about the maritime themes that are intrinsic to its purpose. It has now to go out to the world to promote and market and exploit (in the best and widest sense) the tremendous assets it possesses. That is the real challenge that awaits us. Once the themes are clear, everything else can and will follow — display, acquisitions, education, sponsorship, exhibitions, marketing, and anything else you care to mention.

Before describing the Museum's activities in the specific field of museum docu-mentation, some reference must be made to the management of staff. Over the last year or more the Museum has been through a radical and sometimes painful process of reorganisation and review. Though the financial position is not good, with 85% of budget going on salaries, this review was not primarily a cost-cutting exercise. The objective was to create a better managed, more efficient and more

Fig. 16.1 National Maritime Museum management structure

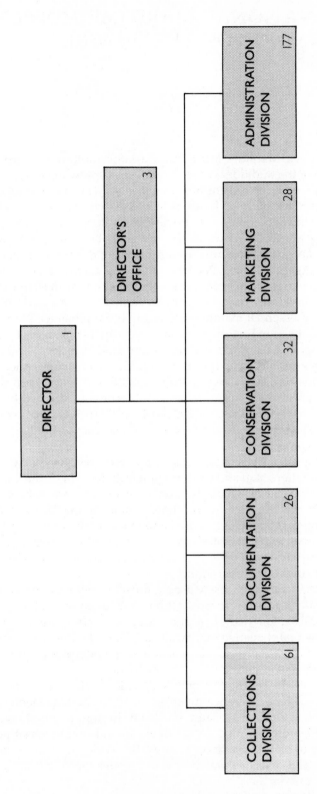

DIRECTOR — 1

DIRECTOR'S OFFICE — 3

COLLECTIONS DIVISION — 61

DOCUMENTATION DIVISION — 26

CONSERVATION DIVISION — 32

MARKETING DIVISION — 28

ADMINISTRATION DIVISION — 177

Total complement: 328

Fig. 16.2 The Conservation Division

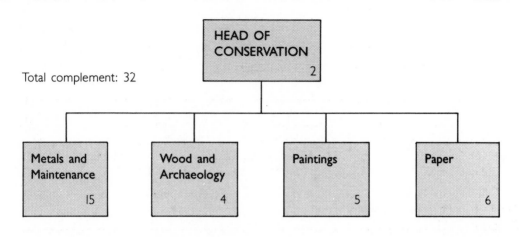

Total complement: 32

HEAD OF CONSERVATION
2

Metals and Maintenance
15

Wood and Archaeology
4

Paintings
5

Paper
6

flexible organisation capable of responding to the challenges which face the Museum in the present climate of enterprise and self-help.

In place of a loose confederation of nine departments reporting independently to the Director, there are now five divisions defined by function: Collections, Documentation, Marketing, Conservation and Administration (Figure 16.1). The five heads of division constitute the senior management team responsible with the Director for policy and planning. Within each division there are sections and subsections and a clearly defined pattern of line management that did not always exist before.

In the Conservation Division, for example, four sections, clearly defined by function, Metals and Maintenance, Wood and Archaeology, Paintings, and Paper, have superseded the earlier, more fragmented structure (Figure 16.2). Jobs can be shared, staff can support one another, priorities can be planned more sensibly, and career prospects are improved. The result is greater coherence, more flexibility and improved team spirit.

The same principles underlay changes and amalgamations in the Collections Division. Instead of six subject or object departments operating with a good deal of independence, there are now four: Records, Astronomy, Ships and Antiquities, and Pictures (Figure 16.3). The new department of Records results from the amalgamation of four sections, Printed Books, Manuscripts, Ship Plans and Hydrographic Charts. It is the first step towards the creation of an integrated Maritime Record Centre.

The Documentation Division offers curatorial services to the Collections Division, but has no direct responsibility for collections. It includes the Education Section, a centralised Enquiry Service, a computer Systems Section, and a Documentation Section with responsibility for team cataloguing projects, loans and the management of museum records (Figure 16.4). The Loans Service is an example of an effective, centralised curatorial function. In the past, loans were organised on a departmental basis, often despatched haphazardly, and there was an absence of well-defined procedures. Loans are now a well controlled activity, with the Museum loans officer coordinating all requests and reporting to a committee of senior staff. The next stage

Fig. 16.3 The Collections Division

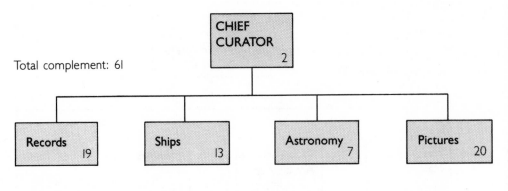

Total complement: 61

CHIEF CURATOR 2

Records 19
Ships 13
Astronomy 7
Pictures 20

Fig. 16.4 The Documentation Division

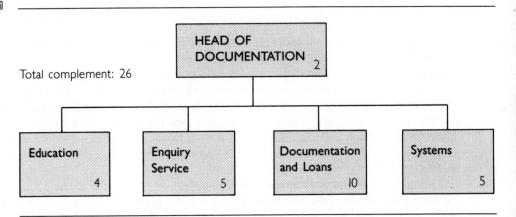

Total complement: 26

HEAD OF DOCUMENTATION 2

Education 4
Enquiry Service 5
Documentation and Loans 10
Systems 5

is to organise acquisition procedures on similar lines, and to replace the 40 odd systems in existence with a comprehensive set of new guidelines.

The largest group of staff in this Division are the members of the catalogue teams. The question of whether to keep the teams together as a separate entity or to disperse them back to departments was keenly debated. The Museum decided on the latter course because of the overriding need for flexibility, and the importance we attach to team effort. For curators the world over, I suspect, more immediate pressures leave cataloguing as an activity for Friday afternoon. The scale of the problems at Greenwich necessitated radical action if any dent was to be made in its backlog of uncatalogued holdings. For the smaller, more traditional museum artefacts, catalogue and documentation systems did exist but they were widely different in type and standard. Many of the huge paper collections were virtually untouched (for example, there was no access to the ship plan collection by ship name).

The Documentation Division has responsibility for tackling the huge backlog of cataloguing collections, implementing museum-wide systems for managing them and keeping them up-to-date, and for establishing common standards and procedures. Each collection or part of collection is the subject of a separate project team, with members drawn from the Documentation Section and the curatorial

PROCEDURAL AND POLICY DEVELOPMENTS

department concerned. It is very much a collaborative effort with input from conservation and other Museum Services. The project to control the collection of 900 flags, many of which would cover a London bus, is a good example of what can be achieved in a short and concentrated time: the flags were unrolled, put in order, interleaved with tissue, properly stored on rollers, numbered, photographed, and recorded, while the computers generated the indexes. Other successes to date include a complete catalogue of books, a concise and thoroughly indexed catalogue of oil paintings (shortly to be published), an index of merchant ships, a negative register, a listing and indexing of acquisition files and a catalogue of ship's badges. Ship models and plans are now being tackled. Ahead loom projects for our huge manuscript collections, historic photographs and prints and drawings. Gone is the heady optimism of the early days, when it was thought that computers would solve our problems easily and rapidly. There is now a mood of sober realism born of experience. It has been shown that given good planning and realist timetabling, it is possible to set up projects, monitor them effectively and finish them. Steady improvement is the best morale raiser of all.

In the last few years the Museum has made a heavy commitment to collections management and it will continue to absorb a large slice of available resources. There will have to be a review of the computer facilities required over the next five years, as part of a current survey of information technology requirements. Objectives will have to be judged carefully against timescales, financial constraints and availability of staff. There is always a danger of outrunning resources, and seeking grandiose solutions that are unattainable. The Museum must also address the question of what it wants from its expanding database and its collections management systems. Objectives to date have included better control, housekeeping, more systematic and accurate information, but what lies at the end of this?

On the records side, the Museum has a vision of a National Maritime Museum Research Centre in which all the great collections of manuscripts, books, charts, ship plans, prints and historic photographs will be gathered together, and serviced centrally. Such a Centre with its expanding database, would act as an unrivalled research facility and source of information for the international maritime community. Through its activities, this study of maritime affairs and maritime history would be actively promoted and advanced, and the academic life of the museum enriched. As the universities have done little to stimulate interest in the maritime past, and there are few or no maritime departments or professorships, it is up to the Museum to give a lead. The opportunity for establishing such a centre exists on our doorstep. The Devonport Nurses Home adjacent to our main building is shortly to become vacant, and the landlords are keen to have us as tenants. All we need are generous sponsors and we are actively seeking for them.

Well-managed collections, supported by sound documentation, can be mobilised more easily for displays, special events, exhibitions, loans, publications, education services, audio-visual and film programmes, and that whole range of activities expected of the dynamic museum today. At Greenwich we envisage sending out major theme exhibitions worldwide as a means of attracting major sponsorship and raising the profile of the Museum. Such a programme will depend for success on sound systems of documentation control. The collections are the vital resource we have to market and exploit, and in order to do that well, we must be able to control them to maximum effect.

17 INFORMATION TECHNOLOGY IN THE LEICESTERSHIRE MUSEUMS ART GALLERIES AND RECORDS SERVICE: PAST, PRESENT AND FUTURE

DR PATRICK J. BOYLAN

I would like to begin with a little background information about the Leicestershire Museums, Art Galleries and Records Service. Following the abolition of the Metropolitan County Councils in 1986, this is now the largest and most comprehensive County Council museum, arts or 'heritage' Service in the UK. Indeed, in terms of its professional staffing and its scale and range of activities, it must be amongst the top one per cent of non-national museums of the world. Our governing body is the Leicestershire County Council which is responsible for most local government functions, including primary, secondary and advanced education, Police, Fire and other public protection services, most highways, many environmental services, Social Services, as well as Libraries, Museums and support for the arts. The County has a population of over 875 000 residents living in an area of 2 550 km². To provide the required services the County Council employs nearly 38 000 people and spends over £2 million every working day. To put my own Service in its local context, despite its very large size in comparison with most other UK local authority museum services, we represent only a little over a half of one per cent of the Council's labour force, and rather less than half a per cent of its annual expenditure.

I think it is also very relevant to my discussion of the use of information technology within the Service to outline if only in an extremely cursory way the County Council's own information technology history. Like many English local authorities, both large and small, computerisation was first introduced in the 1960s (1966 in Leicestershire's case), almost entirely as an accounting tool within the Treasurer's Department. In 1972 a policy decision was taken to not simply renew Leicestershire's elderly ICL mainframe computer systems, but also to seek both hardware and software more relevant to the handling of non-financial data: the County did not just want to replace its financial management system. After an extensive competition open to the major mainframe manufacturers, the contract was awarded to the Sperry Corporation of the USA, and a Sperry UNIVAC 1100/6 was commissioned in 1973 under the guidance of the then Deputy County Treasurer (Ray Hale, now the County Treasurer). Despite some inevitable (and fully foreseen) problems and disadvantages consequent on moving into what was in UK local government terms almost unchartered territory with the UNIVAC, the benefits in terms of generalised information handling was quickly proved in a number of highly successful applications, perhaps the most notably the management of some hundreds of thousands of child health and preventative medicine records for the local health authority.

It was the outstanding performance of the Sperry computer architecture and logic in handling non-numeric data in the health information system that first convinced

me of the enormous potential of the Sperry for museum catalogue information handling. Museum documentation involves extremely large and complex non-numeric data files which are in fact not at all dissimilar to those of the successful health information system, despite the obvious problems of compatibility with the much simpler (though far less powerful) internal structures of the IBMs and ICLs being used for most museum documentation development work (such as that of the MDA) and despite the inevitable problems of longer-term compatability between ourselves and other museums.

In April 1974, shortly after the UNIVAC 1100/6 came fully into operation we had the major English local government reorganisation under which the scope of the County Council was greatly expanded through the creation of the 'new' County covering not only the former County of Leicester, but also the City of Leicester and the County of Rutland. Despite the fact that it was already amongst the largest and most powerful of its kind in the country, the UNIVAC soon required major and frequent enhancements. Over the period 1975 to 1987 we have had substantial upgrades and enhancements roughly every twelve to eighteen months, with three complete replacements of the central processors and associated equipment. Following the merger between the Sperry Corporation and Burroughs, the mainframe and associated equipment is now known by the new corporate designation of UNISYS, although at the present time our equipment is essentially that derived from the Sperry rather than the Burroughs predecessor.

The current installation is a UNISYS 1100/73H2 mainframe with three parallel processors. At the present time (September 1987) the mainframe can address simultaneously nine gigabytes in 18 online disk stores, but a further six gigabytes (on six double capacity online disk drives) are currently being installed and will be in use within the next six weeks. The mainframe can also address five tape readers, which are heavily used for security back-up purposes as well as for generating a very wide range of IBM (or other mainframe)-compatible output tapes for processing elsewhere (for example, for bank credit payments or direct debits), or the payments of a wide range of public utility bills (gas, electricity, water, etc.). The tape reader capacity is also currently being extended with the installation of two further high speed disk drives. The front end processing and communications to more than 300 online remote terminals (including 33 in the various Museums) is through a powerful integrated DCP 40 processor, and a second DCP 40 is also on order both as back-up and to assist in handling the rapidly increasing terminal network demands.

Two further major developments, also of considerable relevance to the information technology development within the Museums Service, were both introduced in 1983. After a six month trial (in which the Museums were heavy users on a test basis), the County Council installed that year Sperry's fourth generation language and relational database — MAPPER. This highly successful system, while not *quite* making COBOL programmers redundant (as some of the initial publicity suggested!), is certainly ideal for both numeric and coded data and for short free text entries. All of these can then be searched, sorted, analysed and manipulated in very many ways by someone who is not a computer specialist after just a few hours training and practice, whilst the '4th generation' capacity holds out great promise as a tool for trained programmers and others with a special flair for and interest in more advanced computer applications in relation to their own jobs.

Also in 1983 the County Council decided to adopt WANG PC microcomputers as its standard for both stand-alone word processors and personal computers, and also for all central typing pool and network purposes. Subsequent development by WANG specifically for Leicestershire has produced a generalised communications board for one of the spare slots in WANG PCs enabling them to communicate fully with the UNISYS mainframe network (and, incidentally, the Council's Compugraphic computer typesetter in the central printing unit). This is opening up a very wide range of new possibilities for the transfer of data backwards and forwards between the PCs, simple MAPPER systems and the mainframe, through to highly specialised dedicated mainframe systems and back down the line again into WANG's sophisticated word processing system (for example, for final editing and preparation for typesetting).

I have gone into the County Council's overall computer facilities in some detail because these are in fact extremely relevant to both policy decisions and past and current practices in relation to the development of information technology systems within the Museums Service. It is also important to stress that we have been immeasurably helped by both the enthusiastic support of the County Treasurer and his staff, and by the Council's policy of carrying centrally virtually all of the costs of the central Computer Services Branch of the County Treasurer's Department. Individual Departments only have to pay for the purchase and running of their own terminal network and PCs, together with the cost of any specialised commercially-available software purchased for their particular purposes. The very enlightened policy of carrying most development costs and all mainframe running expenses centrally has been of paramount importance to my Department (and indeed most others of the County Council) over the past decade or more of very tight government financial controls. Without it, I doubt if more than a small fraction of all of the computer development work that has taken place in Leicestershire over the past twelve years or so would have happened at all. Certainly there is no way at all that my budget could have met the figure of approximately £0.5m that would have represented a realistic re-charge for the in-house computer services and development work that we have received from the County Treasurer's Department over the past eight years.

Turning now to the Museums, Art Galleries and Record Service itself, this has a long and distinguished history in relation to manual museum documentation systems. The original Leicester Town Museum was established as a result of a decision of the Leicester Borough Council in 1846 and opened in the oldest part of what is now the Leicestershire Museum & Art Gallery, on The New Walk, Leicester, in 1849. Thus it has been a public museum throughout its history — unlike quite a number of older (and younger) City Museums in the United Kingdom, which began as Society Museums run on a voluntary basis by local enthusiasts. The original Leicester Museum had a professional curator from its inception, with a good standard of basic documentation by means of a serial number inventory and accession book system established before the museum actually opened in 1849. I think it is also worth noting that in the Edwardian period a much more sophisticated documentation system was adopted, with accessions being number serially under the year of receipt, and with the possibility of an extension number from one to infinity to cover individual parts of an object through to a complete collection. The Leicester documentation system as a whole (not just the numbering system) was

widely adopted in UK museums (and indeed further afield) over the years. It became particularly well known from the early 1930s onwards when the Leicester Museum and its staff played a leading role in the establishment of the Museums Association's training Diploma, with many, perhaps the majority, of the Diploma students spending some of their training period at Leicester on Diploma courses organised in the Museum, where they naturally became familiar with current Leicester practices. Indeed these documentation practices have from time to time been referred to as the 'Leicester System'.

However, the Service has long since expanded far beyond the original Town Museum and its comparatively straightforward documentation and collection management problems, and the situation was made even more complex in 1974 when the City Museums and Art Gallery, the Rutland County Museum, and the City and County Record Offices all merged (with various historic buildings as well) to form the 'new' County Council's Museums, Art Galleries and Records Service, which has the status of an independent Department of the Council under its own Chief Officer (the Director of Museums & Art Galleries).

Currently we have responsibility for nine museums, one major regional level art gallery, eight historic buildings opened to the public plus two other important ones used as working accommodation. We also have responsibility for the County Record Office, a major Museum Education Service providing both intramural and education loan services, and we also have a major additional responsibility in advising the County Council and the ten district councils of Leicestershire on environmental impact issues in relation to planning or other development proposals in the fields of archaeology, ecology and geology. The collections of the Service cover just about every major museum field from geology to contemporary arts and crafts, and whilst the greater part of our fields of interest and responsibility are either local or regional, we have national and indeed international collections and responsibilities in a number of more specialised areas. For example, the Art Gallery is very much an international one, with the leading public collection of twentieth-century German art in the country, whilst the Technology Section is responsible for much the largest and most comprehensive collection of knitting machinery anywhere in the world, reflecting the dominance of hosiery and knitwear in the Leicestershire economy over a period of more than 300 years.

Like most if not all museum services, our initial approach to information technology issues was in relation to specimen documentation. Despite their very high external reputation, it was clear to all of us actually working within the institution that existing standards of documentation were no longer satisfactory in relation to either the retrieval of information that staff, researchers, students or indeed the general public, *really* needed or wanted to know about the collections of the Service and — even more important — the immense volume of primary information that these explicitly or implicitly contain. Also, the standards clearly no longer met current views of security and audit requirements, as developed nationally by the Comptroller and Auditor General in his studies for the Public Accounts Committee investigations of the national museums and galleries in the late 1970s, nor indeed with the explicit terms of the County Council's own financial regulations in relation to the inventory control of material assets of the Council.

After much preliminary consideration of various possibilities, a detailed study was carried in 1979 out by the Chief Executive's Work Study Branch, the County

Treasurer's Audit and Computer Branches, and my own staff, to investigate various possibilities. They established as a kind of benchmark the staffing and resource requirements necessary to check, transfer and where necessary re-accession the current collections and their documentation using the by then well-established Museum Documentation Association (MDA) record card system, supported by appropriate indices, whether manually or computer generated (such as by the MDA on an agency basis).

However, it was quickly apparent that this approach was quite unrealistic in our case, faced with the enormous volumes of data within our defined data capacity parameters (over two million individual museum specimens, an estimated six million archive documents in the Record Office, and a required capacity of something of the order of 200 000 non-specimen records, such as ecological, geological, archaeological or historical site records). Using established clerical work measurement standards, the Work Study Branch estimated that the Service would require between 20 and 24 additional clerical and secretarial staff continuously for a period of ten years to set up an adequate manual system to meet required contemporary standards, over and above the curatorial and other professional staff input (which obviously would be required whether manual, MDA, or in-house computer systems were adopted). At that time we had only four clerical staff of the grade suggested, and a seven-fold staff increase in this grade would have quite literally required us to buy or rent an additional building purely for the documentation clerical staff, quite apart from the extraordinary cost (and doubtful efficiency) of such a complex manual system.

The preferred alternative that came out of this broadly-based and comprehensive study was that we should take advantage of the proven potential of the Sperry UNIVAC mainframe system, as demonstrated in other non-numerical information handling systems, such as the extremely large-scale health information system already referred to. In reaching this decision we fully realised that the whole software package would have to be specially written for the Sperry, as there was no comparable system running anywhere in the world on a UNIVAC. (It was clear from the outset that because of Sperry's sophisticated mainframe architecture and logic, the MDA's GOS system developed on the Cambridge IBMs several years earlier (and written in BCPL) was going to be exceedingly difficult if not completely impossible to run on a Sperry mainframe, so regretfully the MDA/GOS alternative was discounted at an early stage.)

For our in-house computer system, we therefore added to the potential capacity parameters referred to above (two million museum specimens, six million archive specimens and 200 000 non-specimen records) four further important basic parameters, three of which were far more ambitious than those of any comparable actual or projected museum documentation system of the time. These were (1) the data structure should as far as practicable follow the MDA Documentation Standards (in order to facilitate data transfer between the Leicestershire and the MDA systems); (2) we should from the beginning plan to operate on the basis of online input of data from each of the eleven Departmental establishments housing professional staff, with as much online validation at the time of input as possible; (3) online retrieval by the staff and (subject to confidentiality) in due course the general public as well, should be incorporated in the system from the beginning; and (4) we should seek from the outset the highest possible online communication and processing speeds.

The joint proposals of the three Chief Officers (Chief Executive, County Treasurer and Director of Museums & Art Galleries) were accepted by the County Council in January 1980 and implementation began immediately. Dr Tony Fletcher, at that time working as Assistant Keeper (Botany) in the Biology Section, had for some months prior to this been seconded to the documentation and study team on a part-time basis because of his previous computing experience, and on the adoption of the new strategy, he was appointed Keeper of Documentation and Information Retrieval. Because of the very large range of subject areas covered by the Service, detailed system analysis was of the highest importance, particularly in trying to define and as far as possible harmonise data structure and data standards across very different subjects. Fairly soon, approximately 100 standard data fields were identified, which covered the whole area of the Museum & Art Gallery collections. Of course, no one Section required all of the potential 100 fields as standard requirements, but it was felt most important to allow virtually unlimited field sizes to meet particular data requirements.

For most data input purposes the needs of each particular Section (or Sub-Section in the case of larger and more complex areas such as Decorative Arts) were converted into double-sided A4 data input cards (very similar in layout to MDA cards but following the Leicestershire standard), matched by a set of four data input screens, each of the set of four matching half a side of the standard input card for that Section. Also, a considerable amount of validation was built into the input system from the beginning, so that obvious errors or omissions are referred back to the person at the input terminal at the time for checking and alteration. This is supported by an automatic keyword analysis with daily printouts intended amongst other things, to pick up inconsistencies, as in spelling keywords or usage. (The fundamentals of the Leicestershire approach and system over its first five years (to 1984) were described in some detail by Fletcher (1986), and a substantial update is currently being prepared jointly by Tony Fletcher and his successor as Keeper of Documentation and Information Retrieval, Fiona Marshall.)

From the time of my own involvement in the initial study of 1979 I have been absolutely convinced of three basic points needed to achieve satisfactory progress. First, contrary to the widely held view in museum documentation circles at the time, speed of processing and turn-round would be of crucial importance, and hence massive computing power of the sort offered by the Leicestershire UNIVAC installation was the right road to take. Second, it was equally important to offer good online interactive retrieval systems if you are to satisfy the *actual* needs and working methods of curators, researchers and other enquirers. It was (and remains) in my view frankly unrealistic to expect anyone to work up great enthusiasm for a computer system *per se*, if in fact it is quicker to look things up in a printed catalogue (albeit perhaps, one printed by a computer) of the sort that has basically been around for over 300 years. I do not think it is much of an exaggeration to say that many people in the museum documentation field in 1979 or 1980, both here and abroad, thought me quite mad to be insisting so firmly on the need for what was at that time seen as a mega-computer (though seven years on some of the new super-PCs are approaching the same order of magnitude of processing powers that the biggest mainframes could offer at the beginning of this decade), and even more so for my insistence on interactive inputting and retrieval systems, but I think that our original objectives implemented first by Tony Fletcher and currently by Fiona Marshall, have been entirely vindicated by our experience.

Third, I am equally unrepentant about my insistence that the curators of individual collections should remain the managers of their collections and be accountable for them, rather than pass the day-to-day internal 'ownership' and management of the collections to some sort of central Registrar's Department. I think this would in any case have been extremely difficult to achieve in the Leicestershire Service with such a wide range of collections and (not least) different buildings (with collections in 22 buildings in six towns across the county).

On balance most of the problems, changes and challenges that have taken place over the past seven or so years were foreseen at the time that we embarked on our 'great adventure'. Thankfully, we were entirely correct in our assumption that online storage costs would continue their near-vertical tumble and that as a consequence the County's online disk capacity would at the very least keep pace with our Departmental demand. (It is fortunate that we were correct in that assumption, since our current 450 megabytes, including 180 megabytes of collections documentation storage, is only about 3% of today's total mainframe capacity, compared with around 60% of the total 1979 capacity of the County mainframe.) However, we certainly have had unforeseen problems, such as the extreme difficulty of establishing a classification and standard terminology for the History group of Sections of the Service (Antiquities, Leicestershire History, Rutland County Museum, Harborough Museum and the Technology Section).

One other unpredicted development of even greater significance was the rapid emergence of a wide range of computer uses outside the anticipated priority of specimen and related documentation, and these perhaps secondary applications have been of tremendous value in breaking down the inevitable barriers of fear and mistrust of such a fundamental change in approach, not just to specimen documentation, but to just about every area of the operational side of the Service. From the earliest days, even when we only had a single terminal installed together with a 64K Digico Prince (Osborne) microcomputer, any member of staff interested in exploring the possibility of applying computer systems to any of their activities, whether in a curatorial or research field or to some aspect of their administrative work, were given full computer access, assistance and basic training. Once trained, interested members of staff were given an 8 000 track personal working area on the mainframe and/or their own disks for the micro, as they wished. In the early days extensive use was made of a simply Sperry mainframe program package called UNITAB with its associated formatted print run system, UNIPRINT, and this was paralleled on the Digico micro by either data handling with the DMS software package (or in a few cases systems written in BASIC) or text handling with WORDSTAR.

At the time of our 1979–80 study we had assumed that our medium to long-term requirement would be for something of the order of 15 terminals — one at each of the 11 buildings at which professional staff of the Service are based, with an extra one or two terminals at the largest establishments. However, we have already far exceeded our original expectations because of the sheer demand for terminal capacity from the staff. Consequently, we now have a sophisticated and extensive sub-network of our own, all driven through the UNISYS mainframe at County Hall, Glenfield (five miles from the centre of Leicester), with a total of 33 terminals in the 11 Departmental buildings served by our network.

Communication both between establishments and with the mainframe itself is via the DCP 40 front-end processor at County Hall. We have a dedicated 9 600 Baud

British Telecom link from County Hall to our Central Leicester branches distribution network, which is controlled from the Documentation and Information Retrieval accommodation in the Departmental Headquarters at 96 New Walk, Leicester. This system covers terminals throughout the Departmental Headquarters, the Leicestershire Museum & Art Gallery and the Leicestershire Record Office (both also on New Walk), together with the Newarke Houses, Jewry Wall Museum and Wygston's House Museum of Costume branches, most establishments having several individual terminals. The Rutland and Harborough branches are linked to the DCP via dedicated high-speed lines shared with the appropriate District Council (which in each case have their computer facilities close to the museum accommodation), whilst the Leicestershire Museum of Technology and the Humberstone Drive Annexe premises, both in Leicester, have their own dedicated direct lines to County Hall. The final establishment, the major new Snibston Industrial Heritage Museum under development at Coalville in North West Leicestershire, is at the moment served through a dedicated line shared with other County Council establishments in Coalville (the Libraries and the Technical College), although we anticipate that we will very soon outgrow this shared facility and will need to put in a much more powerful link to cope with the increasing demands of the Snibston site.

It is interesting to note that although our Department represents just 0.5% of the County Council's total operations in financial terms, we currently have over 12% of the total number of mainframe terminals, and our total current computing requirements and usage are far in excess of those of major Departments such as Education and Social Services in absolute terms. In addition to the mainframe terminals, we have at the present time nine WANG PCs (the smallest being 10 megabyte and we are increasingly moving towards 20 megabyte as standard), and two Amstrad PC 1512s. We also have an Amstrad PCW 8512 word processor to provide technical support and back-up for members of staff using their own PCWs for work at home. In addition, we are making increasingly heavy use of a Tandata modem and DATATALK software as a communications package between one of the Amstrad PCs for communication with PRESTEL, Telecom Gold and private viewdata systems.

This is of course a rapidly changing scene, and already four of the WANG PC 280s (which are IBM–AT clones) are being used as multi-purpose work stations in some of the smaller branches, complete with full mainframe communications, as well as word processing. Several other PCs with the same configuration are on order at the present time (September 1987), and it is likely that a majority of our 'dumb' mainframe terminals will in due course be replaced by high powered PCs with full mainframe communication capability. Another extremely valuable development on order, this time using an Amstrad PC 1512 plus three Telecom Quertyphones, and using the advanced conference call facilities on our new Departmental Monarch electronic telephone system, will be to provide visual text interpretation of speech on both external and internal telephone calls to a member of the curatorial staff who is profoundly deaf.

Other statistics which may well be of interest are that as at 23 September 1987 we had a total of 91 559 fully computerised accessions available in the online system, together with approximately 21 000 site/locality records in the various archaeological and ecological locality databases. Of course, not least for Data Protection Act purposes, users and their access to particular systems are closely monitored, so we

have accurate statistics at all times of those using particular areas of the mainframe capabilities. At the present time we have 54 registered users of the main Catalogue System, 62 users of MAPPER for more than 30 different applications, 47 users of the County Council's Electronic Mail system (around one-sixth of the County network's total), and 48 staff with access to the mainframe's 'Demand Mode', giving access to a very wide range of other facilities and applications including the opportunity of writing and developing their own mainframe programs. Our Mailing List system is heavily used by not only the Department, but also by a wide range of Museum and Record Office professional organisations both nationally and internationally. Currently we have a database of approximately 8 500 names on a total of 70 different lists, and we are as a Department registered under the Data Protection Act as a Computer Bureau for DPA purposes.

One of the welcome features of Leicestershire's information technology policy over a considerable period of time has been the willingness of the County Treasurer and other Chief Officers to exchange computer information and access to specialised systems. It is, for example, a great help for us to be able to have direct access to our own files within the Council's accounting system, including details of progress with payments of creditors or the handling of debitors, and a wide range of valuable budget analyses facilities through the General Ledger package. Administration also has access to the Property Department's Energy Management & Conservation data in relation to all of our premises, and every Section of the Service has full access to the County Libraries and Information Service's main catalogue. (In return for this, all of our specialised journal holdings are registered in the Library main catalogue and we act as an inter-library loan facility in relation to these journals.)

However, perhaps the greatest area of unpredicted expansion has been in the use of MAPPER, the Sperry/UNISYS fourth generation system, already referred to above. MAPPER was in fact under development by various UNIVAC users in the USA from 1965 to 1979 as primarily an internal private user group system, and its first public release was at level no. 29! Leicestershire uses the current release, no. 31, and the great majority of applications both within our own Department and elsewhere within the County Council are in the form of tabulated data using either an 80 or 132 column format. The system offers more than 200 standard MAPPER functions, or commands, which together cover most standard and easily recognised COBOL, FORTRAN and BASIC functions within MAPPER itself, greatly simplifying (and extending) the programming possibilities. It is also a very powerful tool for data analysis, and MAPPER 'runs' (that is, system-generated operating programs) are being used for more complex functions, both on a stand-alone basis and in conjunction with other mainframe applications. For example, much of our requirements for analyses of progress on the Catalogue System, including individual staff performance, etc., is now abstracted by means of MAPPER runs direct from the Catalogue System's security log and similar internal records, and then processed again within MAPPER to produce easily understandable management reports, available both online and as regular printouts.

Also, although some of the publicity claims for MAPPER in terms of self-programming by non-specialists need to be taken with a large pinch of salt, it is certainly true that any non-specialist moderately interested can very quickly learn to set up and manipulate MAPPER formats to meet their own specific needs. The mainframe has an open access experimental area available to all registered MAPPER

PROCEDURAL AND POLICY DEVELOPMENTS

users for their own development and testing work. Once the user is happy with a trial project, it can be checked, tested and transferred to an appropriate 'live' area more or less immediately by the MAPPER Co-ordinator, avoiding certainly days and possibly weeks or even months on the Computer Branch's waiting list for conventional programming of the particular requirement. We have also been fortunate in that the present Keeper, Fiona Marshall, came to us already trained and experienced in MAPPER, which she had used in her previous information, library and museum job with British Gas.

Current MAPPER applications within the Service include the archaeological and ecological sites records already referred to, together with an index to the names and other data occurring in Wills held by the Leicestershire Record Office – a database that will eventually contain approximately 200 000 lines of 132 characters (an indication that MAPPER is not solely a system for small-scale jobs as is often thought by non-users and indeed UNISYS's competitors). At the other end of the scale, several Sections are using MAPPER for internal information systems such as their equipment inventory.

We are also using MAPPER increasingly in the management and administration fields. I have already referred to the MAPPER-based analyses of the catalogue system usage statistics, etc., as one example of this. It is also used extensively in the management of internal budget allocations to the 17 operational Sections of the Service. Up to 1981 the detailed analysis and breaking down of our overall budget allocation from the County Council into more than 300 operational areas spread across the various Sections involved something of the order of three weeks' clerical work per year. In 1981 with the help of Tony Fletcher, I wrote a simple UNITAB system which reduced the job to around four days' work a year, but the conversion of this to a MAPPER system by the present Keeper of Documentation & Information Retrieval in 1986 not only cut the job to a matter of just a few hours per year, but also gave us a whole range of new possibilities, including 'What If' questions through its spreadsheet facilities, and the ability to extract and process updated reports and stationary for the necessary periodic financial returns of the Section Heads throughout the year.

Other internal management facilities have included the establishment of a three year forward Exhibition and Events Diary covering 15 branches, which is available on a read-only basis to every Section, and internal management systems for activities as diverse as the monitoring of building maintenance and repair orders, of the processing of invoices received, and the Photographic Section's internal and external works orders.

Whilst I would not wish to minimise the very real problems and difficulties that we have had, I think it is clear that very considerable progress has been made since the initial decision to proceed with a major information technology initiative in 1979. What then of the future? Certainly we have a long way to go in checking and re-cataloguing into the computer system the existing, often very inadequate, records of the huge collections of the Service, and in some fields (for example the Record Office) we are still only at a very early stage of systems analysis. A high priority is to make both our existing facilities and all new developments much more user-friendly, and we see great potential for the further use of MAPPER, particularly in the development of MAPPER runs for analysing and presenting data from the catalogue (and indeed all other) databases. Similarly, we aim to establish in the fairly near future a

10

total integration of our information technology systems — particularly mainframe and micro systems — to form an integrated information system for not only the staff of the Service but also our actual and potential users of all kinds. We certainly hope that within the next two years at the most we will be in a position to produce comprehensive printed catalogues of important areas of the collections direct from the primary catalogue database, through intermediate editing systems to computer typesetting output ready for printing.

However, I believe that we are still only scratching the surface of the true potential of the information technology 'revolution' in the museum field (Boylan, 1986), and think that bearing in mind the extraordinary speed of change that we have experienced in Leicestershire in this field over the last seven years, it would be foolish indeed to try to make any firm predictions about what exactly will have been achieved in an equivalent period forward (that is, by the mid-1990s). However, the planning of our major new Industrial Heritage Museum at the former Snibston Colliery in Coalville, in North West Leicestershire, has assumed from the very beginning that most if not all of the professional and visitor services operations would be information technology 'driven'. We are therefore giving high priority to the development of visitor accessible online databases which we hope to make available not merely to visitors to the Museum itself, but also more widely through the use of viewdata systems. We were in fact involved in one small landmark in public viewdata systems ten years ago, when to mark the twentieth anniversary of BBC Radio Leicester we helped to mount the first public demonstration (in the Leicestershire Museum & Art Gallery) of the local information potential of the BBC's then experimental CEEFAX system.

We are currently experimenting with the use of PRESTEL (despite its relatively small public usage at the present time), and have arranged for Microtec Viewdata Systems (who already handle the National Museum of Photography at Bradford for the Science Museum), to run an experimental one year's PRESTEL service publicising our own facilities and special events, and incorporating a response frame for those seeking further information about either the Service or our various Friends of the Museum organisations. For the Snibston development we will certainly want to establish a comprehensive viewdata information system about both the historic and contemporary industries of Leicestershire, and also a first-class database on all tourist facilities within the County. We are not yet sure how in technical terms this would be operated, but certainly direct public access will be a high priority, preferably through a choice of communication links (for example, direct dial-up, through the County Council's own network from all County and District Council establishments including local schools), and also through a PRESTEL Gateway facility for other enquirers, such as the general public and — not least — the travel trade which is currently one of the major users of PRESTEL.

PROCEDURAL AND POLICY DEVELOPMENTS

18 NEW APPLICATIONS FOR COMPUTERS IN THE NATIONAL MUSEUMS AND GALLERIES ON MERSEYSIDE

RICHARD FOSTER AND PHILIP PHILLIPS

The National Museums and Galleries on Merseyside (NMGM) was constituted by Order in Council in April 1986 to assume responsibility for the collections of the Merseyside County Museums and the Merseyside County Art Galleries. The National Museums and Galleries on Merseyside comprise seven major institutions including the Liverpool Museum (established 1851), the Walker Art Gallery (established 1877), the Merseyside Maritime Museum, the Lady Lever Art Gallery, the Sudley Art Gallery and the Large Object Collection.

The collections of NMGM are extensive and diverse, covering fine and applied arts, antiquities, ethnography and archaeology, the physical sciences and geology, botany and zoology, science, technology and industry, and social history.

The first use of a computer located in the museum, as opposed to an external mainframe, was not associated with collections management but rather as an aid to the interpretation of the public displays.

Way back in 1979, we experimented with a Commodore PET and a simple visitor-operated program on animal identification produced by our staff. These experiments resulted in a microcomputer being built into an exhibition on evolution which has been working reliably ever since. We shall be concentrating on the topic of public displays, since we feel that this is a major area where the abilities of modern systems to organise and retrieve information and present it in an attractive fashion can be used to great advantage.

Of course, we undertook to document our collections on computer partly in order to make the information more accessible for our own internal purposes. However, we were equally interested in using the computer to assist in making our collections more accessible to the public on the gallery.

Current usage for collections management purposes

In common with many institutions, we have made good progress with the computer documentation of large parts of the reference collections, resulting in significant savings in time and effort in a variety of routine tasks. So far some 70 000 specimen records have been entered. This work is continuing, both retrospectively for material already in the collections and especially for new additions. For example, we have just recently completed the documentation of some 4 600 mineral specimens transferred to the Geology Department from the University of Liverpool. The collection was already well identified and it was a straightforward matter to work directly from the trays of specimens and input the information into our database. This was then edited to conform with existing records. The specimen labels, as well as full lists of the material, were then printed out from the computer.

We have used outside agencies for inputting data where the condition and completeness of existing records has made this possible. Over 6 500 records of British marine molluscs were entered by trainees on a Community Programme organised by a local training organisation (METEL), working from a typed ledger prepared some years earlier.

Other group of trainees from METEL worked in the museum on the task of entering a card index of our collection of ship models and paintings, some 1 500 items in all. One of the Maritime Museum staff was on hand to resolve any ambiguities arising from the hand-written cards. Work is in progress on final editing of this database before it can be used in the Maritime Record Centre or as a publication.

We have followed a number of guidelines in the deployment of microcomputers. In particular, we would not become committed to any particular hardware or software that did not allow the ready transfer of data to new systems. This is in recognition of the rapidly changing technology available.

Having noted that, it is true that we are at present very much committed to IBM or IBM-compatible systems. We use mainly Sperry ITs and Tandon PCAs along with a smaller number of Amstrad 1512s. In all there are 37 machines employed on collections documentation and word-processing with a further dozen or so used for other tasks.

The database software we employ is dBaseIII+ and we have found that this is flexible enough for our needs. dBase has its own programming language which can be used to tailor applications to the requirements of a particular user. It can also be used directly in interactive mode or through the medium of the ASSIST option. In addition there is extensive online help available. The effort involved in coming to grips with the complexities of the programming language is well repaid by the control over the data that the system offers.

The combination of IBM compatible PCs and dBaseIII has become almost a standard for many database operators, both in the commercial field and in some museums. Liverpool Museum was one of the first, if not the first, British museum to adopt this combination. Moreover, this took place at a time when prevailing opinion advised that it was not powerful enough. The fact is that as our needs have grown so have the capacities of the available machines. Three years ago, a 10 megabyte hard disc was the norm, nowadays all of our Tandon and Sperry machines have at least a 40 megabyte hard disc and one of them has two 40 megabyte drives — quite enough to cover the largest single collection on one machine. Disc capacities of over 100 megabytes are now by no means unusual and the promise of optical disc drives with capacities in the range 200 to 600 megabytes means there is a long way to go before we exhaust the possibilities.

All of the machines are single-user set-ups, the apparent cost savings of networks being offset by the falling cost of peripherals and by the greatly increased software overheads involved in running a network. Where there is a need to share information among several users then this is done by using the large capacity floppy discs.

There is a well established procedure for making back-up copies of data to guard against the threat of data loss through mechanical or indeed operator failure.

In some areas we have employed a strict terminology control, for example in the case of mineral names, so that our usage is consistent. New records are automatically checked for conformity with a prepared list. Either the record is amended to follow precedent or the list is extended to allow use of the new term.

The Natural History Centre

The first case study we wish to discuss is the Natural History Centre. This is the culmination of a series of experiments designed to inform our visitors about the nature and significance of the one million geology, zoology and botany specimens stored in the reference collections.

Experiments with the concept of making natural history collections more accessible to the public have been conducted in the gallery for several years. The activities have generally been held during the summer holidays when we receive the largest number of visitors. The experiments have allowed the staff to test public reaction to the opportunity to closely study a wide range of natural history material (fossils, insects, shells, mounted birds, skulls and skeletons, rocks and minerals, etc.).

Visitors were encouraged to handle the items or examine them under a microscope. We were particularly concerned to monitor how the specimens stood up to this treatment and found that with the level of supervision and guidance provided by the demonstrator staff there were no serious problems.

Building on this experience over two summers, we decided to construct a permanent facility where ordinary members of the public could come into contact with parts of the reference collections in a stimulating but controlled way. Construction of the Natural History Centre was completed in time for a pilot opening session during August and early September 1987. This pilot season (which lasted five weeks) attracted a further 20 000 visitors and will inform the method of operation for a permanent opening of the centre in the future.

The Natural History Centre as it now exists was in two parts. The first of these is an Activity Room where carefully-selected specimens were presented for display and examination. These included a hippopotamus skull, a giant clam, dinosaur footprints and a multitude of smaller fossils, birds, insects and minerals. During the school holidays an important feature of the Centre was a children's area where younger visitors could complete quizzes and draw specimens. The remainder of the room was divided into three areas covering the subjects of Invertebrate Zoology, Vertebrate Zoology and Geology, each of these areas being staffed by subject specialists attached to the relevant department.

The second area was a Collections Room containing 30 cabinets, each with 11 drawers of material, a total of over 10 000 specimens from the reference collections. In the majority of these cabinets, the specimens were fixed in position and protected by a perspex cover, but there were also three cabinets of rocks, minerals and fossils where visitors were invited to handle the objects and even to take them over to a microscope for closer examination.

If we were to be successful in our objective of bringing to the visitor's attention the significance of the reference collections, then we had to establish a link between the small part that was available in the collections room and the rest of the material still in store. For the Geology collections this link was made in three ways.

First, demonstrator staff were positioned in the Collections Room in order to supervise and guide visitors. They could introduce the fact that there was even more material housed in the museum in the course of conversations with visitors.

Second, computer printouts of complete parts of the Geology collections were available for consultation, both by the staff to help them answer enquiries and directly by the visitors themselves.

Third, a microcomputer was installed which provided information about the entire mineral collection of some 10 088 specimens. The visitor could browse through a list of mineral species displayed on the computer screen. When the user selected one, he or she was presented with details of the chemistry, properties, occurrence and uses of that mineral, while a photograph of the mineral was called up from a videodisc controlled by the computer and displayed on a second monitor.

The computer, meanwhile, worked out how many specimens of that type of mineral we had in the collections and displayed the result at the bottom of the screen. Next the visitor could browse through a list of place names from which we had examples of their chosen mineral and finally they were returned to the list of minerals ready to make another selection.

The most popular selections were, perhaps not surprisingly, gold, silver, diamond and platinum with the more common minerals such as quartz, calcite and dolomite trailing somewhat. Even the most exhausted grandparent perked up when they found that we have 101 specimens of native gold in the museum.

The computer was also programmed with a glossary of 300 geological terms, again illustrated with the videodisc pictures. Additionally it was used to control a number of short one to two minute film sequences, on topics such as The Rock Cycle or Weathering and Erosion, from the videodisc.

We found that this use of the computer had an appeal right across the age spectrum, from children only just old enough to read, through to the elderly who are sometimes rather intimidated by the thought of using a computer. One of the reasons for this broad appeal was that we did not use a normal keyboard, but constructed a special one with five keys, only three of which were used for most of the programs. The vast majority of visitors very quickly grasped how to operate the equipment to find the information they wanted.

We found that the easy access of the computer information coupled with the attraction of the videodisc images made a powerful combination. Even the most ardent computer enthusiast would recognise that strictly text based information has its limitations when trying to help non-specialists and the video buff will acknowledge that one of the problems with videodiscs has always been simply finding the one frame that you want to see out of up to 50 000 stored on the disc.

In the Natural History Centre we were employing the products of ordinary specimen documentation, supplemented by a specially constructed glossary of mineral properties and uses and illustrated by high-quality videodisc images, to make an absolutely fundamental contribution to achieving our objective of informing the visitor about the size and diversity of the reference collections.

In addition, by having the computer database available in the Centre, the museum staff were able to answer enquiries from the public in minutes, which would have taken hours if not days by any other means. For example, one enquirer came into the Centre and told us he and a friend had donated a mineral specimen from Malaya some 15 or 20 years previously: he did not know exactly what the specimen was, but he had another piece of it at home and would like to see the bit he had given us; also did we know what it was? It was the work of a few moments to find that the specimen, which turned out to be hematite, had been donated in 1971 and was recorded under his friend's name. We were able to produce the actual specimen from the reference collections within a few minutes using the storage location information on the computer.

So the Natural History Centre is seen as the logical extension of our efforts to manage our collections. Our Trustees are extremely concerned to improve accessibility to the collections and the Natural History Centre is one of a number of experiments along these lines. Our concern runs this way: in common with most museums we have large collections held in store consulted mainly by the curatorial staff and visited or used directly by perhaps 3% of our 1.2 million users. The maintenance of these collections in terms of staff and plant probably costs about £1.5 million out of our budget of £9.4 million. It would make sense to maximise use of these collections by the public, accepting that our running costs would rise still further.

However, to invite the public in any numbers to make direct use of the stored collections might be impractical. Many people would find this opportunity daunting in any case. Providing an enquiry desk in the foyer of the museum with a computer and videodisc would be a welcome breakthrough and, for example, the Dutch appear to have made significant progress with this method at the Prins Hendrik Maritime Museum in Rotterdam. It will be very interesting to examine their experience since the system has only just been installed. However, we believe that if we are really to successfully advocate the 'literacy of the object' to a mass public, a facility on the gallery, making use of a 'ministore' and staffed by knowledgeable, demonstrator personnel is essential. Television in particular has created an enormous latent demand for non-vocational use of collections in store, but in museums we have only scratched the surface in deciding how to respond. If we do not we shall continue to meet criticism about hoarding our collections and pressure for disposal will increase. Most seriously of all, museums will pass up an opportunity to be a kind of 'university of the people', and to offer their services to an eager public.

The Decorative Arts project

The second case study concerns computer applications to the problems of providing information in depth about objects on display.

The Decorative Arts collections include some 6 000 ceramic items in store, along with a large number of pottery sherds. It was decided to attempt to display the greater part if not all of the complete specimens in a phased programme. The first phase involved the selection of some 500 specimens to be incorporated in 'The Art of the Potter'. The specimens ranged from medieval dishes and bowls right up to modern studio pieces.

The existing documentation for the collection was not uniform and varied somewhat in quality. Information, where present, was scattered over a number of sources and needed careful checking. A start was made on documenting the entire collection, using a Sirius and dBaseII, to a very basic level, enough to serve most collections management purposes, but stopping short of full descriptions of the items. Alongside the task of documentation went the selection of material for the new exhibition, items being provisionally graded as to suitability (probables, possibles, definitely nots, etc.), and the grade recorded as part of the computer record. Notes on any conservation or photographic requirements were also included. All of this information was most useful when it came to making the final selections. The 500 chosen pieces were then transferred to a new database and full descriptions added. The printed captions to accompany the specimens were derived from information already in the computer.

Two other databases were also prepared for use in the display, one containing short biographies of 100 of the ceramic makers represented and the second a glossary of some 150 terms employed in describing ceramics. In the glossary a system of keywords was used to create links between related terms so that, for example, the term Glaze was connected to Firing, Galena and Tin-glaze among others.

Once all the specimens to be used in the display had been fully documented and the supplementary databases were complete, the information was transferred to a BBC microcomputer. We decided to use BBC machines for the final display for two main reasons. Firstly, they had a very good colour display even when used with relatively inexpensive monitors and, secondly, the cost was very low at about £500 each without monitor. (This was at a time when even the most basic IBM PC, with no hard disc, cost over £2 500.)

A straightforward BASIC program then used the data from the Sirius to present the information. Once again we did not use a full keyboard, but constructed a special one with a limited number of keys. The visitor makes use of the system by selecting an object by case number and individual number (both indicated in the display case). Punching these numbers into the keyboard produces a description of the piece and a menu offers the possibility of further information on the makers or explanations of the terms used in the description. No graphics or printout facility is included as yet.

This then was the first phase. The next step, which is well underway, is to display at least the greater part of the remaining 5 500 specimens in an adjoining gallery. This will also have a computer information point for the public, as well as one for more detailed enquiries in a study area. In the longer term we intend to produce a videodisc holding a mixture of still images and short moving sequences relevant to the themes of the display, and to use this in conjunction with the computer information in much the same way as we have already done in the Natural History Centre. The still images would include close-ups of parts of the items on display (for example, makers' marks or inscriptions), as well as stages in the manufacture of the items where possible. The capacity of the videodisc at 50 000 frames per side means that we are limited only by our imagination.

19 COLLECTIONS MANAGEMENT POLICY AND PROCEDURE INITIATIVES AT THE SMITHSONIAN INSTITUTION NATIONAL MUSEUM OF AMERICAN HISTORY

KATHERINE P. SPIESS

The Smithsonian Institution, in Washington, DC, administers the largest museum complex in the world, a complex which includes the United States National Museums. The collections cover art, decorative arts and design, history, natural history, anthropology, science, technology and live specimens. The size and variety of the collections dictate that modern systems of collections management be employed to ensure maximum control over and documentation of these collections. Nevertheless, the employment of such systems has been a long time in coming; only gradually could practices of many years standing be altered, traditional staff structures be reorganised, and new systems based upon sound principles be developed and implemented.

The National Museum of American History is one of the 13 museums of the Smithsonian Institution. Its collections currently number just under 16 million artefacts; these include approximately 13 million philatelic items, one million numismatic items, and over two million items in the general collections. Each year, 1 000 acquisition transactions (on average) and approximately 1 700 incoming and outgoing loan transactions (combined total) are processed, and over 100 000 public enquiries are received. In addition, several hundred thousand objects are relocated due to the installation and deinstallation of exhibitions, acquisition and loan activities, and building renovations.

The programmes of the National Museum of American History demand museum-wide access to collections and their related documentation to support the continuing development of the Museum's holdings, multi-disciplinary education programmes (including exhibitions), and efficient management of its collections. Extant manual files and record systems do not support such access. The sources of the problem can be attributed to the continued growth of the Institution and the many administrative and curatorial reorganisations which have occurred in the past 142 years, as well as to lack of Smithsonian-wide documentation standards, consistency among record systems, and standard procedures for documenting the physical reorganisation and movement of the collections themselves. The National Museum of American History therefore serves as an excellent case study in the development of collections management policy and procedure initiatives.

Background

To understand the depth of the problem, one need only consider the history of the development of the Museum. The Smithsonian Institution was created by Act of Congress in 1846 following acceptance of the James Smithson bequest. The bequest

was to be used to create an establishment 'for the increase and diffusion of knowledge among men'. The Act of Congress required the establishment of a library, museum and gallery of art.[1]

Collections began to arrive almost immediately from such sources as the Wilkes Expedition of 1842; the Pacific Railroad Surveys of 1855; the 1858 transfer of the national 'cabinet of curiosities', originally housed in the US Patent Office; and the 1861 acquisition of the collections of the National Institute, formerly the Columbian Institute for the Promotion of Arts and Science, chartered by the US Congress in 1818. As the collections of the Smithsonian grew, curatorial departments and divisions were created which reflected the various types of objects and specimens being acquired. As a result, the Smithsonian Institution evolved into its present configuration of separate museums holding millions of artefacts and specimens.

The collections of the National Museum of American History have their origins in the national 'cabinet of curiosities' and in acquisitions from the Centennial Exposition, held in Philadelphia in 1876. The manual records of the Museum predate the 1846 establishment of the Smithsonian, for they include documentation which accompanied the transfer of collections from the National Institute. Indeed, the Smithsonian Institution continued the National Institute's 1818 record system for the registration of collections until 1976.

This registration record system was maintained initially by a central office established in 1880, with the appointment of the Smithsonian's first Registrar, Stephen C. Brown. The Registrar serviced all subdivisions of the United States National Museum, functioning as the record, storage and transportation clerk. With the death of Stephen Brown in 1919, the Smithsonian abolished the position of Registrar. From 1919 until 1956, maintenance of records which documented accessions, object examinations and reports, and object distribution was assigned to the Division of Correspondence and Documents. In 1956, a central Office of the Registrar was re-established and given responsibility for maintenance of accession and loan files, the central shipping and packing facility, customs work, distribution of mail and publications, and travel arrangements for staff. During the 1960s, separate offices were established for managing the distribution of mail and publications and for handling staff travel arrangements.

As the United States National Museum was split into separate museum entities, each assumed responsibility for developing and overseeing its own acquisition and loan programme; the central shipping and packing facility remained available to any museum wishing to use it. By the mid-1970s, only the National Museum of Natural History and the National Museum of American History continued to rely upon the central Office of the Registrar as a repository for acquisition, loan and shipping documents and for shipping and packing services. In order to better service the

1. Many books contain a history of the development and growth of the Smithsonian Institution. The following volumes serve as good starting points for anyone wishing to read more on the subject: *Guide to the Smithsonian Archives* (1983), Washington, DC: Smithsonian Institution Press; Hellman, Geoffrey T. (1967), *The Smithsonian: Octopus on the Mall*, Philadelphia: J. B. Lippincott Company; Ripley, Dillon (1969; reprinted 1982), *The Sacred Grove: Essays on Museums*, Washington DC: Smithsonian Institution Press; True, Webster P. (1946), *The First Hundred Years of the Smithsonian Institution, 1846–1946*, Baltimore, Maryland: The Lord Baltimore Press

needs of the two museums, planning began in 1973 for the decentralisation of these functions. Total decentralisation took place during the summer of 1976.

Prior to 1972, most collections management activities at the National Museum of American History were conducted and supervised at the curatorial division level. The development of standards and systems for managing and documenting the collections was left to these individual units. As a result, non-uniform and inconsistent collections management practices and cataloguing systems existed museum-wide.

Although registration files have always been maintained centrally, initially at the Institution level and more recently at the museum level, all catalogue and research files were established and maintained by the various curatorial departments and divisions. Collections were often transferred and reorganised and, as a result, many of the objects became separated and disassociated from their documentation, as well as from other references to related records.

Records documenting National Museum of American History holdings can be found in the files of the Smithsonian Archives, the National Museum of Natural History, the National Museum of American Art, and the Smithsonian's Conservation Analytical Laboratory, as well as in the Museum's own 21 collecting units and its Office of the Registrar, Division of Conservation, and various public programme offices. Each record system has its own structure, vocabulary, and standards — or lack thereof. Centralised access to the collections and the information documenting them, although increasingly necessary, therefore has been impossible.

The National Museum of American History was established as a separate Smithsonian museum in 1957; in 1963, it moved into its own building. Almost immediately, the Museum's staff recognised the need for a centralised collections documentation system and a strong collections management programme. Modern standards dictate that a professional collections management programme provide legal and ethical accountability for collections, standards for proper physical care and handling of collections, and accurate and timely documentation of all collections-related activities.

I will concentrate on a discussion of only two areas of the Museum's overall collections management programme: the development of a centralised collections information system and the evolution of the centralised collections management staff structure. An overview of the steps taken towards achieving modern standards in these two areas is given below.

The development of a centralised collections information system

In 1966, a survey was conducted of all curatorial unit files in the National Museum of American History to determine their strengths and weaknesses in terms of their varied purposes. Among these were catalogue files documenting the Museum's holdings, reference files on related objects outside the Museum's own collections, subject area reference files, photographic files and registration files. In addition to surveying the files, staff analysed their content and the indexing methods employed with each. The survey report, submitted in February 1967, noted inconsistent content and format within files, proliferation of numbering systems and card formats, and the lack of a central index to the collections of the Museum.

Following this report, several staff members began to explore issues relating to the cataloguing (or documentation) of museum collections. They determined that a

central cataloguing system would require a uniform approach to the categorisation of collections information. Although uniform, the system would have to accommodate the information needs of curatorial divisions with diverse fields of interest such as the decorative and fine arts, folk culture, history of science and technology, and social and cultural history. The system would have to be flexible and open to modification as knowledge and experience dictated, demands on it expanded, and implementation methods changed.

Under the leadership of Dr Uta C. Merzbach, Curator of Mathematics, and Miss Virginia Beets, the Museum's first Registrar, the Museum Information Retrieval and Documentation System (MIRDS) was developed to serve as such a generalised cataloguing system. MIRDS was designed to meet three major user needs: collections management, general information retrieval and scholarly research. By 1972, hundreds of categories had been defined and organised into the MIRDS Object Data Descriptor list.[2]

These defined categories provide for the recording of data related to object classification, physical description, provenance, associative inferences, related documentation, subject associations and collections management activities. The basic structural design of MIRDS includes provisions for establishing one logical record for each museum object or object group and for annotating each entry with its source and date. In this manner, all information relating to an object or object group is contained in one central record and is therefore available for both management and research needs.

In 1974, the Office of the Registrar initiated the first systematic application of MIRDS with the preparation of initial accessioning data for computerisation. The Honeywell system maintained by the Smithsonian Institution's Office of Computer Services, now the Office of Information Resource Management (Chapter 10), was employed for the creation and regular updating of the resultant collections-related master file using the SELGEM program package.

The Computer Services Center, within the Museum's Office of the Registrar, became the coordination and control point for all entries into the Museum-wide objects database as well as for individual curatorial research projects utilising MIRDS/SELGEM.

In 1978, the United States Congress mandated an inventory of the holdings of the Smithsonian museums. As a result, shelf survey data was added to the National Museum of American History's MIRDS database. At that time, the Museum established a separate Inventory Survey Office to manage the inventory project. Seeking to meet a 1983 deadline, the Survey Office placed tight limits on the nature and volume of data which could be collected for each object or object group during the shelf survey.

The status of the Museum's shelf survey was formally reviewed in 1980 and found to be behind schedule; 40% of the available time had elapsed, but only 15% of the collections had been surveyed. Furthermore, a computerisation backlog of 176 000 survey worksheets existed. Inconsistencies in data recording abounded, and many felt that the information being collected was insufficient for inventory control.

2. Copies of the Museum Information Retrieval and Documentation System handbook may be obtained through the National Museum of American History, Office of the Registrar, Central Catalog.

PROCEDURAL AND POLICY DEVELOPMENTS

As a result of this review, the project was restructured and Francis D. Roche, who served as Collections Manager of several bicentennial exhibits, was appointed Project Manager. New policies and procedures were instituted by the Office of the Director: the Inventory Survey Office, the Computer Services Center, and the curatorial divisions were to work together in defining data requirements and survey schedules; data catagories were to be kept to a minimum, but were to include sufficient information for inventory maintenance.

Thanks to the shelf survey, the Museum now has approximately 1 200 000 computer records with basic, minimal information documenting the Museum's holdings. Associative data is being added to this information, as resources permit. In addition, item-level records are being created from batch records as the use of the collections demands. It is hoped that resources will eventually permit the reconciliation of shelf survey findings with existing, manual files so that objects can be reassociated with their original documentation.

In order to maintain inventory control over its holdings, the Museum realised that it would have to acquire an interactive computer system. In 1981, the Museum began a review of such systems with the assistance of the Smithsonian's Office of Information Resource Management (OIRM). Three primary requirements were defined for the initial installation: timely maintenance of location changes, contemporaneous recording of information documenting newly acquired objects, and timely tracking of certain collection-related activities. A WANG VS system met these requirements; in 1982 a system was installed with 15 workstations. Since then, the WANG VS has been upgraded as use demands, and 142 terminals and microcomputers have been installed.

Two collections-related applications have been developed for the WANG VS system, using MIRDS standards and category definitions.[3] One application allows Museum staff to interactively create batch updates to the SELGEM file. The second, the Local Collections Information System (LCIS), is designed to hold data for newly-acquired items and such collections management activities as accessioning, lending and borrowing, shipping and packing, and movement tracking. Condition reporting, treatment reporting, exhibition management and photography will be added to this system in 1988.

While the Museum is continuing to maintain SELGEM records and develop the LCIS application, it is also working with the OIRM and other Smithsonian museums to arrive at a common data dictionary and a unified data model. These products are intended to be used in developing a Smithsonian-wide Collections Information System (CIS) utilising the IBM/INQUIRE system. National Museum of American History staff participate in such Smithsonian-wide committees as the CIS Steering Committee, Data Dictionary Working Groups and Data Modelling Working Groups.

Over 50 members of the Museum's staff are directly involved in defining data elements and functional requirements, serving as members of museum-wide working groups established for these purposes. In order to achieve an outcome which successfully meets all needs, working group members are drawn from the curatorial, registration, conservation and computer services divisions of the Museum. An in-house CIS Steering Committee collates the results of these working groups into

3. User documentation for these application programs may be obtained through the National Museum of American History, Office of the Registrar, Central Catalog.

reconciled museum documents. The Committee comprises two curators, one museum specialist, one collections management technician and one computer specialist; the Assistant Registrar serves as Committee Chair. All Museum staff have an opportunity to review Committee documents in draft form before they are considered final. In short, the committees and working groups, formed to participate in the design of the CIS and LCIS, serve as examples of the approach taken by the Museum in developing its collections management policies, procedures and systems.

Evolution of the centralised collections management staff structure

In the 1960s, the museum profession in the United States began to recognise that an increased commitment to professional standards was necessary if public trust and confidence in museums was to be maintained. Among the standards that began to be developed were stricter policies governing acquisition, more rigorous legal procedures for documenting museum object transactions, and closer and more regular attention to matters relating to object conservation. The resulting body of principles, practices and new staff positions came to be grouped together in the 1970s under the term 'collections management'. Developments at the National Museum of American History reflected this national trend.

In the late 1960s, the American Association of Museums (AAM) led the move to establish an accreditation programme for museums in the United States. This programme provided a structure for evaluating the policies and practices of individual museums and a peer review system to measure those policies and practices against recognised professional standards. The National Museum of American History supported the development of this programme and therefore it applied for accreditation in 1971. The members of the Accreditation Committee assigned to the Museum submitted their final report in early 1972. In the area of collections management, the Committee recommended that a formal collection policy be developed and enforced and that the Museum work towards eliminating registration and cataloguing backlogs. Following the recommendations of the Accreditation Committee, the Museum took formal steps towards the establishment of a modern collections management programme and thereby became a leader at the Smithsonian Institution in collections management matters.

In 1972, the Office of the Director created a Collections Committee with membership drawn from the curatorial staff. This Committee was asked to develop a series of recommendations for policies and procedures to govern the acquisition, accessioning, deaccessioning, lending and borrowing of the Museum's collections.

In December 1972, the Collections Committee presented a draft document of recommendations to the Director. After review and a final revision, the Museum's first Collection Policy and Procedures statement was adopted; this was in March 1973. This document has been amended and expanded twice, as experience and need have dictated, and is to be revised again in 1988. The Collections Management Policy of the Museum now addresses the management of acquisitions, deaccessions, and loans, as well as addressing issues relating to personal collecting, physical care and control of collections, access to the collections, insurance and risk management, inventories, and the maintenance of records documenting the acquisition, use and disposal of collections.

The role of the Collections Committee has continued to expand since its formation in 1972. Today, the Committee draws its membership from the curatorial staff on a

PROCEDURAL AND POLICY DEVELOPMENTS

rotating basis; the Museum's Registrar, however, serves as a permanent member. The Committee oversees the use of the Museum's acquisition budget and reviews potential acquisitions, deaccessions and loans.

A Collections Management Office, now the Office of the Registrar, was also established in 1972. The task of preparing a plan for the development of such an office was assigned to Miss Virginia Beets, then the Museum's Administrative Officer. The plan which she submitted addressed the management of accessions, loans, insurance, the transportation of objects, the numbering of transactions and objects, object storage, inventory, and the formation of a central catalogue for the Museum's collections. The newly-formed Collections Committee endorsed the establishment of this office, anticipating that it would contribute significantly to improved collections management procedures within the Museum.

In implementing the plan for the creation of an Office of the Registrar, priorities were set which were based upon the Museum's areas of greatest risk. Acquisitions had been effected through 'gentlemen's agreements' and letters of correspondence. No standard contracts existed which consistently outlined the legal terms of these arrangements. Therefore, the first order of business was to develop a Deed of Gift which would formalise donations; such a document was drafted by the Collections Committee and the Office of the Registrar with the assistance of the Smithsonian's Office of General Counsel. Museum-wide use of the Deed of Gift for all donations became mandatory in 1973.

The lending and borrowing of collections had been handled over the years in much the same way as acquisitions. As was typical of museum practice at the time, permanent and indefinite loans had been accepted almost casually by the Museum. In addition, objects were left with curatorial staff for identification, without any receipt being issued which would document their status and the Museum's legal responsibility for them. Correspondence noting the acceptance and transmittal of loans was inconsistent and often imprecise in detailing terms and conditions, if such were mentioned at all. For the most part, correspondence did not mention the responsibilities of the borrower concerning physical care of objects.

In the early 1970s, with the upcoming United States Bicentennial celebrations, the Museum fully expected significant increases in borrowing and lending activities. This expectation drew attention to the lack of an effective programme for the management of such activities and the need to take action in an area which constituted the Museum's greatest risk at the programme level.

An Assistant Registrar, Martha Morris (now Registrar) designed the Museum's Loan Program, including the attendant policies, procedures and forms, in consultation with the Smithsonian's Office of General Counsel and its Office of Grants and Insurance (now the Office of Risk Management). Working with the Office of Grants and Insurance, she initiated a blanket insurance policy for the Museum, a policy which was later expanded to include all of the Smithsonian Institution museums. Use of loan forms in the National Museum of American History became mandatory in 1973. Legal contracts, outlining lender and borrower responsibilities and rights, now governed all loans in which the museum participated. Procedures were instituted to ensure regular and timely renewal of loan contracts and the return of loaned items. In conjunction with this programme, the Office of the Registrar initiated the preparation of periodic damage and loss reports to document the nature and causes of loss and damage to all collections.

By 1974, plans for major Museum exhibits relating to the United States Bicentennial Celebration were in full discussion by committees and individuals. Hundreds of thousands of square feet of museum space were to be converted to house thousands of borrowed objects. The Office of the Registrar received approval to recruit a Museum Specialist and two Museum Technicians to manage the temporary storage areas set aside for these exhibits and to handle all related loan details. This was the first time that the Museum had hired a special collections management staff to support a major exhibit. The scheme worked so well that it is now standard practice for the Museum to assign a Collections Manager to each major exhibit.

The Museum's Accession Program was also initiated by the Office of the Registrar in 1974. In planning that programme, the Registrar had decided that the information supporting it would be automated and that the time was right to begin formal implementation of the Museum's central catalogue. The author of the present paper, who was Registration Specialist at the time, was given the task of establishing acquisition policies, procedures and forms in consultation with the Smithsonian's Office of General Counsel, to ensure the legality of acquisition documentation and accountability for recorded objects. Policies and procedures likewise were instituted to govern the physical care and storage of acquisition and loan documents and their use, by both museum staff and visiting researchers. In addition, standards for the information content of initial acquisition files were set which addressed research as well as management interests.

The Computer Control Center (now called Central Catalog) was established in 1974 as part of the Accession Program. Since its establishment, Central Catalog has coordinated curatorial unit efforts in developing standard terminology, minimal cataloguing standards, and classification structures for the Museum's central collection-related database, where possible and desirable, and has managed the implementation of such standards as a central service to the curatorial and collections management units of the Museum. Central Catalog has also been responsible for drafting the specifications required to develop automated systems which support the maintenance and use of the Museum's collections information and for training the Museum staff in the use of the resultant computer systems.

The Office of the Registrar inaugurated the 'Exhibit Prop' system in 1974 while managing the Bicentennial exhibits. The curatorial staff of the Museum acquired many objects for these exhibits which were not to be accessioned into the permanent collections; curators also wished to postpone decisions concerning certain objects until after the Bicentennial exhibits closed. To provide a mechanism for recording and tracking these items, the Registrar defined a collection status of 'Exhibit Prop'. Items registered with this status were assigned special numbers that linked them to the specific exhibit for which they were collected, and a separate log was kept which listed them all as props.

The Office of the Registrar has expanded the system for designating a non-accession collection status. Since 1975, objects collected as exhibit props, as spare parts for technology collections, as reference collections, for hands-on educational programmes, and as archive and manuscript material, are registered as 'Non-accessioned Acquisitions' and assigned registration numbers which indicate this status. The Museum's Collections Management Policy states the documentation and level of administrative approval required for the acquisition, use and disposal of such objects.

A security proposal which recommended the establishment of a control point for the receiving and shipping of all objects was the next collections management priority to be implemented by the Registrar. The Objects Processing Facility (OPF) opened in 1975 with T. Kenneth Bush as Manager; he proceeded to equip the facility for collections preparation, condition reporting, limited shipping and the receipt of incoming objects. In May 1976, full shipping functions were transferred from the central Registrar to this unit. In 1977, crating and packing demands had increased so greatly that a shop was added for the design and construction of crates. New security measures were introduced in 1977 when OPF assumed responsibility for monitoring all package flow into the Museum's loading dock area. This facility was the first of its kind at the Smithsonian Institution.

In 1976, the Smithsonian's central Office of the Registrar completed the decentralisation and distribution of registration records to the various National museums, thus ending its involvement in the active maintenance of registration records. The Museum received its portion of the files, which document acquisition, accession and completed loan transactions dating from 1958. The Museum's Office of the Registrar established a records complex under the management of the Office's Accession Program to house and administer this manuscript collection. The National Museum of Natural History also received its portion of these post-1957 files, while the files documenting transactions prior to 1958 were transferred to the Smithsonian Archives. The demarkation of 1958 was chosen because that was the year in which the National Museum of American History was established as a separate administrative bureau of the Smithsonian Institution.

Because registration files are never closed and ever dynamic, in January 1988, the Smithsonian Archives began the transfer of pre-1958 records to the respective registration files of the National Museum of Natural History and the National Museum of American History. This transfer re-establishes a central unit of records which document the Museum's acquisition, accession and loan transactions.

The programme areas assigned by the Museum to the Office of the Registrar have continued to expand and increase as the Museum recognises the effectiveness of centralising certain collections management activities. The functions of the Office of the Registrar now include the keeping of central collections records, both manual and automated, management of acquisitions, loans, insurance, damage and loss reporting, shipping and packing, preparation of condition reports, maintenance of security photographs, management of off-site collection storage facilities, management of special exhibits and exhibit staging areas, and coordination of internal audits and inventory control. Besides administering the programmes of the Office, the Registrar also serves as the chief adviser to the Director and to the museum staff on all matters relating to collections management.

Responsibility for the physical conservation of the Museum's collections, however, resides with the Division of Conservation. The Division was established in 1978 by the consolidation of the Musical Instruments shop with the Science and Technology Technical Laboratory. Musical Instruments conservator, J. Scott Odell was appointed Head Conservator and supervisor of this division, the current activities of which include: systematic surveys of the collections, in conjunction with divisional staff, to determine priorities for short and long range conservation needs; conservation examinations, analysis and treatment; advising on proper storage, handling and installation techniques; training of Museum staff in the proper care of

collections; and, in conjunction with curatorial unit staff and the Office of the Registrar, maintenance of the records relating to collections conservation.

Growth of the National Museum of American History in the latter half of the twentieth century led to a periodic reorganisation of the division of labour within the Museum. At present, the curatorial divisions are organised into two general collection departments (the Department of Social and Cultural History and the Department of the History of Science and Technology), each with a chairman, and two National Collections (the National Numismatic Collection and the National Philatelic Collection), each with a director. The collections contained within each department number in the hundreds of thousands, while the National Collections number in the millions.

Over the years, the curator's responsibility shifted from paying direct attention to the care of collections and turned to the scholarly duties of research and publication. The Museum therefore found it necessary to create the position of Collections Manager in order to deal with the complexities inherent in managing and caring for collections of such size. Individuals holding the position of Collections Manager are recognised as having primary responsibility for the proper care and documentation of objects within the collection unit to which they are assigned. The position exists at the department, National Collection, and division levels.

At the department level, Collections Managers are supervised directly by the department chairman. Each serves as the chief collections management adviser in matters pertaining to the department, represents the department in all collections management standing committees, and acts as liaison with the Office of the Registrar. Within each National Collection, the Collections Manager is supervised by the respective Director, serves as the chief collections management adviser for that Collection, and acts as liaison with the Office of the Registrar. At the divisional level, Collections Managers work under the supervision of the curator in charge of their respective divisions and generally have primary responsibility for either overseeing or carrying out proper management of divisional holdings.

New or revised collections management policy and procedure statements may be prepared by any office or unit within the Museum, and all curatorial, collections management, and administrative staff members are asked to review and comment on these proposals from their professional and functional perspectives. In addition, certain standing committees have been established to advise the Office of the Director on specific areas of the Museum's collections management programme; one such, the Collections Committee, has already been discussed. Three others are discussed below.

The *Space Committee* coordinates the allocation and use of space within the Museum's building on the Mall in downtown Washington and in off-site storage and exhibition facilities. The Committee evaluates the impact on the collections of intended uses of museum space, and it attempts to reconcile conflicting schedules for such use. The Committee consists of representatives of the curatorial divisions, the Division of Conservation, the Objects Processing Facility and the Building Manager's Office; the Registrar serves as Committee Chair.

The *Collections Management Steering Committee*, focusing on issues of accountability, sets priorities for use of the Museum's limited collections management resources and for the development of automated collections information systems. Committee members include the Chairman and Collections Managers of the two

PROCEDURAL AND POLICY DEVELOPMENTS

collection departments, the Chief of Computer Services and the Assistant Director for Administration; the Registrar serves as Committee Chair.

The *Storage Committee* sets standards for the construction of collection storage units and has worked with commercial vendors in designing state of the art units to meet the Museum's specific needs. Committee members are drawn from the curatorial units and the Division of Conservation; the Collections Managers of the two collection departments serve as Committee Co-chairs.

In addition to these standing committees, formal and informal working groups are created for limited purposes as the need arises. A Collections Management Policy review group has been formed each time that the Policy required review and revision. Another group has been formed to draft the Museum's first formal collections management handbook. For each computer application developed, requirements groups have provided the information needed to draft technical specifications. Members of these groups have then tested and evaluated the programmes prior to the programmes being placed in actual use. All staff are invited to participate in the working groups; all staff then have an opportunity to review the group's findings and recommendations before they become policy or final documents.

To summarise, the Registrar, the Chairman of the Collections Committee, and the two department Collections Managers oversee the daily collections management activities of the Museum. They each serve on one or more of the Museum's collections management committees and are represented in all working groups. They are usually in daily contact with one another, sharing information and concerns.

Conclusion

The development and implementation of modern collections management policies and systems in the Smithsonian Institution's National Museum of American History, along with concomitant staff adjustments and realignments, took over 20 years and much staff labour to accomplish. Has it been worth it?

The road to implementation and accommodation was a difficult one for the Museum to travel. At the outset, and many times along the way, the curatorial staff was afraid that it would lose its control over the collections, that there would be some sort of interference with its relationships with donors, and that, in short, curatorial competence and general professionalism were being called into question by the new policies and procedures. At the same time, the Registrar's staff faced many difficult challenges whenever the curatorial staff objected to or ignored proposed measures for carrying out new collections management policies. To add to this, the various Directors and Assistant Directors of the Museum who served during this period occasionally asked if the record-keeping systems for tracking objects and for processing registration transactions were really necessary — were they worth the resources and personnel required to set them up and maintain them?

The centralisation of collections management activities and the development of systems to organise and control them have indeed proven to be necessary in a museum such as the National Museum of American History, where the collections are large and are used in a multi-disciplinary manner, that is, across curatorial divisions. Because of this cross-disciplinary pattern of work, the team approach to the development of policies, procedures and systems has been the mechanism by

which modern collections management has finally been achieved. It is the only approach which ensures maximum support of the staff; one-to-one discussions, group meetings, and use of the systems over time have resolved most of the ill feeling and doubts. Although some doubts remain, the mechanism now exists for staff challenges and debates to take place in a constructive manner.

Our systems and procedures reflect our size. Our policies and team approach to collections management are applicable to museums of all sizes.

PROCEDURAL AND POLICY DEVELOPMENTS

20 INTER-RELATIONSHIP OF COLLECTIONS AND RISK MANAGEMENT

TOSHIO YAMAMOTO

This paper presents an overview of collections management as it pertains to the Royal Ontario Museum (ROM) and places it within the context of the existing administrative and computer environment. The inter-relationship between this programme and risk management will then be discussed from a largely operational perspective. This view 'from the trenches' is appropriate as the author is currently serving the ROM as not only the Coordinator of Collections Management, but also as the Acting Head of Conservation and as the institutional Emergency Coordinator.

Architecture has been referred to as the art of blending form and function in the building process. In museum management, a parallel can be seen, in that the organisational or administrative structure of an institution can be regarded as the form and the programmes and operations as the functions. Each should complement the other and the ability of an organisation to meld the administrative and functional components often determines its success in realising its goals. However, the process of finding the appropriate 'mix' is not an easy task. Museum management is a dynamic process which must react to political, economic, technological and public pressures as well as to extraordinary opportunities. Changes in institutional direction or priorities can be accompanied by new policy initiatives and these, in turn, are reflected not only in shifts in associated programmes and operations, but also through the resulting organisational changes, staff restructurings or new appointments.

Similarly, the automation of collections related information into an institutional database can be regarded as having a form component, the system architecture, and a functional one, the applications. In this case, the applications desired should determine the functional specifications. The ability to match these user identified needs with the available hardware and software will likewise be an important factor in achieving stated objectives.

The establishment of a Collections Management unit at the Royal Ontario Museum serves as an example of how changes have come about. The origin of this service group is historically tied to the ROM Renovation and Expansion Project which took place in 1978–81 (see Tanner-Kaplash, 1986).

In preparing for the start of the building project, the Senior Management of the Museum recognised the need for a more systematic approach to the problems associated with the anticipated relocation of the collections and the need for a liaison between the Museum and the Project Director who was involved with the construction process. Consequently, the position of Coordinator of Collections Management (CCM) was created to deal with the management of the extraordinary range of collections related activities imposed by the Project. This position was initially put in place as a term appointment with the incumbent reporting to the Associate Director – Curatorial (ADC). The organisational structure shown in Figure 20.1 illustrates

Fig. 20.1 Royal Ontario Museum organisational chart, June 1986

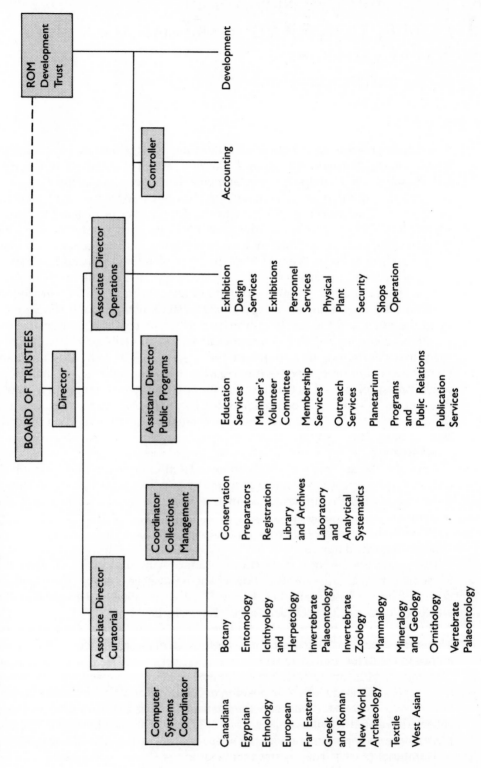

PROCEDURAL AND POLICY DEVELOPMENTS

the placement of this position within the organisation and represents the situation as it was during the latter phases of the building project.

The CCM position was made a permanent part of the institutional organisation at the close of the project and the role of collections management at the ROM was defined in 1982 with the following words contained in the Museum's Statement of Principles and Policies on Ethics and Conduct:

> The Museum recognizes Collections Management as the planned, organized and coordinated effort of the Institution to be accountable, at all times, for the collections it holds with respect to all physical and administrative aspects essential to their well-being. (Royal Ontario Museum, 1982).

The collections management programmes are administered through the office of the CCM. These programmes include the planning and scheduling of collections related activities to ensure the best possible use of resources, upgrading of physical facilities, managing of storage space, monitoring of all aspects of collections safety, developing and maintaining the collections information system — both within the institution and with outside agencies — and developing collections policies and procedures for senior management consideration.

To carry out these tasks, the CCM, who enjoys no line authority, is expected to use the matrix management approach, applying those procedures developed and employed so successfully in carrying out the tasks associated with the Renovation and Expansion Project. The coordination of activities necessary to carry out collections management functions was and is accomplished primarily through the Collections Management Committee whose purpose is to serve as a resource and advisory body to the ADC on all collections related matters. As can be seen from the following list of Committee members, the group represents a broadly based 'project team' whose individual functions are directly or indirectly influenced by collections related activities and programmes:

Coordinator, Collections Management — Chairperson;

Executive Assistant to the ADC;

Administrative Assistant to the ADE;

Head, Conservation;

Head, Preparators;

Head, Registration;

Head, Exhibit Design Services;

Head, Exhibitions;

Head, Outreach Services;

Head, Programs and Public Relations;

Head, Security.

The latest change in Committee composition, the addition of a representative from the Office of the Associate Director — Exhibits (ADE), was made earlier in 1987, in response to a shift in institutional priorities. A new senior management position, Associate Director — Exhibits, was created with the mandate to have, through and under the Director, the ultimate responsibility for and authority over the Gallery Development Project, which is the number one priority of the Museum. This new

Fig. 20.2 Royal Ontario Museum organisational chart, October 1987

BOARD OF TRUSTEES

ROM Development Trust

Director

Associate Director Curatorial

Coordinator Collections Management

Associate Director Public Programs

Assistant Director Administration and Finance

Associate Director Exhibits

Assistant Director Human Resources

Assistant Director Membership and Development

Associate Director Curatorial
- Canadiana
- Egyptian
- Ethnology
- European
- Far Eastern
- Greek and Roman
- New World Archaeology
- Textile
- West Asian
- Botany
- Entomology
- Geology
- Ichthyology and Herpetology
- Invertebrate Palaeontology
- Invertebrate Zoology
- Mammalogy
- Mineralogy
- Ornithology
- Vertebrate Palaeontology

Coordinator Collections Management
- Conservation
- Preparators
- Registration
- Library and Archives
- Laboratory and Analytical Systematics

Associate Director Public Programs
- Education Services
- Outreach Services
- Member's Volunteer Committee
- Planetarium
- Programs and Public Relations
- Publication Services
- Shops Operation

Assistant Director Administration and Finance
- Finance
- Computer Systems
- Physical Plant
- Security

Associate Director Exhibits
- Exhibition Design Services
- Exhibitions

Assistant Director Human Resources
- Personnel Services

Assistant Director Membership and Development
- Development
- Membership Services

appointment, along with the resignation of the Associate Director — Operations, has led to a substantial organisational restructuring (Figure 20.2). Additional changes are even now being considered as the Director has appointed a Structure Review Committee to study the whole organisational system.

The automation of collections related information and the addition of staff to implement the programme also evolved from certain features introduced to manage the move of the ROM objects. During the project, one aspect of the CCM's responsibilities included the task of ensuring that an automated system for main-taining location information for the collections was established and that this system would allow for the maintenance of an audit trail for all art and archaeology objects throughout the period of the project. To aid in this large undertaking, the institution negotiated a grant from the Registration Assistance Program of the National Museums Corporation (NMC). (The NMC has now been devolved and the Canadian Heritage Information Network (CHIN) section is now a part of the Department of Communications (DOC).)

This grant provided the funds to hire three staff members on a temporary basis to assist in the completion of a physical inventory, the retrospective capture of data from the central Registration catalogue cards and the maintenance of the object location information. This infusion of resources allowed for the creation of a database consisting of approximately 350 000 records. These records, although large in numbers, involved only a minimal number of fields as the only application that was being served was that of a location system. The information captured during this period formed the basis for the ongoing development of the Museum's auto-mated collections data system.

In the early 1980s the institution committed itself to the establishment of national databases through the CHIN programme, the retention of the location tracking system, and the continued automation of its collections data. In support of these new objectives, the ROM assumed the costs for retaining the three temporary positions associated with the grant and assigned them permanently to a collections management unit. A programme was then initiated to provide the curatorial and curatorial service departments with access to this centralised body of expertise dedicated to the use of the PARIS system for the capturing and retrieval of collections information. The collections management staff are allocated to departments partici-pating in the CHIN programme on a project basis. With the continued support of CHIN and the internal resources described, the number of departments using the system has increased and the inclusion of full cataloguing information has also expanded the size of individual records. The PARIS system now contains approxi-mately twice the number of records in ten separate databases. Other departments have committed to the programme, but have not yet been assigned space on the PARIS system. While waiting for system access, these departments are proceeding with the capture of their data in a microcomputer environment for subsequent batching to the mainframe.

The gathering and ordering of information, both administrative and object-related, into the centralised computer system currently remains largely within the curatorial and registration areas of responsibility. However, it is recognised within the ROM that actual management of the collections takes place when an information base is queried and action is taken as a result of the answers received. The actions are usually operations that are encountered daily in the management of the collections

and they often result in the generation of additional information that can be regarded as part of the object or institutional history and, as such, should eventually be available either as part of, or by way of, the central database.

Collections management is an integral feature of any loss control system for museums. The efforts of this unit in the area of the physical safety of the institution's holdings will demonstrate its inter-relationship with risk management elements and will also provide examples of some ancillary databases that have been developed at the ROM to aid in the management of the collections. A risk management system usually includes such components as: records, insurance (fine arts, building and liability), claims, incident reporting, risk analysis and inspection, legal, disaster preparedness, fire safety, joint health and safety, security and audit.

The Royal Ontario Museum does not, at present, have a specific policy and procedures document which defines the risk management programme within the building. However, many of the risk related programmes and functions previously listed are in place or are in the process of being developed. For the purposes of this paper, risk management is understood to mean the process whereby an institution identifies and prepares to control inevitable vulnerabilities which could result, directly or indirectly, in a financial loss. The areas of vulnerability include people, property and capital.

In 1980, the CCM requested that the institution create an Emergency Task Force to initiate the process of developing a comprehensive disaster preparedness manual for the ROM. This request was based on the fact that the Museum was in its most vulnerable position due to the large scale movement of the collections and the concurrent renovation activities that were taking place. Due to the pre-occupation of the institution with the building project, the development of the future galleries and the task of fund-raising, the Collections Management Committee was asked to act as an interim emergency planning body and to consider contingency plans only for coping with collections related incidents. The task of identifying risk sources was carried out and a temporary disaster response unit was established with the CCM and the Head of Conservation acting as the interim Emegency Coordinator and Deputy. The procedures developed during this period were put to the test during various incidents that arose and modifications were incorporated as the experience base continued to grow. It became evident that the method for documenting incidents should be expanded to include more than was covered in the existing policy concerning theft, vandalism and damage to the collections.

Consequently, the Security Department, in conjunction with the Collections Management Committee, developed a new incident report form that could be used to cover a wider range of incident types (theft, vandalism, accidental damage, fire, personal injury, illness, mechanical malfunctions and unauthorised access). These reports are filed daily by the Security Officers and copies are distributed to the relevant departments. The CCM receives all such reports along with additional information directly from physical plant, curatorial departments and conservation. This new information has been summarised and loaded into a dBaseIII+ file as have all existing older records from the central incidents file compiled by the registration department. The history and frequency of occurrences of the various categories of incidents are periodically reviewed and reports forwarded to such planning bodies and departments as the Emergency Task Force, Joint Health and Safety Committee, Senior Management, Security, Exhibit Design Services, etc.

This risk analysis tool has been instrumental in the development of a number of preventative programmes and procedures. For instance, the incident history file identified mechanical malfunctions associated with water lines as the primary hazard to the collections. To mitigate any potential water damage to the collections, emergency supplies in the form of rolls of polyethylene sheeting, ducting tape and cutting knives have been distributed throughout the public exhibit areas in mechanical rooms and other service areas. These sources of emergency response supplies are identified by an institutionally recognised logo and the security and physical plant personnel have been instructed in the proper use of these items. Similarly, curatorial departments maintain their own supplies in their collection storage areas. In particularly vulnerable collection storage areas, there is another way to implement preventative actions. The CCM is asked to participate in the allocation of facilities improvement funds and the information from the incidents database is used to justify the needs for substantial physical changes to the storage areas.

Biological agents have always been recognised as a potential source of risk to the collections. Prior to the establishment of the collections management unit, all requests for chemical treatment were channelled through the conservation department which administered the pest control budget. With the installation of the fumigation chambers in the new curatorial centre building, the decision was made to transfer the responsibility and budget for the institutional pest control programme to collections management. Shortly thereafter, a Pest Control Policy and Procedure document was written and accepted by the museum management. One of the statements in this policy emphasised the need for maintaining a history file on chemical treatments not only for the health and safety of staff, especially the object handlers, but also for inclusion in the object files in the PARIS system. To this end, a pest control database was designed to document the organism involved, the pesticide used, the date of application, the location of the infestation, the material treated and the permanent storage location of treated objects. The pattern of certain outbreaks, as indicated by reports generated from this file, have proved useful in determining the sources of the infestations and allowed for the monitoring of the effectiveness of the treatments applied. It has also been used to locate objects treated with specific chemicals so that studies could be carried out to determine whether residual or off-gassing products are present.

Another independent database that has been created as a consequence of the disaster preparedness studies involves an institution-wide chemical inventory. This database identifies all the hazardous chemicals used in the institution and indicates their storage locations. Compiled primarily for health and safety purposes and to comply with provincial legislation, it has also been useful in the development of collection safety procedures in those instances in which the chemical storage area is adjacent to or over a collection space. It should be noted here that the preparation of the complete disaster response manual is nearing completion and that the organisational aspects of the emergency plan have been implemented with the Coordinator of Collections Management designated as the Emergency Coordinator for the ROM.

To date, the specific methods whereby the data in the ROM incidents, chemical inventory and pest control database will be incorporated into or cross-referenced with the central PARIS-based collections information system have not been developed. However, the need to share information generated by collections and risk

management activities is abundantly clear. Collections management is included in any risk management programme and risk assessment principles are applied to all functions associated with the management of the collections. By documenting and maintaining records on actions taken, files will be created and they will become the information base from which future policies and procedures will emanate. In other words, the management of the collections will progress to a more pro-active state.

21 COLLECTIONS MANAGEMENT AT THE AUSTRALIAN NATIONAL GALLERY

MAXINE ESAU

Background

The Australian National Gallery (ANG) was in the fortunate position of being a new institution at a time when many of the mistakes in computer collections management systems had already been made (Sarasan, 1981). What we learnt from other institutions enabled us initially to develop a comprehensive manual collections management system. We were fortunate also in having a Director who supported the policy of a centralised record keeping function within the Registrar's Department.

Chronology

The chronology of the events leading to the computerisation of collections management at the ANG is as follows:

1911

Acquisition of the National Collection commenced. Most of the collection was destined for display in public buildings, in Australia and overseas. Only small numbers of works were involved.

1972

Dramatic increase in the acquisitions programme in preparation for the opening of the Australian National Gallery.

1976

Declaration of the Australian National Gallery Act.

1978

Publication of the Cataloguers' Manual for the Visual Arts, prepared for the Australian Gallery Directors' Council by an Australia-wide committee including ANG staff (Varveris, 1980 and 1986). The committee received guidance and editorial assistance from Teri Varveris who was involved at that time with the Museum Computer Network's Griphos project. The Manual became the basis of cataloguing standards of every art collecting institution in Australia of which I am aware.

1979

The decision was made to enter the catalogue of works of art to a WANG minicomputer and entry commenced in 1980.

1983

It was clear that the system was inadequate for the task and a decision was made to redefine our requirements and to go to tender for a replacement system. The only specifications we issued in our request for tender consisted of user requirements, but our unwritten requirement was that the system should be portable; that the operating system should be widely used by a range of computers from micro to mainframe. Unix and Pick were the obvious operating systems to be considered.

1984

In late 1984, the decision was made to purchase hardware and software from AWA Computers. The software was to be a package (now called IMAGES by the ANG) designed in consultation with the Gallery and implemented in Pick, a computing environment which is particulary suitable for database management and hence for museum systems. (The museum systems using Revelation (Collection, Reformation, the Getty Conservation Information Network) or Prime Information, etc., are Pick-based.)

1985

The hardware was installed in mid 1985. By October 1985, an interim system had been developed using the company's fourth generation language and data was transferred from the existing WANG system. This interim system allowed us improved access to the existing records and data entry of new acquisition data and we were able to analyse the existing data for inconsistencies.

1986

The full accessioning/cataloguing module was being tested by January 1986 and went fully live in March. By the end of 1986, all of the Gallery's collection (the figure now stands at 78 000) had been entered on the computer.

1987

Commissioning of the external movements, loans, locations and finance modules.

Description of systems

IMAGES is implemented on a Sequel minicomputer, with one megabyte of main memory and 560 megabytes of disk storage. It shares the machine with packages which handle accounting, education bookings, the correspondence registry, bookshop and slide library. The hardware currently supports 48 ports and can be expanded to 64 ports. These can be used for either terminals or printers.

The IMAGES System (marketed with AWA Computers under the name GALLERY) uses relational database techniques and consists of a number of functional elements, each of which contributes to the record of a work of art:

accessioning/cataloguing;

locations;

loans;

external movements;

financial reconciliation.

The system has authority control over artist's name, title, source (vendor/donor/lender), origin and subject. Subject is not currently used by us as a retrieval point because we have not located a satisfactory subject heading thesaurus. The Art and Architecture Thesaurus project of the Getty Art History Information Program is of great interest to us.

Vocabulary is also controlled by look-up tables for media category, method of acquisition, country and department of curatorial responsibility. This ensures consistency of data across records, saves storage space in the computer and avoids duplication of data entry.

IMAGES produces receipts and dispatch notes, loan agreements and stock reports of storage location. It also produces checklists of acquisitions for the ANG Annual

Report, and for exhibition. The enquiry language built into Pick, allows extremely flexible reporting and is used to answer enquiries from curators and other staff, from other institutions, and also from the public. In the near future the system will produce labels for record photographs and to identify the works themselves where appropriate.

Structure of the database

The files of records are structured to reflect the hierarchical structure of the collection itself. This applies to the main file containing the cataloguing information and also the file of locations.

There may be a good reason to consider as a single unit a particular collection of works of art. An example is the Felix Man collection of prints and printed material. Within the collection, there are individual prints, portfolios of prints and illustrated books, as well as loose leaves from published material. This structure is represented by three levels in the hierarchy. The collection has the number 1972.509. An individual print in the collection could be represented by 1972.509.256. A portfolio of ten prints could be represented by 1972.509.257.1–10. At a later date, the loose leaves, which are now unrelated individual prints in this collection, can be drawn together into parent-child relationships. Although the accession number will continue to reflect the original status of the work, the hierarchical structure of the records reflects the new relationship. This is an invaluable tool for research.

External movements

The external movements module creates files of Movement Orders and these are linked to the main catalogue files. Receipts and Despatch Notes for works of art are printed.

Loans

The loans module creates a file of institutional incoming and outgoing loans which is linked to a file of loaned items from the main catalogue record. Draft loan agreements are circulated to curatorial and conservation departments for approval before the final forms are printed.

Locations

As with the database itself, the locations system is hierarchical in structure. The system incorporates the concepts of parent and child locations, as well as movable and non-movable locations. For example, the Gallery building is a parent location; the individual display spaces are children. A storeroom is a non-movable child location of the Gallery building and a non-movable parent location of the storage units within that storeroom. A shelf in the storeroom may contain a solander box which holds 50 drawings, and that solander box is a movable child location. If the solander box is moved, then all the drawings within the box are moved as a consequence.

The locations control module includes the facility to use hand-held terminals to take an inventory of store rooms. These terminals can incorporate bar-code readers, and we propose to bar-code locations in the future. The bar-coding of works of art in a collection where 80% of the collection consists of works on paper is obviously unacceptable from a conservation point of view.

Movement and exhibition of works of art

IMAGES addresses the problem of the movement and display of parts of a work of art. It does this by allocating a value to the attributes Exhibit Status and Object Status.

The use of Exhibit Status is relevant to the exhibition of works of art. The record attribute Exhibit Status can take the values Collection, Item or Part, depending on the object's capability of independent exhibition. Functionally, this attribution replaces the ANG's practice of indicating dependence within the accession number.

The use of Object Status is relevant to the movement of works of art. The record attribute Object Status can also take the values Collection, Item and Part. One can move the whole collection, an item from the collection or a part of the item.

These attributes are convenient, because if you move a portfolio, then, of necessity, you have moved all the prints within that portfolio, and all the records will be noted accordingly. A value is assigned, not explicitly but implicitly, for Exhibit Status and for Object Status. By answering the questions about whether the work to which the record refers can be moved or exhibited separately, the correct values are assigned to the attributes.

Financial reconciliation

The finance module allows the works of art to be reconciled to the money we have spent, from Government allocations and other sources.

Conclusion

In this brief overview, I have attempted to describe the innovative aspects of IMAGES rather than given an exhaustive description of the system as a whole. IMAGES has dramatically altered the Registration procedures at the Australian National Gallery and is gaining acceptance throughout the whole institution.

CATALOGUING PROCEDURES AT THE UNIVERSITY GALLERY, MELBOURNE

ANNETTE WELKAMP

Introduction

The University of Melbourne began acquiring artworks over one hundred years ago and the collections have continued to grow steadily by commission, field work, purchase and gift. Independent of the University Gallery, objects are acquired by academic departments, residential colleges, the student union, the library and a number of specialised university museums. The collections are encyclopaedic, emanate from all four corners of the globe, cover many periods in history, and are executed in all possible media.

Records exist for some of the collections, but these are not internally consistent, continuous over a whole collecting period or standardised between collections. For instance, the documentation of departmental artworks has focused on information required for object and field research, while the college collections record information for inventory purposes. It was not until the appointment of the first Curator in 1968 that an attempt was made to centralise the documentation of all of the University's artworks. The end result was the publication of the *Catalogue of Works of Art 1971* (University of Melbourne, 1971), and while this catalogue cannot be considered exhaustive it has provided a very useful starting point for subsequent documentation systems. Maintaining the numerous manual files has been a difficult task given the scope of the collections, the small number of staff involved and the fact that objects are located all over the campus.

The Computer Cataloguing Project

The advent of computerised information retrieval systems promised to alleviate many of these documentation procedure problems, while simultaneously offering new opportunities for accumulating and interpreting the collated information. Investigations into the feasibility of applying a computerised system to the University Art Collections began in 1983, and The University of Melbourne Computer Cataloguing Project was established in 1984. The aim of this project is to catalogue all the art objects in the University's possession and to utilise these records for effective collections management and research. It will eventually encompass all the collections, and is appropriately based under the direction of the University Gallery.

At the time of the appointment of the first Cataloguer, very few visual arts cataloguing projects had been attempted in Australia, although a number of such projects were already in operation overseas. Most art institutions in Australia had established cataloguing procedures, but only the Australian National Gallery in Canberra had a computerised system in place (Chapter 21). The groundwork in this country had been prepared by the Australian Gallery Directors' Council (AGDC) and its publication the *Cataloguers' Manual for the Visual Arts* (Varveris, 1980). This

remains the basic manual for art cataloguing in Australia today, although most institutions make slight modifications to it in order to meet with in-house requirements. This standard reference ensures that the information contained within different databases is consistent even though most institutions are pursuing independent directions in terms of hardware and software configurations.

The University of Melbourne cataloguing project is ideally placed to take advantage of the various fields of expertise and types of services available in a multi-discipline campus. The success of the project has been due partly to the assistance of departments such as Fine Arts, Administrative Systems and Information Services (ASIS), and University Computing Services (UCS). Often these services have been offered free of charge or at a greatly reduced rate.

The Cataloguer is responsible to the Curator of the University Gallery and to the Sub-Committee for the Computerised Catalogue Project which, in turn, is responsible to the Works of Art Committee. The Sub-Committee consists of the Vice-Principal, and representatives from his office, the Professor of Fine Arts, the Chairman of the Department of Fine Arts, the Deputy Director of ASIS, the Curator of the University Gallery, the Curator of the Baillieu Library Print Collection and the Cataloguer. The basic authority for the central recording of all works of art and the establishment of their location, condition, etc., rests on the Vice-Principal's Statute 3.19 under which he is responsible to the University Council and the Vice-Chancellor for all property of the University. The terms of reference for the Sub-Committee are to advise the Vice-Principal on matters related to the Catalogue Project, to make recommendations concerning staffing, accommodation and funding and to ensure that developments in the area of cataloguing artworks are incorporated into the project.

For the first three years, the catalogue system was run on software called GALTERM, which was designed specifically for the project by ASIS. This program was run on one of the University's mainframes, the CYBER 180/830. All records were entered by key punch operators at the University's computer centre thus enabling swift and reasonably accurate processing of large amounts of data. Opting for this solution during the initial stage of the project, rather than choosing independent hardware, not only considerably reduced the cost of purchasing both hardware and software, but also relieved the Cataloguer of the responsibility of undertaking backup of data and overall maintenance, and of ensuring security of the system since this was already undertaken by UCS. However, GALTERM only had online enquiry access which meant the terminal in the Cataloguer's office could only call up information and not enter anything new or make alterations.

The catalogue worksheet

Since the operators were unfamiliar with art terminology and cataloguing standards, the data contained in the worksheets needed to be clearly presented. The catalogue worksheets were based initially on the format recommended by the AGDC and the worksheets being used at the Australian National Gallery. Refinements and adjustments were then made to accommodate the University's special requirements (Figure 22.1). A major consideration in designing the worksheet was that information relevant to all of the different collections could be entered onto a single worksheet. Essential information is recorded in 18 nominated fields but space is also provided for other information which can be recorded at the discretion of the

PROCEDURAL AND POLICY DEVELOPMENTS

Cataloguer. Rules for the completion of all fields were established at the outset but in the interests of the swift completion of a basic working catalogue, lengthy research of individual objects has been avoided at this stage. Completion of fields such as 'Related Works', 'Exhibition History' and 'Subject Matter', for instance, will be undertaken in the future.

For convenience, the worksheet has been designed to take into account the process of physically cataloguing the work. Related fields are grouped together on the form; for example, details gleaned from observation of the object itself are together in group 3, and acquisition details are in group 2. The completed worksheets are also intended to act as backup manual records and a section in the upper right corner allows for a small black and white contact sheet photograph of the object which is taken during cataloguing. This photograph is of suitable quality for quick visual identification and is sufficiently inexpensive to enable every object to be photographed. Location codes have been developed from an existing University system. This consists of three sets of figures which denote building, department and room number.

Practical procedures

It was decided that the most efficient method of cataloguing the collection was to start with the 'easier' objects and then deal with the more 'difficult' pieces. There existed an accessions file in which works had been numbered using a format similar to that of the new system, so these objects were catalogued first. With the new Computer Cataloguing System, only one manual record is maintained, the 'Accessions Register', in which basic information on artist, accession number, title, source and media category is listed by year of accession.

A year of accessions is catalogued in a single batch and once a list of likely locations has been obtained from old records, objects are brought into the Gallery building. Locating objects is a particularly time-consuming part of the procedure. In the past, location records were not maintained consistently for a number of reasons: for example, when individuals and departments moved offices and buildings, works of art were also moved along with all the other pieces of office furniture. Often this occurred without the knowledge of the Gallery staff. An interesting by-product of the Cataloguing Project has been the increased awareness and interest in the art collections by the staff of the University. The Project has been publicised on campus in the University newspapers and in notices circulated to the Deans and Chairmen of Departments advising them of the programme. Departments are notified before objects are collected for cataloguing at the Gallery and relevant forms authorising the movement of the work are completed. Departmental staff are also encouraged to question anyone seen removing art objects, thereby hopefully reducing the incidence of theft.

Works which cannot be located at this stage are noted as 'missing', rather than as 'lost' or 'stolen', because they are usually found at a later stage. Known details of missing objects are taken from the previous records and entered onto the computer.

Works which are difficult to move or too large to travel safely are catalogued on site, as are larger collections in one location. Otherwise all objects are brought into the Gallery. Sometimes two people are needed to move art works and this can be difficult as the staff of the Gallery is small in number, however the use of a small van has eased the problem of moving objects between buildings.

THE UNIVERSITY OF MELBOURNE ART COLLECTION CATALOGUE WORKSHEET

124	ACCESSION NO./LOAN NO.
8	DEPT./COLLECTION
	1 0 STATUS
11	OTHER NO.
15	PREVIOUS NO.
61	PHOTO NO.
18	LOCATION

70	ARTIST/ORIGIN
74	ROLE 2 1 3 BIRTH/DEATH YEARS 2 1 6 SEX
208	ARTIST'S COUNTRY
72	COLLABORATING ARTIST(S) 1 7 2 ROLE(S)
30	TITLE/DESCRIPTION
33	OTHER TITLES
83	DATE OF WORK 8 2 EARLIEST DATE 8 4 LATEST DATE
36	MEDIA CATEGORY
152	SECONDARY CATEGORY

5	CREDIT LINE
3	ACQUISITION INFORMATION
20	METHOD OF ACQUISITION 2 2 DATE ACQUIRED
14	VENDOR
12	DONOR
16	LENDER
6	RESTRICTIONS
7	COPYRIGHT
9	CONFIDENTIAL INFORMATION
	2 4 $ PRICE PAID 2 6 $ INSURANCE VALUE

47	MEDIUM DESCRIPTION

51	SIZE

53	WEIGHT
55	SIGNATURE & DATE

59	EDITION/STATE
57	SECONDARY INSCRIPTIONS

35	CONSTRUCTION OR MANUFACTURE

39	SUBJECT

91	PROVENANCE

85	REMARKS ABOUT ATTRIBUTION/PLACE/DATE/TITLE

99	RELATED WORKS

76	COUNTRY OF OBJECT
78	PLACE OF OBJECT

	ONGOING FIELD(S)

100	INCOMPLETE WORKSHEET

CATALOGUED BY **DATE** **APPROVED**

ACCESSION NO./LOAN NO.	

TERTIARY INSCRIPTIONS

MOUNTING AND FRAMING UNIT

CONDITION

CONSERVATION HISTORY

LOCATION HISTORY

EXHIBITION HISTORY

BIBLIOGRAPHY

REMARKS BY CATALOGUER/CURATOR

When necessary, and possible, works are unframed by the Cataloguer. Numbers are applied directly to the work, accurate measurements are taken, and in some cases important inscriptions on the back of the works are discovered. At this stage, the Cataloguer also notes the condition of the work, and objects which require conservation or further research are brought to the attention of the Curator or the Conservator. When necessary, works are remounted in acid-free card. Some works are retained by the Gallery if they are considered to be too valuable or unstable to be rehung.

The cataloguing of specialist collections, such as those of the Departments of Classics and Middle Eastern Studies, will be undertaken by the academic staff of those departments under the guidance of the Cataloguer to ensure that standard terminology and format is maintained. Other collections which lack substantial documentation will prove much more problematic.

Changes

When the Cataloguing Project was established specific software packages were not yet available; this necessitated the in-house development of GALTERM by the previous Cataloguer, Kay Campbell and Neil Harrington, Deputy Director of ASIS. The international guidelines upon which it was based and the strictness of the control of data input produced a very reliable system capable of fulfilling all of the project's initial expectations. Advancement in computer technology and a re-evaluation of the University's expectations of the Cataloguing Project led to research into whether GALTERM should be updated or replaced with a more sophisticated software program.

GALTERM was limited for a number of reasons. It was written in a third generation language, which made it difficult and time-consuming to modify. The Cataloguer could only make alterations to the system by using programmers at ASIS which slowed the process. The batch input system which was initially an efficient method of entering large quantities of information, proved tedious and time-consuming in the long run because unnecessary errors were made due to the fact that the keypunch operators were unfamiliar with the data. Changes, updates and corrections also had to be put through the batch process. Investigations were made into the feasibility of upgrading GALTERM to the desired level of sophistication, but this proved to be almost as expensive as purchasing a new system.

Coincidently, at this time the Systems Development Group from the Computer Science Department at the University was developing a general database program known as TITAN, and after testing a number of systems, The University of Melbourne Cataloguing Project decided to adopt this software package. Unfortunately, it was not sold with hardware, so the Project had to then test and evaluate a variety of Unix-based hardware options. Expert advice was readily available on campus which made the task of comparing systems and computer companies much easier.

To encourage standardisation between departments, the University has set up the Computer Purchase Advisory Group which considers all proposals for purchasing computers. The Group's terms of reference are to provide technical evaluation and advice regarding proposals for purchasing word processing or computing equipment and software, ensuring that acquisitions conform with University

policies and standards, including those related to occupational health and safety issues. The Group helps those departments purchasing equipment to buy the most appropriate system for their needs, at the correct price and with an acceptable level of support. Under instructions from the Advisory Group the Cataloguing Project was required to ask both the hardware and software companies to rewrite their standard contracts in order to outline more specifically their respective obligations, especially in the area of support. This was to ensure that potential problems with the system would be the obvious responsibility of the company concerned.

TITAN can run on a wide range of hardware, which enables the user to choose the appropriate system from a variety of tenders. A Compaq 386 Model 130 was selected, with two megabytes of memory, 130 megabyte hard disk, 40 megabyte tape streamer, SCO Xenix 386 operating system, and multi-user connections were set up through the Anvil Design's board, STALLION. Facilities have been established for eight connections, but it has the capacity to expand as the need arises. Two portside connections from our computer to GANDALF at the University's computer centre also allows external users to gain access to the databases. These connections will provide direct access for nominated off-campus users to the information in the databases.

As it is envisaged that the databases will be used by a number of people with varying degrees of computer competence, a high priority was, and still is, for a 'user-friendly' system. TITAN enables the database administrator (the Cataloguer) to create the databases, the input and query forms, and the generated reports. Essentially, the system was intended for use by people with no knowledge of programming, but experience has shown that an understanding of Xenix is useful especially in the areas of establishing security and when distinguishing between database and operating system problems. The system can be easily understood after a short period of instruction, however it would require a number of modifications before it could be used by the general public, but this is not currently considered a high priority. The design and attributes of all fields can be altered at any stage which gives the system the flexibility to cope with any changes which may be needed as different types of collections are catalogued. Strict validation controls can be set for appropriate fields and these can be combined with built-in authority lists, thus ensuring that data input will be both swift and accurate. The system also enables global editing and fields of variable and unlimited length can be accommodated. This second feature will be especially useful for enabling large tracts of research to be entered on objects in the departmental study collections. TITAN also has a capacity for a secondary reserve database to be established where information can be held until checked by the Cataloguer before being sent to the primary databases. This facility allows less experienced people, such as new users and volunteer staff, to input information without the danger of corrupting the primary database, and will also allow curators to enter information which can be checked later by the Cataloguer. A single, central administrator will therefore still control the databases but the burden of inputting information can be shared.

Future developments

It is anticipated that a major part of the cataloguing process will be completed by the end of 1989, and that the rate of recording information will be greatly increased by the adoption of the new computer system. TITAN is now managed by an

independent company which is enthusiastic to develop its product and expand into such areas as storing and displaying visuals.

The new system's full capabilities will not be realised for some time, but there is no doubt that it will provide an invaluable resource for both general enquiries and specialist research on The University of Melbourne Art Collection.

PROCEDURAL AND POLICY DEVELOPMENTS

23 COLLECTIONS MANAGEMENT IN THE AUSTRALIAN NATIONAL FILM AND SOUND ARCHIVE

DAVID WATSON

Introduction

The National Film and Sound Archive of Australia was established in 1984 when the Australian Federal Government decided to create an autonomous body with the charter of collecting and preserving Australia's moving image and recorded sound heritage and making it available to the media industries, researchers, educators and the general public.

Although the Archive itself is a relatively young organisation, preservation of Australia's film and sound heritage commenced formally in 1937 with the formation of a small archive as part of the then Commonwealth of Australia National Library. After a chequered career, this archive eventually evolved into the National Film Archive and the Sound Recording Section under the umbrella of the National Library of Australia. For many years, both archives had only meagre monetary and staff resources and it was only in the 1970s, with the rebirth of the Australian film industry, that the film archive and, later the sound archive, attract sustained attention. Growing concern about the future of the film and sound collections led the Government to create the National Film and Sound Archive (NFSA), incorporating both the former film and sound archives of the National Library. Under the NFSA, the National Film Archive has become the Film and Television Branch, whilst the Sound Recording Section is now known as the Sound & Radio Branch.

The NFSA has a very substantial collection in its care, including 500 000 sound recordings and radio programmes, 40 000 films and television programmes (representing about 120 000 cans of film and reels of videotape), 300 000 photographic stills and lobby cards, 30 000 film posters and 75 000 radio, film and television scripts. The NFSA also has extensive collections of newspaper clippings, publicity and promotional material, slides, books, magazines, personal papers, and vintage film, sound, television and radio equipment. In all, the size of the collection is somewhere between one and two million objects. The majority of this material is Australian in origin, but the Archive does have a significant collection of overseas material.

The reason for starting this paper with an overview of the history of the NFSA is that it assists in understanding the variety of collections management experiences that the NFSA has had. It also serves to illustrate the immensity of the task facing the Archive. Another important point is that the Archive is confronted with management of collections that embrace a wide diversity of media, some of which are highly volatile and require special fire precautions. Largely as a by-product of the NFSA's history, the collections management systems range from advanced to non-existent.

A major factor complicating the task of present day collections management has been the priorities of the few staff of the two former archives. Then, the prime focus of staff was on collection building. The attitude can be summed up as follows — 'let's

get the material in before it disintegrates or is destroyed, and we will worry about what we do with it later'. I should add, given the commercial orientation of the media that the Archive deals with, that this has been a not unreasonable strategy.

Another legacy of history is that the film archive of the National Library always had a higher level of resources than its sound archive counterpart. Effectively, this meant that the film archive was able to devote some of its resources to collections management, whilst the sound archive was not able to do so. As a result, a computerised collections management system for the film and television collections has been in place since 1984, whereas, at the other extreme, there is not even a basic manual collections management system for the sound and radio collection.

A further complication for collections management is the NFSA's policy of trying to make its collection as readily available as possible and it is frequently drawn upon as source material for books, films, radio and television programmes. This adds to the complexity of the management problem because objects in archival collections are generally moved more often than objects in most museum collections. Archival objects can be removed from storage for any one of a number of reasons, such as for public exhibition, for broadcast, for viewing or listening by a researcher, for preservation work, and for copying. For a particular object, removal from storage could happen several times a year.

To sum up, the NFSA has inherited large collections, and the degree to which the collections are controlled varies enormously. To make matters worse, the collections have exponential growth potential. Having set the scene, I will now describe what the NFSA has achieved in the field of collections management and what its future plans are.

Current collections management activities in the NFSA

Regarding the Film and Television Branch, there are basically three collections management systems in existence. Firstly, there is a manual system for control of the film documentation collection (this collection comprises primarily paper based materials such as photographic stills, film posters, scripts, and publicity material).[1] This is a very simple system and it consists of a number of card indexes ordered by film title or personality name. Each card has recorded on it whether material is held for each of the various categories of documentation material.

Second, there is the manual system for material that is either film or videotape based. As 90% of this collection is now registered in the computerised collections management system, use of the manual system is being phased out. At the moment, it is used only for nitrate film material. Whenever any preservation action is taken on a particular nitrate film, a new record is created in the computer system and the manual data is transferred.

Third, the major collections management tool for the Film and Television Branch is the computer based system, FLICS (Film Location and Information Control System). Specification and analysis work for FLICS commenced in 1982 and the system went into production in March 1984. Progressively, over the last three years, records from the manual system have been converted to FLICS records.

1. In film and sound archives, the word documentation has special meaning. Documentation is usually taken to mean material that is associated with the production and release of a film. It is generally paper-based.

PROCEDURAL AND POLICY DEVELOPMENTS

The idea for FLICS was conceived because of a perception that the manual record system could no longer cope with the rapid explosion of the Film and Television collection and it was apparent that the collection could only be adequately controlled with a computer system.

FLICS was developed with the following aims:

to control the receipt, accessioning, storage, movement and preservation of Film and Television material;

to enable basic cataloguing of the collection;

to provide information retrieval on the collection.

FLICS uses the database management system ADABAS and the programs are written in the fourth generation programming language NATURAL. FLICS was developed during the days when the Film and Television Branch was part of the National Library. Since the National Library already had ADABAS/NATURAL running on a FACOM M200 mainframe computer, it was deemed appropriate to develop FLICS using these products. Subsequent events have led to the NFSA removing FLICS from the National Library's computer to run the application on a commercial bureau.

FLICS is now installed on a FACOM M380 mainframe computer, and the NFSA pays for all costs at standard bureau charges. Access to FLICS is online, using the Archive's office automation network of 21 Convergent Technologies micro-computers to emulate as IBM 3279 terminals communicating with the FACOM computer via the SNA communications protocol. The size of the database has grown to over 200 megabytes.

Turning to some of the details of FLICS, the fundamental assumption of the data model is the concept of what is sometimes known as the parent/child relationship. There are two types of record in FLICS, the title record (the parent) and the item record (the child). Information that is relevant to describing the film or television programme is keyed into a FLICS title record. Most of the fields stored in the title record concern production credits (for example, Director, Year of Production, Date of Release). Information such as Subject Headings and a Summary is also stored in the title record.

The other way of recording information is the item record. An item record contains information that describes the physical nature of a piece of film or videotape material (for example, a picture negative, a sound negative or a VHS videocassette). Examples of fields stored in an item record include Gauge, Number of Cans, Source of Item, Acquisition Method, Can Size, Sound Track and Technical Description Code. For any one film or television production, there can only be one title record, however, FLICS caters for up to 99 item records for each title. Each title record must have at least one item record and all the item records for any one film/television production are linked to the title record.

All the fields in FLICS are fixed length. FLICs has authority files for both name and subject headings and features extensive online validation. FLICS has facilities for a number of online searches using a variety of parameters. FLICS also issues a number of regular production reports such as sticky labels for affixing to film cans and video-tape reels, receipts for newly acquired material and numerous listings of information.

A major feature of FLICS is its control of the issue of rack numbers for film cans and videotape reels. Since the majority of the collection is not owned by the Archive and

can be removed at any time at the discretion of the depositors of the material, it is important to have a system that permits the reuse of empty space in the storage vaults. For example, if a film that comprises ten cans is permanently removed from a particular storage vault, then the item will be de-accessioned from FLICS. The ten rack numbers that had been assigned to the film will be automatically returned to a pool. FLICS will automatically reassign these rack numbers the next time a ten can film item is accessioned. It will then issue a new set of can labels.

On the whole, FLICS has achieved its aims, some very successfully, some less so. Its main area of success has been in providing better control of the Film and Television collection, bringing about the benefits of considerable savings in staff time and substantial improvements in the accuracy of records. The main area of disappointment has been the inability to use the FLICS database to generate *ad hoc* management information reports. Fundamentally, this is because NATURAL is not as user friendly as it is purported to be. The NFSA does have access to a product called SUPERNATURAL which is user friendly and quite powerful, however, we have discontinued use of this product because it is very resource hungry and, therefore, very expensive to run.

Future collections management developments

As I have mentioned before, there is no collections management system for the Sound and Radio collection (not even a manual one). Planning of a computerised collections management system is currently under way, and the system, tentatively known as SONICS (Sound ONline Information Control System), is scheduled to commence operation in mid-1988. As an adjunct to this, a programme to capture basic collection information will commence. How long it will take to complete is anybody's guess, but it could well be several years before SONICS is as complete as FLICS currently is.

The need for a collections management system for the Sound and Radio collection, together with the spiralling costs of running FLICS on a computer bureau, has acted as a catalyst for a rethinking of the NFSA's use of computers for collections management. A further spur has been provided by the inflexibility of ADABAS/NATURAL as a system development and information retrieval tool. The NFSA does not have its own data processing department and has to rely on external consultants for programming services and we have discovered that whenever we want to enhance FLICS, the cost is very high. Even a simple change like expanding the length of a field can cost several hundred dollars.

The NFSA has also set itself the corporate objective of having compatibility across all current and future computer systems. The ultimate goal is to provide an environment where an outside user can retrieve information on our collection holdings using one enquiry procedure without having to know how to interrogate different databases. For example, if a researcher wants to know what we hold on the current Australian Prime Minister, Bob Hawke, the result of the enquiry procedure would be a list of all Film and Television holdings, any photographic stills, and all radio broadcasts which feature Bob Hawke. The fact that the data would be held in two databases would be transparent to the user.

Obviously to achieve this goal is going to mean a lot of hard work and a deal of compromising between the ideals of the Film and Television and Sound and Radio Branches, for although a lot of the data in each database can be stored quite

independently of the other, there is still a need for compatibility on major access points such as names and subjects. Currently, it is planned to use one Archive wide thesaurus for names and another Archive wide thesaurus for subjects.

One way of achieving this goal would have been to develop SONICS using ADABAS/NATURAL. Having already decided that continuation of FLICS on the bureau was too expensive, the only option left would have been to buy our own minicomputer and run the systems in-house. This option was ruled out because the cost of enhancing FLICS and developing SONICS from scratch under ADABAS/NATURAL would be prohibitive. Another drawback is that it is a package that requires considerable expertise to support it. ADABAS/NATURAL is good software if you intend to support a large network, operate a heavy load of transactions and maintain very large databases. As the NFSA has none of these requirements and cannot afford the luxury of a full-time database administrator, it was decided to look for a database management system that would have greater flexibility, better built-in functionally, was less expensive to maintain and was sufficiently easy to use so that end users could perform their own information retrieval.

The NFSA decided, after a survey of the market, that it would adopt the relational database management system ORACLE for all new development work. ORACLE meets all of the criteria I have outlined in the previous paragraph. It is also the second most popular database management system in Australia (excluding microcomputer packages). In Canberra alone, there are ten ORACLE sites. The significance of this is that it means that when we wish to engage contract programmers for system development work, there will be a pool of experienced personnel available. This is a very important point for a small organisation as it is very dangerous to become dependent on a supplier who has a small customer base. What do you do if the supplier goes out of business? With ORACLE, we have a feeling of security: there is little prospect that the product will disappear from the market.

As well as undertaking the development of the SONICS application, it is planned to convert FLICS from ADABAS/NATURAL to ORACLE. As part of the conversion process, a number of modifications to FLICS are planned. The scope of FLICS will also be expanded to incorporate information on film documentation material.

To support ORACLE, we have selected the Unix operating system, and have acquired a Sequent B8 minicomputer which will be operational in January 1988. The prime reason for choosing the Sequent is its ability to interface with the network of Convergent Technologies microcomputers. This will enable information from databases resident on the minicomputer to be transferred down to the microcomputers. The information can then be manipulated using the word processing, spreadsheet, and desktop publishing software that is available on the network.

Conclusion

The NFSA is well placed for a very exciting future. As a relative newcomer to the field of computerised collections management systems, the NFSA has been fortunate to benefit from the experiences of other institutions. We have also profited from our history and the experience we have accumulated. The Archive has a firm set of corporate objectives and has devised a strategy to achieve them and the next few years promise to be very hectic, but potentially very rewarding.

TRAINING AND ADVISORY DEVELOPMENTS

24

TRAINING AND ADVISORY DEVELOPMENTS
PROFESSOR BRIAN MORRIS

It is surprising, enlightening, and — in the deepest analysis — profoundly reassuring, to find that the problems and perils of training for the museum profession in all its aspects are much the same from one side of the world to the other. When Jeanne Hogenboom states laconically that 'Courses on museum documentation are not uncommon in the Netherlands', the British reader may feel a pang of envy until it is realised what goes on in the UK at the University of Leicester and elsewhere. British methods may be different from Dutch, but the same needs are perceived, and steps are taken to meet them.

Mutatis mutandis the picture is the same in Toronto and in Australia, though obviously, circumstances do alter cases. John Hodge comments wryly on the problems of museum documentation training in an island the size of Australia. Few who were present will forget the opening of his address, when he attempted to 'put Australia into its proper context with relation to size and population dispersal' by superimposing an outline of the British Isles on to an outline of Australia. One of the sharpest illuminations he provided was that the problems of a continent (it is no less) divided into six virtually autonomous States and two Territories are difficult to comprehend in a tight little island off the coast of Europe, with a population of more than 60 million crammed closely together. Yet, strangely, the perceived needs for training in collections management show striking similarities. And progress in Australia has been as uneven as it has been elsewhere. Hodges' rather rueful comment 'So apart from training provided in Museum Studies departments, the training for registrars and collections managers, etc, takes place usually in an *ad hoc* kind of way within the individual museums . . .' could have been made in Britain as easily.

Christopher Newbery, outlining the proposals of the Hale Report, prepared for the Museums and Galleries Commission, painted a picture of what a fully-fledged training programme could look like. It would provide a comprehensive preparation for professional work, and would be based on the sound educational principle of 'continuing education' or 'l'education permanente', which assumes regular and necessary updating of knowledge and skills throughout a professional career. If the recommendations of the Hale Report are fully accepted by Her Majesty's Government, Britain will be in the forefront of museum training and will provide a framework and a basis on which others can build and improve.

The theoretical approach of Geoffrey Lewis, impressive in its weight and depth of experience, was wonderfully complemented by the presentation which Joanne Neri gave of her personal experience of training at the Center for Museum Studies of John F Kennedy University. Suddenly, the theory and the practice coalesced, and one could see how conceptual planning actually produced skilled, sensitive and informed practitioners. It gave a glimpse of the way ahead, and it cheered everyone up marvellously, even though, as John Hodge pointed out, 'We still have a long way to go'.

25 ON THE ROAD AGAIN: THE PROVISION OF DOCUMENTATION ADVICE AND TRAINING BY THE MUSEUM DOCUMENTATION ASSOCIATION

STUART HOLM

If anyone is wondering why I chose 'On the Road Again' as the main title for this contribution, then they have obviously never tried to contact me by telephone or else they have been very lucky to find me at my desk. 'Trains and boats and planes' would have been an equally apt song title to adopt since I regularly use all these forms of transport to reach the museums I visit in the course of my work. You will gather from this that I spend a lot of my time travelling the length and breadth of the British Isles. The reason for all this frenetic activity is that some 3000 or so museums — virtually all of which have inadequate documentation — are served by just one Museum Documentation Association (MDA) Advisory Officer — me.

Development of MDA's advisory and training role

Before examining what I do, whether on the road or at my desk, it is necessary to look briefly at the origins and development of MDA advisory services, as this may help to explain the current position. The MDA grew out of IRGMA (the Information Retrieval Group of the Museums Association) and the Sedgwick Museum computerisation project. These ran in parallel with close co-operation between the mid 1960s and 70s. Their work led to the development of what has now become the MDA Data Standard. Towards the end of this period manual record cards, based on this standard, were given field trials and then, after modification, released for general use. These cards represented a major advance on the then current practice but, because they were designed to cope with the potentially complex nature of museum data, they embodied concepts not readily understood by curators, who had seldom given enough thought to their records to realise that the simple catalogue cards that they had previously used were, perhaps, inadequate for their true needs.

Consequently an education programme was needed: to explain what the IRGMA system was, and then, for those museums which recognised its value and decided to adopt it, to provide detailed instruction in the use of the cards. Thus the role of Documentation Advisor came into being. Initially, Andrew Roberts undertook this work in addition to other duties. With the formation of the MDA and more widespread adoption of MDA cards, the need for advice grew apace and the task of providing it was shared between a small staff of MDA officers, all of whom had other responsibilities. In time new components, such as object control (entry, transfer of title and exit) forms, were added to the MDA system. These also had to be explained to the museum profession. Gradually the MDA advisory role shifted to extend beyond the cards and forms, to providing a more thorough service covering all aspects of museum documentation. One staff member, my predecessor Jennifer

Stewart, increasingly took more advisory responsibility from colleagues who concentrated on other aspects of MDA work.

Due to the way in which funding arrangements had been worked out at the formation of MDA, there was an obligation to provide free half-day advisory visits to Area Museum Council (AMC) member museums who were contemplating system change and the possible adoption of MDA standards. This established the tradition of free advisory visits which has become an important feature of the MDA service, a feature that I hope can continue and indeed expand. National museums which financially supported the MDA were entitled to more substantial free advice. Formal training seminars were also arranged, usually in association with AMCs. As our funding arrangements have become more centralised, so the provision of services is gradually becoming less tied to AMC boundaries and a substantial review of the provision of training and advice is perhaps now due.

In February 1985, I took on the mantle of Advisory Officer. My background was that of a curator with about 14 years service in various local history museums. I believe that this curatorial experience has helped make my advice more readily accepted by the museum community. Although some of my MDA colleagues have probably forgotten more about documentation than I shall ever learn, I do have that special affinity with our clients. I have actually suffered the pain and frustration of curatorship!

Current services

In the case of training seminars, 'Basic principles of documentation' is a consistently popular topic, with 'Computer awareness' courses being increasingly well supported. The latter may become less significant as a new generation of computer literate entrants join the museum profession, but at present these courses fulfill a valuable function overcoming the fear of computers which is prevalent in some sections of the museum community. A very productive relationship has been established with organisations such as Microsystems Centres who have computing facilities and expertise which complement that of MDA staff. Other subjects such as terminology control, storage documentation, etc., are covered less frequently, more through lack of time than lack of demand. There are, however, many variations on the basic themes, each seminar being tailored to the particular needs of the market it is intended to serve.

In the more specific system related field, MDA card use continues to be a popular seminar subject despite the arrival of the microcomputer, but the provision of training in the use of the MODES computer package is becoming increasingly important. In 1988 it is envisaged that demand for training in the use of other computerised systems such as the proposed TINmus museum database package and the Conservation Information Network system will result in a considerable expansion of the MDA training programme.

Documentation training seminars were traditionally provided through the AMC's, but it is anticipated that courses will increasingly be organised centrally by MDA. This will allow greater flexibility and control, particularly in the case of more specialised courses, and experience shows that curators will cross AMC boundaries to attend relevant courses. The MDA will, however, continue to co-operate closely with the Councils to provide the services which AMC's and their members require.

MDA makes a modest input to university museum studies courses and the residential courses organised as part of in-service training leading to the Museums Diploma. On the whole, we feel that more weight needs to be given to documentation on these courses. However, we recognise that formal pre-entry or in-service training should be supplemented by additional training seminars outside the formal museum studies framework.

A recent and developing area of MDA training activity is the provision of specifically tailored in-house seminars for individual documentation teams set up under Manpower Services Commission (MSC) Community Programmes. The availability of a training element within the budget for such schemes permits MDA to offer courses of benefit both to the trainees and the employing museum. We have also recently begun to train AMC field officers and other support staff who, though not usually providing specific documentation advice, need a basic understanding of current practice in order to identify problems for referral to MDA or to provide basic on-the-spot remedial advice.

During 1987, I shall give, or made a contribution to, 30 days of training seminars. This, combined with 29 days of training in the use of the MODES computer program given by a colleague, probably makes MDA the most significant museum training agency outside the university museum studies courses.

On the advisory side, MDA continues at present to offer free half-day advisory visits to museums contemplating a major review of their documentation. Increasingly such visits are prompted by plans to introduce microcomputers. As demand for advisory visits grows, the cost effectiveness of visiting individual museums is increasingly called into question. If the rising demand is not matched by extra advisory staff then sadly the free advisory visit may become an unjustifiable luxury. At present about 50 museums are visited each year. The distribution is somewhat patchy, the greatest demand coming from the South East. This probably reflects the fact that about one third of all museums are situated in this area and that the Area Museums Service for South Eastern England employs a number of field officers who identify problems and refer them to the MDA. In other regions, AMC staff give more direct support and there are fewer new museums requiring initial advice.

An occasional variation of the individual advisory visits is the group 'clinic' where a number of museums with similar documentation needs come together for shared problem-solving sessions. This can sometimes become something of a group therapy session in which I help participants to find their own solutions to mutual problems. Even when participants come from widely differing museums and disciplines their documentation problems can be very similar, making this an effective technique and one which we may increasingly exploit as pressure on the service continues.

From time to time MDA provides in-depth consultancy reports for individual museums. Since this demands the committment of substantial amounts of time, it would prove disruptive to my routine advisory work and is consequently usually undertaken by colleagues, although I normally carry out one or two such projects each year.

In addition to going out to meet museum staff, I receive a substantial volume of written and telephone enquiries. Some require individual responses but where possible I try to produce standard replies in the form of information sheets or notes which can be used again in future to efficiently answer similar enquiries. This is seen

TRAINING AND ADVISORY DEVELOPMENTS

as another cost-effective response to the demand for advice and could usefully be expanded in future.

Apart from training and advising museum staff, I also provide an input into the work of MDA colleagues who are producing publications, developing manual and computerised systems, etc. In this way I can represent the views of the museum staff with whom I am in regular contact and can feed back their ideas and needs into the work of the MDA.

Finally, I see myself as having a public relations role in view of my high profile within the museum community. I find MDA policies, products and activities are sometimes misunderstood within the profession and myths, prejudices and popular misconceptions about MDA need to be overcome.

Relationships with other agencies

MDA is not working in isolation. We are not the only agency working in the field of documentation, nor should documentation be divorced from the wider field of museum activity. We aim to provide a service which supports good museum management and collections management, not viewing documentation as an end in itself.

I try to work closely with the AMCs. They, perhaps more than anyone, can help to put documentation into perspective since they have an across the board interest in improving museum practice and must often decide on priorities when distributing limited grant aid resources. Most Councils are strongly committed to improving documentation and represent powerful allies in the campaign to raise standards. Being in close contact with member museums they are well placed to detect problems and refer museums to us for assistance where necessary. They can also help publicise other services offered by MDA such as seminars, etc. AMC officers may also be able to provide basic documentation advice more cost-effectively than central MDA advisory staff and to this end training has recently been provided for AMC field officers to help them identify, and where appropriate deal with, documentation problems.

In addition to working with the AMC's, I provide some teaching input on the various university museum studies courses. If the appropriate recommendation in the Hale Report (Museums and Galleries Commission, 1987) is accepted, MDA's input will be extended to include advising on course content in the field of documentation. Other bodies with whom I liaise in the course of my advisory and training work include the Museums Association, the various Collections Research Units, specialist curatorial groups, archivists, documentation experts in other countries and independent advisory and training consultants.

Naturally I cooperate closely with MDA colleagues with, in my view, highly beneficial results. However, it has been suggested that I cannot provide unbiased advice whilst employed by an organisation which itself supplies documentation systems and services. I hope, however, that my advice is as objective as possible. Inevitably I often recommend MDA systems since these would not have been developed in the first place if adequate alternatives were available from other sources. Any bias which may creep in due to my greater familiarity with MDA systems is equally likely to effect an independent consultant who would inevitably get to know one system better than others, and is more than outweighed by the benefits of being able to both learn from and influence the research and development work of MDA colleagues.

Audiences for advice and education

Having considered what I do and with whom I liaise in providing these services, I shall now outline the types of client I serve. Many of the museums recently supported by MDA advice and training lie within the category of new small local history museums of the type which are springing up at the rate of one every few weeks. Another major group is that of the more established museum which is now contemplating computerisation. Many museums in both categories are from the independent sector and are often run by volunteers, and it is encouraging to find that they are increasingly seeing documentation as a priority and are anxious to work to professional standards. The influence of the AMC's is obviously being felt here. An increasing number of MSC Community Programme workers are attending MDA training seminars and several specially tailored in-house courses have been arranged for museums setting up large MSC documentation teams. These have been most effective in ensuring that those projects got off to a good start. The basic computer awareness courses have attracted experienced curators who feel intimidated by computers and need to gain confidence in this area so that they can communicate effectively with computing colleagues, suppliers, etc.

Advisory visits sometimes serve to give more experienced curators reassurance that the strategy they propose is indeed viable and a good approach. Less experienced curators may need much more guidance, with it usually being desirable for them to have attended a basic training seminar before seeking a personal visit. One AMC is increasingly requesting that I visit applicants seeking grant-aid for documentation projects. Allocation of grant is conditional on a favourable report on the proposal. This should help to ensure that grant-aid is used effectively, but increases the burden on the already overstretched advisory service.

The explosion of microcomputer use triggered by the availability of powerful microcomputers at low prices has placed a considerable extra burden on the advisory service. I frequently find myself acting in the role of 'interpreter' explaining museum needs to consultants, suppliers or council computer experts who speak a jargon-laden language ill-understood by the average 'computer illiterate' curator. I believe this to be a particularly productive area which could be expanded. If free visits cannot be sustained, museums might profitably involve MDA in this kind of dialogue on a consultancy basis since substantial economies can be made by avoiding wasted time or, worse still, unwise investment in unsuitable systems.

▨▨▨▨▨ Effectiveness of the current service

A failing of the current approach is that the service is purely reactive, responding to those who request help rather than identifying those who most need support and seeking more cost-effective ways of helping as many museums as possible. All the while I am chasing around the country I have little chance to consider better ways of serving the whole museum community and so a period of reflection and re-assessment is proposed for the new year, leading to the formulation of a revised advice and training strategy for 1988–89.

Several delegates remarked, particularly during the pre-conference study tours, on the amount of 're-invention of the wheel' which they have noticed in UK museum computerisation. There is a feeling that this duplication of effort should not be occurring in a country which has a central documentation advisory body. Certainly it

TRAINING AND ADVISORY DEVELOPMENTS

is ironic if effort is being expended on dead-end computer systems when it could be spent on the development of standardised national systems. It must be understood, however, that MDA acts in a purely advisory capacity and not all museums support our approach or are prepared to wait for the ideal solution. If free enterprise were stifled some valuable pioneering systems would never have appeared. There is, however, an undoubted need to strengthen our information service so that even if we cannot ourselves provide solutions for a particular museum, we can refer them to others who have already solved similar problems or would be willing to co-operate to seek a solution. In this way unproductive duplication of effort might be avoided.

Another area which I neglect at present is that of following up visits and seminars. I feel certain that many curators would find regular return visits during a period of system change beneficial, but this cannot be supported with present staffing levels.

The future

Without pre-judging the re-assessment which will be undertaken in 1988, it is clear that more advice and training staff will be required if real progress is to be made. The Commission has recently conducted a review of our operations (Museums and Galleries Commission, 1986) and has proposed changes to our management structure which should allow the museum community more direct involvement in policy making. Encouragingly, the MGC has supported proposals from ourselves (Roberts, 1986a) and some of the AMCs to appoint locally based field advisors in the regions. It is considered that extra staff combined with a review of the way in which the training and advisory service currently operates, would lead to much more effective documentation support for the museum community.

I should like to end by briefly outlining some of my personal hopes and aspirations for the MDA support service of the future. In the field of training I would like to see an increase in the number of documentation seminars provided, covering more topics and reaching a wider audience. New topics might include describing objects, movement and location control, retrospective documentation, management of system change, etc. Seminars could be largely self-financing, although many museums have not yet appreciated the true value of training and spend curatorial time making mistakes rather than paying to educate their workforce properly. Other training agencies perpetuate the devaluing of education by offering courses at fees which barely cover the cost of tea and biscuits. Whilst the speakers are in many cases of the highest quality they must give their time voluntarily or their services must be paid for by their employers. In the documentation world this cannot be supported on a regular basis. Undoubtedly, some genuinely impoverished museums or individuals would need financial help if documentation training was realistically priced, but this might best be given in the form of AMC bursaries to genuine worthy causes rather than cut-price training for all. Only by realistic pricing can we offer the quality of instruction, venue and equipment that the subject deserves.

I would welcome a corresponding increase in the proportion of time devoted to documentation on university postgraduate museum studies courses. I appreciate that a vast curriculum must be squeezed into the limited time available but just because curators have to be 'jack of all trades' does not mean they can master documentation any more quickly than, say, a librarian who spends far more time on the subject. Perhaps there is a case for extending the length of museum studies courses.

I envisage future seminars being complemented by distance learning packages using tape/slide, video, computer aided learning and correspondence course techniques. We also need to revise existing MDA publications and extend the range of titles available, both by writing new works and commissioning them from others.

I believe we must set up better practical teaching resources at MDA, in the regions and at those universities offering museum studies courses. I look forward to using demonstration systems using real data accessible through a variety of manual and computerised techniques so that students can gain practical comparative hands-on experience of various approaches to documentation. I would also like to see certain museums whose documentation systems are reaching a satisfactory standard regarded as 'centres of excellence' which can serve as a model for other local curators.

I also hope that the Hale Report proposal for locum curators will be accepted. Just as pre-entry training justifies more time than it is allocated at present, so in-service training requires curators to attend more than the one or two days they can manage at present. A locum facility which freed staff in small museums for longer periods would be invaluable.

On the advisory side, I hope that greatly improved information resources will be available in future. To achieve this museums might have to complete yearly questionnaires similar to that successfully circulated to museums in the South East last year. A proportion of advisory staff time would be absorbed processing the results but the data would be an invaluable resource, identifying areas of maximum need, allowing referral of enquiries to local museums with similar problems, etc. This resource would be even more useful if it included more comparative evaluations of hardware, software and manual system components than we can undertake at present.

I hope that, despite pressures to cut back, the advisory visit programme can be extended, possibly concentrating on group 'clinics' to increase the number of museums served. I would also wish to see regular follow up visits being undertaken to monitor progress and reassess strategies in the light of experience. Brief advisory visits need, in my view, to be followed more often by thorough consultancy work. Underfunded museums need to be persuaded of the cost benefits of spending substantial sums on consultancy reports.

In addition to advice, many of the more isolated curators in small museums would benefit from more practical support. If MDA advisors could be seconded to such museums for a short period to devise and commission new documentation schemes, with regular follow-up visits to monitor performance, this would benefit both the museums and the advisors who would remain more closely in touch with the practicalities of documentation work than I have been able to since I left mainstream curatorship. Another resource which could be developed if museums had the requisite funding to support it, would be the creation of specialist teams of peripatetic documentation experts who would be invaluable for tackling large backlogs. As a result of various MSC programmes, such teams already exist but the continued availability of 'free' (though untrained) MSC labour ensures that the trained teams are unlikely to find further employment.

Finally, I should like to see further exploitation of the documentation expertise which exists within other bodies such as the AMCs, curatorial groups, etc., and I hope we can develop our already productive relationships.

26

THE IMC FOUNDATION'S
ADVISORY AND TRAINING ACTIVITIES
FOR DUTCH MUSEUMS

JEANNE HOGENBOOM

At the beginning of 1987, MARDOC 'transformed' into Stichting IMC. In this paper, I will explain why this happened and Stichting IMC's role in the Dutch museum field. IMC's advisory work and training plans will also be described.

The MARDOC project

The MARDOC (MARitime DOCumentation) project started in 1970 as one person's research on maritime documentation methods. The five main Dutch maritime museums had taken the initiative to start this project. At an early stage, great attention was given to the Museum Documentation Association's (MDA) activities in the UK. For testing purposes, some 1500 records of ship models and marine paintings were processed by the MDA. A Dutch manual including a list of terminology was published for pictorial collections, based on the MDA Pictorial Representation Card. By 1982 the employee of MARDOC, Jan P. van de Voort, had become a general adviser on museum documentation, going far beyond the maritime aspect. More staff were needed and both an art historian and an automation specialist joined MARDOC. The staff increased up to the eight employees that are working for the foundation nowadays.

During the last five years, MARDOC took part in the development of a lot of small, but also some major automation projects within Dutch museums (van de Voort, 1986). The major projects were carried out for: the Jewish History Museum at Amsterdam, the Netherlands Office for Fine Arts at The Hague, the Museum for Ethnology and the Maritime Museum 'Prins Hendrik' at Rotterdam. So up to 1986, MARDOC built up a lot of expertise on: database design and construction, thesaurus construction, data entry, laservision discs, special courses on the use of software packages and online public access catalogues. This included both PC's and mini-computers being used for the information on various kinds of collections.

From MARDOC to Stichting IMC

However, 1986 turned out to be a troublesome year for the MARDOC foundation, which until then had been fully subsidised by the Dutch Ministry of Culture. As in many other countries, funds are getting harder to find. This problem was felt in the Dutch museums field in many ways. The Netherlands Open Air Museum at Arnhem, for instance, which is owned by the national government, was told to find its own funds. This caused a lot of commotion and protest among the Dutch people and the Minister thereupon agreed to go on financing this museum: but only partly. The museum is now looking for solutions to its financial problems.

Fig. 26.1 In 1987 MARDOC changed its name into Stichting IMC

The MARDOC foundation was approached in a somewhat similar way. After long and difficult negotiations with the Ministry of Culture, an arrangement was reached that might give the IMC/MARDOC-foundation a chance to survive. The next three years will show a decrease in support from the national government. After that the annual budget will be subsidised only for 20–25%. Due to this prospect the MARDOC foundation had to change its attitude towards the museums field and from 1987 onwards payment was asked for several services.

Besides that the foundation's staff was advising more and more organisations that are not museums, but do have to manage a cultural collection. Such organisations are archives, libraries and documentation institutions.

Neither the name nor the organisational structure of the MARDOC foundation any longer reflected these changes. So a new, semi-self supporting organisation was founded under the name 'Dutch Institute for automated Information in Museums and other Cultural institutions', the abbreviated name being Stichting (foundation) IMC (Figure 26.1).

Stichting IMC and Dutch museums

In the Netherlands there are some 700 museums. There are small specialised ones such as the Barometer Museum, but also large ones with several major collections. Some of these museums are owned by the national government, some by provincial or local government and some others by private foundations. The level of automation is also very inconsistent. This diversity, combined with a general opposition against centralisation, causes the Stichting IMC to approach the Dutch museums individually.

However, the annual fund by the Ministry of Culture is supposed to pay for several activities by IMC that will serve *all* Dutch museums. These are activities such as: take part in working groups, attend conferences and report about it, give lectures, issue a newsletter, give basic training, do research on and evaluate both documentation techniques and hardware and software developments, do research on thesauri and classifications. Special activities by IMC, that serve only an individual museum's purpose (such as database design and automation planning) will have to be paid for; while non-museums have to pay for all IMC activities. One of the problems that appear is that the Dutch museums are hardly used to pay for services like the IMC's, since only a very small budget is usually available for documentation. (Still, the IMC is not at all as expensive as a purely commercial organisation would have to be.)

Advisory work

The main income of Stichting IMC in 1987 came from paid advice on: automation plans, purchase of software and hardware, database design and database construction. The pattern the advice follows is dependent on the situation in each museum, but a general outline can be recognised.

The first step is a briefing meeting without costs for the museum. This meeting is necessary to get enough information to be able to make the museum an offer, dealing with the costs to set up an automation plan, and — sometimes — to make an estimation on the software and hardware costs the museum will probably have to deal with. This financial scheme is quite often used by museums for fund raising.

Once the offer is accepted, interviews are held with relevant staff-members and a closer look is taken at the existing documentation. The main goal of this is to find out what problems there are and what the museum finally wants to achieve through automation. The result of this analysis is a report that is used as the basis for further steps and therefore has to be agreed upon formally by the museum. Now a database design can be drafted and selective criteria for software and hardware are listed.

The next part of the project is more variable. The Stichting IMC might assist the museum on the purchase or implementation of the system and very probably some adaption is needed of the standard software that is rarely designed for practical museum use. The Stichting IMC either carries out these adaptions itself or assists the software house.

Once the system is ready, IMC mostly finishes its task by instructing the museum staff. Some museums call upon Stichting IMC for further assistance, while others seem to be able to handle the automation of their documentation quite well by themselves.

Training in the Netherlands

Courses on museum documentation are not uncommon in the Netherlands.

SIMIN is the section for information specialists within the Dutch Museum Association and can be regarded as the national equivalent of the International Committee of Documentation, CIDOC. When, in May 1987, SIMIN celebrated its tenth anniversary it could proudly look back upon several achievements: a general handbook on collection registration and information retrieval was published in 1981; the MDA History Artefact Card was translated and is now generally accepted; and a manual for that card was issued in 1982. During this same period members of the SIMIN board gave (on a voluntary basis) one-day registration courses to their colleagues in museums. This was sometimes done in coordination with the provincial museum advisers, who are employees of the provincial governments and play a general adviser's role in areas such as exhibitions, conservation, documentation, etc. Unfortunately, nowadays due to decreasing finances, few SIMIN members are allowed by their directors to spend much time beside their actual job. So the courses have stopped and for the time being the Dutch Museum Association gives short courses once a year.

Students of the Museology Faculty of the University of Leyden have a few lectures on museum documentation included in their educational scheme. (One of these lectures is usually given by Mr Van de Voort of Stichting IMC.)

Also in Leyden, students at the Reinwardt Academy for Museology are being trained in registration methods and — generally — in automation.

In spite of (or because of) this scattered pattern of training possibilities, the Stichting IMC has been asked several times to start training courses on automated museum documentation. In June 1987 IMC began developing such courses, by sending a short questionnaire to most Dutch museums, to investigate the actual need for training. Though the results turned out to be more or less as IMC expected, a few remarks can be made.

Forty-one per cent of the responding museums had no automation plans at all in the near future, while 32% are considering automation and 27% are either developing a computer system or already have one operational. As far as registration methods are concerned: quite a few museums (50%) have a traditional registration system that was developed within the museum, while only 19% use a standardised method. Fifteen per cent do not have collection registration at all, the result being that they cannot even roughly estimate the size of their collections. A main problem for the quality of documentation systems appeared to be that a lot of museums, especially the small ones, have to work with volunteers, students or temporary employees.

As a result of the questionnaire, IMC had a better view on the types of automation courses the museums need. The courses are set up as a series of mostly one-day modules. Depending on what museum employees already know, or depending on their function, they can pick out those modules they find useful. The whole programme is meant to be an introduction to the field of museum documentation and automation. The result of the course has to be that museum people can discuss those matters on such a level that they may be able to make important — and expensive — choices. Through each module IMC tries to explain the pro's and contra's of those choices.

'Introduction to museum documentation' is meant for those who have hardly any knowledge of registration methods. Illustrated will be: what should be registrated about an object when it enters the museum; what types of registration might be useful; what are the consequences for organisation and quality of the registration.

'Introduction to computers' is a general introduction to the possibilities of using a computer in a museum. The aspects dealt with are: what is automation; reasons for automating; what is a computer (network); what are databases.

Those two courses are followed by 'museum-registration and automation', which is a combination of the previous ones. Another introduction the museums appeared to need is on the possibilities of word processing (this course is not meant as a word processing instruction). Information about 'computer graphics' can be obtained in a course that deals with: a general outline of automated production process of printing; possibilities for museums; costs.

Like any other organisation, a museum has administrative and financial aspects. Therefore a special course on 'administration and automation' is added to the programme. And last but not least there is a course on 'organising an automation project'. A general approach towards management of an automation project is adapted to the museum situation and explained step by step. The Stichting IMC considers this last course to be a crucial one: for various reasons (as mentioned above: finances, staff, insufficient registration), badly organised automation projects are extremely vulnerable.

It happened in 1987, that a Dutch museum working with an advanced mini-computer system, 'withdrew' to a microcomputer because no finances were reserved to maintain the system. Also the system was never completely integrated within the functions in the museum and was therefore looked upon as a very expensive 'hobby' of one of the employees. Actually data that had already been entered had to be 'thrown away'. By giving the introductory courses the Stichting IMC hopes to avoid such difficulties.

Later in 1988 a second series of courses will probably be set up on various items, such as: documentation methods; thesaurus construction; advanced courses on computers and on organisation of automation; the compilation of system manuals (for one's own museum).

Through its research, advisory and training activities, Stichting IMC hopes to continue its role as a central organisation, that Dutch museums and other cultural institutions can use whenever they want to automate their documentation.

27 TRAINING FOR COLLECTIONS MANAGEMENT IN THE UNITED KINGDOM

GEOFFREY LEWIS

Introduction

The term collections management means different things to different people. It is necessary therefore to start with some terminology control. For the purposes of this contribution, the term is taken to involve all aspects of the management of museum collections as a resource. This will include a number of activities from the act of collecting itself to the care, documentation, research and utilisation of such collections. In defining collections management in this way, it should be noted that a wider definition than that implied in the published curriculum of the Department of Museum Studies (University of Leicester, 1987) at the University of Leicester is being used.

The view is taken in this paper that an analysis of job content should be the first step in the development of a vocational training programme. This may appear to be stating the obvious but it does not always happen. Indeed, in the present adverse fiscal climate in higher education there are increasing tendencies to adapt existing courses or resources for new situations without proper consideration of the job concerned. Put more bluntly, the objectives are perceived more in terms of financial survival, or even profit, rather than as a service to the vocation concerned. This is to be deplored.

Another consideration, particularly relevant with increasing specialisation today, relates to the need for museum staff to operate as a team. Two factors should be mentioned in this connection. The first is that training should embrace the totality of the function concerned to provide a broad operational perspective. Secondly, and particularly if the individual is a specialist, provision should be made for job progression which is more likely to be in the wider aspect of the museum operation than in the specialism. For both reasons, therefore, there is a core curriculum requirement which should normally be common to all museum practitioners.

Staffing for collections management

The execution of the activities involved in collections management used to be the preserve of the curator. Today, although the responsibility remains with the curator, there is considerable variation in the division of labour for the exercise of this function. For example, the conservation of collections is largely the specialised province of the conservator. Documentation is in some museums the responsibility of a trained registrar, although far less so in the United Kingdom at present than in North America. Is the curator then becoming just a collector and interpreter of things? These factors and varying perceptions about the work involved in collections management can lead to very different staffing solutions. By the same token and

because of major variations of practice, the way collections management training is organised may well itself influence how this area of work is undertaken in the museum. It is important therefore to be clear about the intended outcome of any training programme.

A dichotomy faces the manager of any enterprise when considering its personnel requirements: should the knowledge and skills sought for its staff be matched against the resources or the activities of that enterprise. What skills should be employed to achieve the enterprise's objectives? Now, objectives are normally analysed in terms of the activities necessary to achieve them; the resources required for this purpose are seen purely as means to these ends. Does one, therefore, appoint staff skilled in the activities to be achieved, for example collecting, fund-raising, or with the resources involved like collections, finance and so on? There is an important difference here. It is, of course, the well accepted distinction between line and staff personnel or, over-generalised in another way, the doers and the advisors, one active and the other passive.

Now a dynamic, enterprising organisation will emphasise the line function — the activities to be achieved. Notice how the independent museums in Britain have responded here. Do they have large numbers of specialist curators? No, the emphasis in staffing is on their activities: marketing, interpretation, etc. Similar motivation was behind the separation into divisions of the key activities in some of the larger local authority museums at the time of local government reorganisation a decade ago. This is also happening currently in some of Britain's national museums where an added factor is the increasing imbalance between personnel costs and the finance necessary to support staff activities. Consider also the employment, or at least use, in many museums of such specialists as conservators, information scientists, designers, educationists, sales staff, etc. Notice that all of these identify specifically with a museum activity. If we take the concept of a collections manager, implied in the title of this paper, we recognise immediately that it identifies with the resources of the museum rather than its activities.

The 'resource' approach

Presumably for those museums that have taken the broad collections manager approach, there has been a recognition of the need to service the museum's resources: the need either for a sort of collections administrator or a curator-substitute. The latter raises interesting questions and can arise either in the larger museums where the keeper or curator fulfils little more than an academic role or in smaller institutions where the perception of curatorship is perhaps equated with a sort of librarianship. The former, properly understood, is perfectly tenable. The latter is a disaster for the museum concerned, failing as it does to recognise the input into most of its activities of the disciplines inherent in its collections. There is no substitute for a curator in this context.

Another danger resulting from the resource approach is that indirectly, some-times even directly, a value is placed on it. Here it should be recognised that it is not the cost of the resource in isolation that matters so much as the value of the activity it generates. Considerable investment in documentation is essential, without which the success of a museum, whether through display, teaching or publication, would be severely curtailed. Roberts (1985, page 23) estimated that expenditure on documentation was in excess of £10 million a year in the UK. But the cost or value of the

14

resource is meaningless unless it can be identified against a specific activity, the success of which can be measured in social as well as economic terms.

The 'activity' approach

Can we take documentation as an activity of the museum and ask how significant it is? Consider for a moment a picture without its provenance, an artefact devoid of its archaeological associations or a natural history specimen lacking locality or habitat data. Clearly such items are reduced severely in their value to scholarship and as interpretative media. Good documentation, then, rests at the heart of museum activity. As Roberts (1985, page 26) has shown, documentation is a key mechanism in the effective realisation of many museum activities. But there is much more to documentation than this. By identifying documentation as a key area of the museum operation, the fact that museum collections cannot stand on their own is underlined. Museums are far more than repositories for things: they are stores of knowledge holding unpublished information and, frequently, the results of undisseminated scholarship.

Continuing with the documentation analogy, a far more realistic approach would be to recognise this as a vital activity of the museum and to match this against personnel requirements. In smaller museums this is also likely to be linked with other activities and properly forms the lot of the curator. For other museums, there is justification for a full-time line specialist who may take on staff responsibilities as well, but whose prime allegiance is documentation as one of a number of inter-related museum activities.

Training for collections management

For those who wish to enter museum work or are early in their museum careers, whatever their specialisation, there is an indisputable case for the proper management of museum collections to form part of the core curriculum for their training. This then ensures an understanding of the key resource of the museum and the activities resulting from it. When the concept of collections management is analysed for the key activities that contribute to the museum operation, a mixture of line and staff functions will be found, particularly when the collections are viewed as a contribution to interpretation. The main activities, however, may be defined as collecting, documenting, conserving and researching with the understanding that all of these provide bridges from the input to the output functions of the museum; it is essential to recognise this when designing the curriculum.

Like the Leicester learning goals (Lewis, 1983; University of Leicester, 1987), the Hale Report on museum professional training (Museums and Galleries Commission, 1987) also includes these activities in its core syllabus and gives priority to them, although it treats research as a function of interpretation. From this set of activities, three broad specialisms can be identified, those of the curator (concerned with the understanding, care, research and development of the collections), the registrar (concerned with the capture and retrieval of collection and other information) and the conservator (with special responsibility for the scientific and technical maintenance of the collections and their physical environment). All professional museum staff should have a sound general understanding of these activities at an early stage in their career.

TRAINING AND ADVISORY DEVELOPMENTS

Space does not permit an analysis of each of these activities for training purposes. However, some comment on the type of provision appropriate to the documentation activity would be apposite for this paper and highly topical in the light of a number of recently published comments on this topic. As far as existing training provision is concerned, it is generally agreed that insufficient time is devoted to the topic on both the full-time postgraduate courses in museum studies and the in-service courses leading to the Museums Association Diploma (for example, University of Leicester, 1984; Roberts, 1986a). The differing training needs of increasingly specialised museum staff, with particular reference to documentation, have also been recognised by the University of Leicester Board of Museum Studies and in the Hale Report.

In the wider sphere of documentation training, the Museums and Galleries Commission (1986) has supported the idea of a central training officer at the MDA, together with the establishment of some regional posts, although it is clear that these are intended to be generalist appointments with some advisory functions as well. However, leaving aside the specific training for system implementation, up-dating or continuing education, all vitally important in maintaining efficient documentation in museums, there remains the issue of pre-entry and early in-service professional training. These are likely to be shaped by the proposals in the Hale Report, the substance of which has much to commend it; Chris Newbery's paper (Chapter 31) gives some more information on this Report. However, on this particular issue there are two elements: documentation training for museum staff and museum training for documentation staff.

Documentation training for museum staff

All professional staff involved with collections should receive documentation training. This should seek to provide a clear understanding of the significance of documentation across museum functions and establish the theoretical base for museum documentation practice. From this students should be able to assess the contribution that museum documentation can make to any aspect of their work and, at minimum, assess the general effectiveness of a system that they may be required to use.

In addition, they should be aware of those elements of an object or specimen which should be recorded for the general management of a collection, as well as those traits and their terminology required by the subject discipline concerned. The latter is an area of some difficulty in that there is no guarantee that first degree training will necessarily have provided experience with objects and their interpretative significance. This particular issue affects museum studies training generally.

We are fortunate, in the United Kingdom, to have a national museum documentation development and advisory service in the form of the MDA. This provides a source for training and also a documentation system applied in over 300 of Britain's museums and therefore appropriate as a standard on which to base training. The fact that the MDA record cards can be used manually or as computer input documents has particular advantages from a training viewpoint.

While the emphasis for training museum staff should be in basic documentation theory and practice, the question of computer literacy arises. This has far greater application than the collection documentation field. There is evidence to suggest that the personal computer is being used by an increasing number of museum staff

for a wide variety of purposes. This is likely to increase with the greater availability of expert systems and artificial intelligence work, which could lead to important diagnostic tools for museum research. But there are also internal reasons for this to happen now, with the release of a program package by MDA which provides for a computerised object data entry system (MODES). This, combined with the availability early in 1988 of TINmus, a multi-user museum system, is likely to encourage computer use even further. There seems to be a case, at least for the short-term, of formally introducing museum studies students to the potential of the computer; a text such as that in Andrews and Greenhalgh (1987) would provide a sound foundation. It is likely, however, that this will become redundant within a few years as computer usage becomes commonplace in schools and in undergraduate work. The training of museum staff should not, however, be concerned just with the mechanical processes of documentation; this tends to encourage a task orientated view of this activity anyway. The end result should be a full understanding of the significance of documentation and the methodology involved to the museum as a whole.

Museum training for documentation staff

With the increasing employment of information science specialists in museums the question of training for them must arise. The Hale Report sees a need for in-service courses for such personnel which will equip them to work in and understand the museum environment. A suitable conversion course is clearly intended here which, as with other non-curatorial specialists, will provide the necessary appreciation of museums, their resources and operational characteristics. There may be also the possibility of providing full-time graduate museum studies courses in which there is a specific museum documentation module, similar to that provided at Leicester University for museum education staff.

Hale also raises the question of postgraduate information science courses introducing one or more modules relating to museum documentation. This is clearly a desirable development but is likely to be determined by market forces. As noted earlier the number of documentation specialists employed in museums is small, even in percentage terms, to that in North America. Current developments in the United Kingdom, however, suggest that their number will increase, particularly if such staff are used to provide expertise into the museum's general information handling problems. This has certain implications for the content of training but the provision of more specialised options in a university context also encourages research into the subject concerned.

Conclusions

The message is self-evident. Documentation is a legitimate activity of the museum on which many other activities depend. There must be a greater availability of training to encourage and develop museum documentation. It can no longer be left to *ad hoc* training arrangements. The nation's health is looked after by a highly qualified service. The nation's cultural wealth in museums should equally be subject to a well qualified service accredited by a recognised independent national body, as proposed in the Hale Report. Without a well qualified service we shall not have the confidence of the public we serve.

TRAINING AND ADVISORY DEVELOPMENTS

28 TEACHING COLLECTIONS MANAGEMENT FOR MUSEUMS IN THE INFORMATION AGE: CURRICULUM PLANNING FOR THE MUSEUM STUDIES PROGRAM UNIVERSITY OF TORONTO

DR LYNNE TEATHER with the assistance of TOSHIO YAMAMOTO

1987 was a significant year in the development of the Museum Studies Program at the University of Toronto, as several developments triggered a re-evaluation of the philosophy, syllabus and curriculum design of the Masters Program. The problems of teaching collections management were selected as a starting point for updating the curriculum, due to the resource implications for its support. Some of the findings of the initial phases of study are offered in this paper. Furthermore, the preparation of this joint paper by a Faculty member and a museum professional is testimony that the curriculum review process can only be built on collaboration between the Program and expert practitioners within the Canadian museum community.

There were several catalysts for this exercise. First, the question of what amount and what type of education about computers is appropriate for a Museum Studies course is a problem with which we have been wrestling for several years. We have only been able to begin to address the questions raised by the rapid evolution and complexity of the use of computers in museums; a conceptual shift was necessary to design learning based on the information processes which underly museum operations (specifically collections management), rather than the traditional teaching solutions of descriptions of museum documentation methods and systems. The question is further complicated by what degree of general hands-on experience of computers is appropriate for students and should be provided by the Program. The decisions have serious implications, not only in the design of courses, but for the acquisition of computer equipment and the use of existing or custom designed software or networks for our purposes. Despite the generous assistance with human resources of the Canadian Heritage Information Network (CHIN) and the Royal Ontario Museum (ROM) and other institutions, these solutions have been beyond the resources of the Program to this point, but may be achieved in the next period, with the assistance of a five year implementation plan to underpin fundraising.

The second circumstance causing the general review of the learning objectives and curriculum design of the courses is a change in the level of support from the University. While the Museum Studies Program has been in existence at the University of Toronto since 1969, it has passed through a number of stages of development, struggling against suspicion of the academic viability of this new interdisciplinary field of study, a shortage of suitable physical, financial and human resources — a story all too familiar to other university colleagues involved in Museum Studies education. This year has seen a significant change in the Program's circumstances, with the appointment of a new Director, Professor Ursula Franklin, a noted material scientist and expert in the scientific examination of ancient materials;

the upgrading of faculty appointment to tenure-track; and consideration of the development of facilities, additional courses and faculty and other resources. But any plans require a clear vision of the learning outcomes and the steps to reach them before the necessary resources for the operation of the Masters Program can be targeted. Thus, the Director and faculty have embarked on a general review of the role of the Program in the education of museum workers, developing curriculum guidelines with the assistance of museum experts so that a suitable five-year plan can be developed, accommodating both the academic and resource objectives of the Program.

The first year course, Introduction to Museums, was chosen for the initial redesign of the collections management curriculum, as it must be taken by all students in the first year of the Program. (The only other required course in the first year is a Conservation course entitled The Museum Environment. Students supplement their courses from offerings in university departments according to their interests in museum work.) Introduction to Museum Work is a museological survey course divided into three basic units covered in 26 weeks over the Fall and Spring Term: I. The Museum Context, looking at the museum from the historical, legal, political and theoretical viewpoints; II. Museum Operations: a. Collections and Their Management, b. The Visitor's Experience: Exhibition and Educational Theory, and Programming Experience: Exhibition and Educational Theory and Programming; and III. Managing in Museums: Putting It All Together. Consequently, the schedule is a major curriculum design consideration as the collections management material is covered in four weeks of four lectures, supplemented by two seminars within the first year course.

Reviewing the manner in which collections management issues have been treated in earlier years in the Program, one is struck by the parallel to the general evolution of museum practice over the last 100 years, from record-keeping and registration, to documentation, and on to collections management and information retrieval. In the first years of the Program, registration was addressed by a staff member of the ROM who would discuss the specific registration system of that institution. The implicit assumption was that this experience would provide students with an example of a working registration department, as a case study for future reference.

So too in the early years of museum record-keeping, discussions of the underlying principles were all too rare. With some exceptions, treatments in the literature of the registration experience similarly tended to discuss specific record systems. Much of the concern about keeping records about collections was directed to evolving definitive classification systems, often representing research and discipline pre-occupations rather than improved museum information use.

By the late 1970s, the teaching approach in the Museum Studies Program had evolved to address the procedures of acquisition, registration and documentation, beyond the specific situation of one museum, although the emphasis was still the steps of the process, and in addition addressed problems of insurance and particularly the ethics and legal issues of acquisitions. The parallel in the museum field was the 1952 decision of the Registrars Section of the American Association of Museums to develop a manual for registering and cataloguing museum accessions and loans, resulting in the work produced by Dorothy Dudley, registrar at the Museum of Modern Art and Irma Bezold Wilkinson, registrar at the Metropolitan Museum, which produced *Museum registration methods* in 1958, now in its third edition (1979).

But Dudley's manual emphasised the methods or techniques of museum registration and was primarily oriented to art museums. Daniel Reibel's later work allowed for a more general discussion of documentation procedures for museums of all sorts (Reibel, 1978).

In recent years, however, several factors have brought about a major change in the approach to documentation in museums, matched by a keen struggle to evolve an appropriate curriculum to match the rapidly changing environment. The first is that museology itself has evolved so that, to allude to Raymond Singleton's words, the field of museum studies ought to address the why's of museum work, not the how's. The premise is that the museum is not one single kind of institution but a process enacted in a variety of types of collections, mandates and operations, while working to distill the analytical principles behind a museum activity. The aim is to equip students with the ability to articulate and apply the principles of museum studies, analysing particular problems rather than simply applying a set of idealised procedures to any museum situation.

In addition, the sense of the failure of earlier approaches to documentation in museums, first in the quantity and quality of documentation yet conducted and second, in the shortcomings of early computerisation efforts, has provoked a reconceptualisation of collections management from record-keeping to information management. This initiative has been supported by the major steps in information science as seen in libraries and archives as well as the profit-sector.

Consequently, the Museum Studies Program is struggling to develop a collections management curriculum which incorporates traditional questions of the procedural steps of acquisition and documentation, responding to growing pressures of accountability, within the framework of understanding collections as part of the process of creating, maintaining and using information in the museum. This shift requires an orientation of students to information science principles which support the understanding of computerisation, while retaining museum specific questions such as how collections are formed, the role of research and users needs, the role of policies, acquisition and registration procedures, documentation files and so on. For this stage, works such as Elizabeth Orna's *Information handling in museums* (1987) and Andrew Roberts's *Planning the documentation of museum collections* (1985) represent the new texts.

Table 28.1 provides the tentative outline of the resulting syllabus with which we are at present working. This is built very much on the University of Leicester syllabus combined with our own experience.

There is an additional problem in designing the curriculum for the Program in Museum Studies which is a two-year course of study. How can the objectives regarding collections management be met in each year? The premise of a two-year Masters is that students can concentrate more in their second year on several areas of Museum Studies and have an opportunity to produce an original piece of research in their research paper. Due to factors in the evolution of the Program, no second-year course in collections management or curatorial processes has been set up, a partial reflection of two factors. First, the growth of the importance and complexity of collections management and of computerisation is recent; second, it would seem that in earlier years of the Program, more students were interested in the public functions of museum work and have had a negative orientation to 'registration' as somehow a clerical exercise.

Table 28.1

1. The process of collections and their management

To understand the way objects/specimens are created, saved in society and in the museum environment historically and currently

1.1 Objects, artefacts, specimens: the basic unit of the museum

To introduce questions of the philosophical aspects of objects, materials and specimens, their functions in various states in society and in museums

a. Introduce theories of objects/specimens in society and in museums

1.2 The history and current state of museum collections

To understand the historical development of collections and their treatment in museums by type, size of museum, etc.

Explore the nature of contemporary museum collections, size, use, etc., by type of museum, geographical distribution, etc., as well as the collections management characteristics, such as state of documentation, who does it

To identify the sources, methods and problems in the acquisition and disposal of collections

To discuss the law and ethics related to acquiring and disposing of collections

To identify the issues in defining collecting policies for museums

2. The purposes of museum collections: research and beyond

To understand the issues involved in supporting the research and other functions of museums

a. Traditional arguments for and against

b. Changing issues, philosophical

2.1 To understand the formation and use of museum collections for research purposes and the difference in museums by type, discipline, etc.

a. Research processes by discipline, and changes in using museum collections

b. Changing factors: priorities, facilities and resources questions, etc.

2.2 To identify the strengths of museum collections and information resources for museum research

2.3 To understand the implication to collections and management of other museum functions

3. The nature of the museum as an information system and the process of computerisation

To understand the principles of information science as applied to museums for the purposes of better information systems, whether manual or automated

3.1 The evolution of documentation systems in museums and the current state of the art

To understand the evolution of the stages of information handling in museum

3.2 The Museum as an information system

To articulate the principles of information systems applied to museums

3.2.1 Theories of information systems

Table 28.1 *Continued*

3.2.2	The principles involved in analysing museum collections as an information system
3.3	From information system to computer system
3.3.1	Computer solutions in museums: history, issues and problems
3.3.2	Steps in computerisation of museum collections
3.3.3	Problems of information standards for museum systems
	— terminology, thesauri
	— classification systems

Given the existing offerings, students can pursue an Exhibit Development half course, or one of two Education courses, a second Conservation course or a Museum Studies Research Methods Course which supplements the museological research of their final research paper. Students interested in Collections Management or Curatorial Research aspects of museum work could pursue their interests through a special project course or indeed in-depth in their final research paper which operates like a mini-thesis.

These solutions are really quite piecemeal; several students have, however, produced some major research works relating particularly to terminological problems raised in collections. Clearly, a second-year course in Curatorial and Collections Management questions must be designed to respond to the gap in the design of the Program. This problem has been discussed over the past four years, although shortage of resources prevented the redesign of the Program. Proposals have been made for several half courses, such as one for Computers in Museums. It was decided that discussion about computers should not be treated separately but integrated into the parts of the course where it was appropriate: from collections management, to educational systems to management applications. The more significant gap in the second year offerings is a course on collections management methods, as well as one currently under development on museum management.

Planning for the better treatment of collections management questions in both years of our Program will be intensified in 1988, with the assistance of Dr David Barr, Associate Director — Curatorial, Gene Wilburn and Toshio Yamamoto (ROM) and Peter Homulos (CHIN), as well as consultations with collections management practitioners. As can be seen, the refinement of our curriculum is both necessary and complex, but it is also exciting. We should soon be able to share some of the conclusions offered by this exercise with the museum community.

29 COLLECTIONS MANAGEMENT IN RELATION TO MUSEUM STUDIES TRAINING IN AUSTRALIA

JOHN C. HODGE

I think it is important to put Australia into its proper context with relation to size and population dispersal. Because the Mercator and similar projections of the world have flattened the globe, Australia appears to be smaller than Greenland, while the reverse is actually true. If we superimpose the British Isles on to Australia we get a more easily understandable perspective (Figure 29.1).

Fig. 29.1 Australia and the United Kingdom: size contrasts

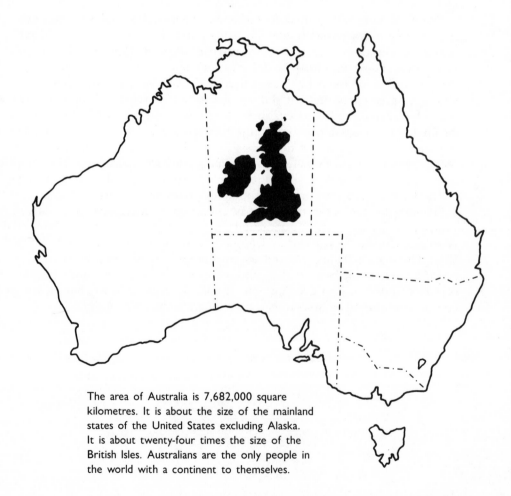

The area of Australia is 7,682,000 square kilometres. It is about the size of the mainland states of the United States excluding Alaska. It is about twenty-four times the size of the British Isles. Australians are the only people in the world with a continent to themselves.

TRAINING AND ADVISORY DEVELOPMENTS

The continent is divided into six States and two Territories. Could I also emphasise that Tasmania is one of the States not a separate country — though some Australians find this concept difficult to comprehend; ICOM is also in this category, and some museum labels I have read in England indicate it is not appreciated here either!

The population is approximately 15.5 million and of this number nearly half live in Sydney and Melbourne. The centre is very dry — a desert in fact — and the fertile soils are more or less restricted to the coastal plain. Queensland is the most de-centralised of the States and Western Australia is the largest. New South Wales has over 300 small (usually Historical Society) museums and all the State capitals have at least two major museums (McIntyre, 1987). Sydney has the oldest museum in the country — The Australian Museum — and the Art Gallery of New South Wales. The Power House Museum (a division of the Museum of Applied Arts and Sciences) is due to open in 1988 (our bicentennial year) as is the new National Maritime Museum. A National Trust Museum/Art Gallery, a geological and mining museum, four buildings under the direction of the Historic Houses Trust, the Mint and Barracks museums and the old Observatory constitute the other major museums in the city.

Distances are vast: even while I was President of the New South Wales Branch of the Museums Association of Australia, I was not able to visit one quarter of the museums in the State over a two year period. I have never visited Broken Hill for example and the Branch's Executive Officer managed to get there once in seven years! It took four days because there are no daily air services.

It takes three days to go by train from Sydney to Perth and the cost of a domestic air flight is nearly $A900 (£380). It is cheaper to fly from Sydney to New Zealand than from Sydney to Adelaide in South Australia. Perhaps this is one reason why there is so much interstate rivalry; why we have seven parliaments (some with two Houses) and also why the States maintain a fierce independence. Queensland, which has two-thirds of the State in the tropics, does not go onto Eastern summertime!

The size of the country and the division into States is probably the main reason why the Museums Association divided into branches. In New South Wales, the oldest and largest of the Branches is further divided into Chapters. In the 1950s, the Art Galleries dissociated themselves from the Museums Association of Australia and even have their own secretariat funded essentially via the Australia Council — a body concerned with the Arts. Unlike the USA we have no National Endowment for the Humanities and unlike the UK we have no Museums and Galleries Commission, though it was a major recommendation of the Piggott Report, 12 years ago.

This separateness and dichotomy poses particular problems with training. Let me say at the beginning that I am referring to the training offered by the Museum Studies Unit at the University of Sydney but it applies across the board. The Diploma in Museum Studies, while differing in detail, is similar to the Certificate Course in Leicester with one major exception. We also have an art history option which in England is dealt with exclusively by the Museum Studies course at Manchester University.

We endeavour to train students to enter the profession at the curatorial/assistant curator level. This has its own problems because some of our graduates move into large State capital museums and others become 'Directors' of small historical museums and regional art museums. Each of these situations calls for very specific training. In the small museum, relationships with local councils and the community are often seen as more important than even (for example) having a published

collections policy. Curators and assistant curators in large museums are rarely called on to deal directly with any form of government. This role is the prerogative of the Director or Deputy Director or the Board of Trustees.

We are constantly faced with the kind of decisions such as how much personnel management training is suitable, adequate or necessary for our students, or how much accounting practice should be provided in a one year Diploma course. How much should they know about conservation? Do they need to know anything about Australian Colonial furniture or pottery — and so on.

In regard to art, science, anthropology, archaeology, history, technological and industrial museums, should all students be faced with the idiosyncracies of disciplines different from their own? Is there a basic commonality to all types of museums? Is there a museum profession? This last question I dealt with at the Museum Training Committee meeting in Mexico City in 1980 and I will not go into it here. It suffices to say that if I and many of my colleagues did not believe in what could be described as a core curriculum for Museum Studies we would not be teaching a Museum Studies course.

Jennifer Game (Chapter 4) has outlined the variation in collections management practice that she has found throughout a number of Australian museums. The problem goes even further than this when it is discovered that a private organisation in one State is setting itself up as the answer to all the historical museums scattered over the country. They are offering a service to small museums to put their collections on computer. Let me hasten to add that this is not a collections management system but merely a registration cum catalogue system. I am currently debating whether I shouldn't purchase the programme to show my students what they should avoid.

Maxine Esau (Chapter 21) referred to the cataloguer's manual for the visual arts (Varveris, 1980). This has become the standard for art museums both large and small and while there may be slight variations or modifications, the manual was never fully completed and has never been updated in the decade since it was produced. Likewise, in the area of natural history the Australian Biotaxonomic Information System (ABIS) was developed in 1978 by the Australian Biological Resources Study but there is no requirement on any of the museums to adopt the system of Data Interchange Standards (though there is general agreement among natural history curators). While government funded museums were able to obtain some funding in regard to assistance from ABIS, certain other museums (notably university museums) were not. We had a golden opportunity to set up an Australian Documentation Association but alas we did not. History and technology museums are even more diverse and there are no systems which are compatible between States. History curators cannot seem to agree on such things as classification and any attempts to coordinate their thinking nationally seem doomed to failure. Part of this is due to our problems of size — often referred to as the 'tyranny of distance' — but the lack of a national coordinating body such as the MDA must be a contributing factor.

A collections management system as opposed to a cataloguing system is a relatively new concept in Australia and has, I would suggest, even in other parts of the world, been brought about firstly by the changes in museums — or rather the changes in museum emphasis; secondly a recent concern about legal obligations; and thirdly, technological developments which would extend or expand what museums could achieve, particularly in the research field but also in management.

Having provided a rather sketchy background to the Australian situation, let me now consider training in collections management and how it has been approached in the last three to four years.

First of all we would contend that the basis of any collections management system is a sound record keeping system and all our students receive lectures/tutorials on a fairly generalised manual system for museum objects. This is reinforced by practical work in one of the University's museums. Each of the options (Fine Arts, Anthropology, History, etc.), then have specialist tutorials on collections management, usually within a museum and provided by museum registrars or their equivalent.

Then comes the introduction to the computer. While computers are now in nearly all of our secondary schools and in many primary schools, few of our present graduate students in Museum Studies have experience with, and knowledge about, computers. It is necessary to teach a whole new vocabulary, and it is necessary to give them practical experience.

Apart from the University's CYBER mainframe we have a department of computing science like many other universities and we are able to use computer laboratories equipped with PCs in that department.

We have three PCs for our staff and student use. This year we have accessioned the collection of a local history society — art, historical objects, ethnographic material and a very large costume collection. As the student exhibition was based on this collection the appreciation of a good collections management system became obvious. Occasionally we have visiting lecturers from overseas. Elizabeth Orna — an information management consultant — has been in Australia lecturing on information management policy and thesaurus construction.

Collections management training is only part of our graduate Diploma course. We try to present a basic understanding of the components of collections management systems but what happens when students go into this specific area of museum work? Jennifer Game has one of my graduates in the Registration Department of the National Maritime Museum and has taught her to operate the system used there in less than one week. This person then taught me! Obviously there will have to be a mixture of training methods — on the job training and training which provides an overall understanding of the concepts of collections management and of course some training in computer technology.

I have heard it said that many museum professionals when contemplating a particular system have no idea what questions they should be asking. Lenore Sarasan (Chapter 9) deals with one aspect of that particular problem, but I would also want those asking the questions to understand why they are asking them! Who is going to train these people? Is there any specific training available for them? I don't train people to become registrars though I hope I provide an understanding of what a registrar does and the relationship which exists (or should exist) between registrar and other staff. But now we are finding that museums are appointing collection managers, documentation specialists, call them what you will. The concept expressed by A. E. Parr some years ago that museums are a plurality of professions while we were trying to promulgate the single museum profession, would seem to be again descending on us.

As we prepare to celebrate 200 years of European settlement it is hoped that there will be some feeling of nationalism which will result in closer cooperation. At the

moment there are only two national groups closely associated with the Museums Association of Australia that meet regularly in conference and who publish their papers — the Museum Education Association of Australia and the Conference of Museum Anthropologists (COMA — an unfortunate acronym but I can assure you they are not moribund). I cannot speak for the Art Associations. (One can get the feeling that we are over-run by over-organisation.)

So apart from training provided in Museum Studies departments, the training for registrars and collections managers, etc., takes place usually in an *ad hoc* kind of way within the individual museums, though some of our smaller museums are looking to the Museum Association of Australia's branches for guidance. These branches organise workshops and seminars dealing with basic documentation and other subject areas but while much of our heritage is located in our small museums the idea of a national inventory is a long way off.

There is a need for trained Registrars and I would hope that Museum Studies departments in universities would be able to contribute to that training. I would also hope that our national museums would assume what I regard as part of their mandate — to assist in the training of the profession. Some of them do; others do not.

Registrars, collections managers, information scientists, *et al*, all need some general museological training. While those responsible for conservation courses in Australia are slowly coming to this realisation, many other museum 'professionals' are not. We have made some gains. We still have a long way to go.

TRAINING AND ADVISORY DEVELOPMENTS

30 A GRADUATE PROGRAMME FOR DOCUMENTATION TRAINING: A STUDENT'S EXPERIENCE

JOANNE M. NERI

Introduction

The great aim in education is to equip the scholar for his or her future career. A professional career in museum documentation, through the appointment of a registrar, is well established in the United States, with recognition from the American Association of Museums (AAM) and more recently from the museum community. A professional training programme to prepare candidates for this type of position is described in this paper.

With the increasing specialisation of job roles in museums over the past 15 years, university-based institutions have succeeded in providing opportunities for individuals to pursue scholarship in specialist areas and to subsequently generate professional development in museums. Efforts to open channels of communication between students and professionals of museology have therefore never been more dynamic, however, based on personal experience as a graduate of museum studies, have also never been so urgent.

Open communication has been observed and experienced not only through the practical component of internships, where students participate in the working environment of museums, but also as students seek to evaluate and apply theoretical-based knowledge, in consultation with the profession, to specific museum programmes and contemporary issues. Dynamic communication is also reflected in the liaison between the faculty of museum studies programmes, who generally consist of professionals working in museums or related business organisations, and the students. With an understanding that instructors and advisers are potential future colleagues within the field, students and faculty work towards meaningful study. Further, in the United States there is a continuing commitment to strengthen professionalism, in conducting moral and ethical judgement within the standards set by the profession (Weil, 1986), and it is under these auspices that students and professionals vere towards common goals.

The urgency of open communication comes from outside the profession, as increasing demands are placed upon our society. Museums face resounding consequences in their attempts to change, grow and develop in accordance with the world around them. Specialised skills to identify and respond to a museum's ever changing needs and requirements continues to challenge effective progress. Internal management and control of tangible resources are areas demanding closer investigation as today's economic climate fades deeper into spending cuts and limited government support. And technology often invades without recourse to thoughtful planning or a guided direction. Management, technology, improved resources and communication insist for attention in museums, yet these are areas traditionally segregated to business and industry.

Professional training is a means by which transition can be readily accepted and understood. Professional training also acts as a mediator between traditonal values and professional development. Lastly, professional training reflects the desirability of influencing rather than responding to change.

Within the field of museum documentation, high standards of administration and high standards in the use of technology are greatly influenced by high standards of scholarship. In relating the curriculum, teaching methods and learning process of a museum studies programme offered at the Center for Museum Studies of John F. Kennedy University, high standards of scholarship become evident. Since this degree qualification is designed to prepare students for generalised and specialised areas of museum work, the programme description will not concentrate solely on documentation training. A broader academic framework, consolidating institutional structure, purpose and responsibility is therefore included in this profile.

The origins of museum training programmes

The training of basic museum principles and theory, in conjunction with a specialist area, has, in fact, directed the approach of museum training programmes in the United States since their founding in 1908. An example of museum studies courses offered in 1921 at Harvard University, include: the history and philosophy of museums, organisation and management, buildings, collections, installation, restoration and storage, record-keeping, museum policies and museum ethics (Cushman, 1984). The turn of the century also witnessed a proliferation of museums, a severe lack of professional museum staff and the founding of the AAM in 1906; but despite this period of growth and recognition of professional standards, museum studies programmes were unable to progress systematically and freely.

Initial evaluation of museum training programmes began in 1917, when a museum studies committee of the AAM published *The report of the Committee on Training Museum Workers* (Malt, 1987). Subsequent discussions at the AAM annual meetings in 1919, 1926 and 1945 were only moderately successful in resolving appropriate action. In 1926, requirements of an effective training programme were defined by the museum studies committee. University-based institutions were established to educate future museum personnel; however, the cost of the programmes deterred applicants from pursuing generalised training in a field where financial rewards were limited (Cushman, 1984). A greater influence emerged in 1968 with the Belmont Conference on Museum Training, sponsored by the National Museum Act. In response, a conference on museum training was sponsored by the AAM and two influencial documents were published, *Museum studies: a curriculum guide for universities and museums* and *Minimum standards for professional training programs* (Anon, 1976). In 1984 the Office of Museums Programs identified 11 universities and colleges awarding graduate degrees in art history and museum studies and nine programmes in non-art related subjects and museum studies (Malt, 1987). This survey did not include the numerous courses offering museum training certificates as an adjunct to other academic disciplines.

The Center for Museum Studies

Founded in 1974, the Center for Museum Studies of John F. Kennedy University is the only professional development programme available on the west coast to offer higher degree qualifications specifically in museological fields. A historical,

theoretical and practical understanding of museums is the basis on which the J.F.K. programmes are designed. The following description will concentrate on the residential programme leading to a Master of Arts degree in Museum Studies which is available to individuals wishing to pursue a career in museums, and to professionals wishing to enhance their existing knowledge.

Students from a diverse background, holding a bachelors degree in a range of subjects, enroll with the intention of working in museums as museum managers, registrars, educators, exhibition designers or curators. The Master's degree programme is designed to prepare students for entering specialist professional positions in conjunction with a broader understanding of history, purpose, institutional development and the museum's role in contemporary society. By fusing this generalised and specialised instruction, students can more readily appreciate the specialist's role in an institutional context.

Students are involved in several kinds of coursework, including: core and elective classes, internships, tutorials and a final thesis project. Courses are offered in the evening to enable students to work and subsequently reduce the burden of educational expenses. These, I might add, are a substantial amount, but to invest in the future is an American philosophy adopted, and generally supported, by the students.

A total of 58 units are required for this degree qualification and these are generally drawn out over a two and a half year period. The History and Philosophy of Museums provides an introduction for students entering the programme, giving an overview of the origins, operations and trends of museums in the United States and abroad. Specific activities pursued in this course include: visits to surrounding museums, meeting and interviewing museum personnel, reading literature in the field, discussing current issues and writing reports based on the above. Some of the issues raised are museum professionalism; ethical, moral and legal considerations in managing collections; acquisition and collecting policies; accreditation; social issues involving public interest; and small verses large museums and financial management. In addition to these museological issues, speaking, writing and analysis skills are developed in this introductory course, incorporating research, evaluation reports, critical analysis of readings, conducting interviews and the presentation of reports. Unity, coherence, development and clarity is the basis for subsequent verbal and written presentation.

In addition to core curriculum requirements, classes are selected by students according to interest in the following subject areas: documentation of collections, membership and development, conservation, education and curatorship.

The criteria on which students are graded are based on his or her ability to comprehend the subject matter through competent expression during class participation and in written work. Specific readings, which are instrumental to an understanding of the materials discussed in class, are assigned for each designated session. These readings are drawn from reference texts of published material relating directly and indirectly to each museological field, and, from a collection of research papers culled from professional journals and bound within individual course readers. The latter are particularly instructive as they provide the most current and provocative literature in each field.

To concentrate now on documentation training, the Documentation of Collections course motivates an awareness in documentation principles and theory, develops

practical skills in performing the routine functions of the museum registrar and encourages the student to investigate and select a specific topic area of interest within the broader disciplinary areas of documentation. The primary aim of this introductory course is to develop the knowledge and skills necessary to establish efficient documentation systems towards the accountability of museum collections, and to the accessibility and retrievability of data required for organisation and control procedures. The variety of disciplines covered in the general documentation training are listed as:

inventory control;

the preservation of objects in transit, in storage and on exhibition;

handling and transport arrangements; measuring and marking objects;

scientific description of objects and condition reports;

institutional and professional standards;

loans management;

exhibition planning and implementation;

risk management and indemnification;

policy implementation;

computerisation as an aid to the registrar.

The registrar's role in juxtaposition to other museum departments was a recurring issue throughout the majority of these disciplinary areas. The importance of negotiating agreement and the redundancy of imposing change substantiated topics raised in previous classes regarding collaboration, professionalism, museum policies and ethics. The registrar as policy-maker was analysed and the formation of collections committees highly recommended as a mechanism to involve relevant staff members in the decision-making process when improved documentation systems are proposed.

A range of course assignments included registering and cataloguing a collection of at least 20 objects, inclusive of comprehensive accession records (containing physical descriptions and catalogue information, photographs, and a series of cross-reference indices); a description of packing and shipping requirements for the documented collections; and, an in-depth paper on a topic of interest pertaining to documentation and proper registration methods.

Based on the content of the above course description, standards of professionalism within the documentation field were appropriately formed around the following descriptions:

the structuring of functions in a logical and efficient manner;

creating well-defined guidelines for registrarial procedures;

defining management responsibility in information, staff and systems operations;

documenting progress reports and distributing to relevant departments;

acting upon collaborative policies with other departments to minimise stress on objects in the collection and contributing towards institutional problem-solving;

forming a representative body within the professional association.

The conservation class complimented this study of documentation by encouraging an understanding and interest in the care and preservation of artistic and historical works. Preventative measures for slowing down the deterioration process of museum collections were taught as the desirable method in conservation practice.

TRAINING AND ADVISORY DEVELOPMENTS

As managers of storage areas and frequent handlers of objects for care, control and identification purposes, the registrar is well suited to influencing preventative measures of conservation. The class is not intended to train specialist conservators, however, it provides sufficient knowledge in making immediate valued judgements concerning an object's stability, in preparing routine condition reports (when, for example, the museum obtains physical custody of an object) and in knowing when to relinquish conservation responsibility to those with specialist knowledge.

Personal experience in documentation training focused on the use of computers as a management tool. Management techniques and computer literacy were conveyed in three elective courses entitled Long Range Planning, Collections Management and Computers and Legal Analysis and Problem-solving in the Museum context. These condensed three week classes covered current aspects of museum work not generally treated in depth within the core curriculum.

After the first year of core curriculum courses, students engage in an independent tutorial requirement which is designed to strengthen expertise in an area of specialisation and to serve as academic preparation for the internships and thesis. Research topics are chosen by the student and developed in consultation with a museum studies director and an outside instructor who possesses a knowledge of the selected topic area.

Students also undertake two part-time or one full-time internship (640 hours in total) as a practical introduction to museum work in a museum or museum-related organisation. Professional level responsibilities are assumed in internship placement and opportunities to apply theoretical-based knowledge within a practical application is both challenging and rewarding to the students.

With the majority of coursework behind them, students enroll in the Research Seminar class. This course instructs students in the identification and application of systematic research as preparation for the final thesis project. In addition to understanding formal approaches in research methodologies, a comprehensive investigation of the thesis topic is developed. The primary aim of the research seminar is for students to produce a thesis proposal incorporating a historical background of the thesis topic, a review of current literature in the relevant fields to substantiate the proposed study, and a description of the precise methodologies to be used in conducting the thesis.

The final thesis is subsequently developed by students to reflect their expertise in a specialist subject area. The final manuscript contributes to the growing body of professional literature in the museum field and is most significant in providing a primary mode of evaluation in museums. This formal approach to measure achievement is undoubtedly the most challenging and dynamic component of the J.F.K. museum studies programme. The research, writing and production of the manuscript is carefully monitored by policy guidelines established by the university and the AAM. In addition, guidance and support is offered by a subject specialist within the museum profession and a J.F.K. adviser. Upon completion of the final project, to be submitted within a maximum of an 11 month period, a Master of Arts degree in Museum Studies is awarded.

Summary

To summarise some of the major strengths and weaknesses of the described programme, I feel compelled to note that the credibility of the Center for Museum

Studies is marked by the high ratio of graduates placed in museums and related organisations both before and after the course requirements have been fulfilled. This ratio is proportionate to the number of entering (20) and continuing (65) students per annum. More generally, by defining a path for professional development this programme provides high standards of scholarship designed to satisfy training requirements in all museological fields.

A recent expansion and relocation has provided improved library facilities and administrative offices. The expansion also accommodates other J.F.K. programs such as the production of the *Museum Studies Journal*. This relatively new museum studies periodical not only extends literature in museum history, current research, literature reviews and bibliographies, but acts as a credible advertisement to the further degree programmes offered at the Center. In parallel to this development has been the reorganisation and restructuring of the academic curriculum to facilitate a more balanced and broader range of subject areas.

An additonal strength is the continuing evaluation process by the director, the faculty and the students. Formal evaluation sheets are distributed for each course requirement and all individuals involved in the programme actively seek to improve and enhance existing programmes, teaching methods and academic procedures.

In reflecting upon possible areas of improvement, I consider greater access to national and international contacts within the museum field a continuing goal to be actively explored. Being distantly located on the west coast of the United States does sometimes limit the availability of instruction from a wider range of resources, particularly during the formulative years of the core curriculum courses.

Until recently, there has been the need for more in-depth training and education in subjects relating indirectly to museum work, such as those areas covered in just three weeks of the two required elective classes. This has since been rectified with the restructuring of course requirements and will benefit successive years of entering students.

Lastly, if the cost of the programme continues to increase, as it has done over the past two years, there is a risk of falling into the previously experienced dilemma of providing museum training at a cost that is not commensurate with future earnings. Although the majority of students work throughout the degree programme to compensate tuition fees, long-term educational loans generally supplement the total cost. The pressure this exerts on the students often diminishes their ability to perform unaffected. In the interest of the museum community, it seems appropriate that issues concerning training and educational fees in relation to proportionate financial benefits be addressed, regulated and controlled.

In conclusion, through my experience as a recipient of museum studies training, I can only say that the motivation among students, who have devoted such time and energy to the study of museums and related sciences, must be the most hard-earned yet committed that the museum community will find in future museum personnel. Since motivation is the heart of performance, it is essential that professional training programmes continue to develop as dynamically as would seem evident in today's society.

TRAINING AND ADVISORY DEVELOPMENTS

31 MUSEUMS AND GALLERIES COMMISSION (MGC): NEW INITIATIVES

CHRISTOPHER NEWBERY

For over 50 years, the Museums and Galleries Commission (MGC) (formerly known as the Standing Commission on Museums and Galleries) has played a central advisory role in relation to the development of museums and galleries in the United Kingdom. In more recent times it has also acquired a wide range of executive functions. In January 1987, it became incorporated under Royal Charter and in April of the same year it acquired grant-in-aid status. These changes have placed the MGC on the same footing as the Arts Council and Crafts Council. The MGC has an annual budget of some £6 million of which more than one-third is passed on to the seven English Area Museum Councils (AMCs) and the Museum Documentation Association. These organisations are in the forefront of promoting improved standards of collections management.

In this paper I intend to concentrate on three recent initiatives, all of which have a bearing on the subject of collections management. The first of these is the publication of the MGC's *Eligibility criteria for the grant-aided storage of excavation archives* (1986). Archaeological excavations create archives comprising objects, samples and records which need to be preserved for posterity and museums are generally seen to be the most suitable repositories. The Historical Buildings and Monuments Commission (English Heritage) is empowered to grant-aid the preservation of those archives which derive from excavations it has funded and the MGC advises English Heritage as to which museums are capable of handling and storing specialist and sometimes unstable archaeological material. The Eligibility Criteria for acceptance to the MGC approved list of museums include the following requirements:

a museum must have a staff complement of at least one archaeologist with professional curatorial training;

it must have or be able to obtain sufficient storage capacity to house existing and forseeable excavation archives; and

it must provide adequate standards of documentation, environmental control, security and access.

Minimum standards are detailed for each of the above criteria. The documentation standard specifies that within three years of the archive's arrival (unless previously arranged otherwise with the AMC) the museum should, in addition to having made the appropriate entry into the accessions register, undertake to:

prepare inventory records and indexes;

integrate these records and indexes into the museum's inventory and control systems to the end that individual items and their associated records can be rapidly located for study;

prepare a duplicate set of basic records to be kept in a separate building.

Assessment of museums wishing to be added to the approved list is undertaken by the English AMCs. They then forward their recommendations to the MGC which makes the final decision as to whether or not a museum is added to the approved list. There is an initial review of eligibility after three years and thereafter at five year intervals. A category of conditional eligibility is available to museums which agree formally to meet the minimum standards within a specified timetable.

Inevitably, a number of museums wishing to gain a place on the approved list were concerned at first about the resource implications of meeting the minimum standards. The grants from English Heritage will normally only stretch to the provision of physical storage (for example, boxes and racking) and many museums discovered that they did not have the resources to provide the required environmental control and security facilities for their stores. In order to overcome some of these difficulties the MGC decided to offer conservation grants in 1986–87 and 1987–88 to a number of museums striving to meet the minimum standards.

Implementation of the *Eligibility criteria* for archaeological storage has generally gone smoothly and a number of people have suggested that similar guidelines should be produced for other types of collections. This is tempting, but it should be remembered that the success of the scheme has depended on substantial grants from both the MGC *and* English Heritage. Similar funds to enable major initiatives relating to the storage of other types of collections may be difficult to obtain, although AMCs will continue to do their best with the limited resources at their disposal.

The second MGC initiative which has important implications for collections management standards is the scheme to establish a national register of museums and galleries. The key requirements of registration will be as follows:

accordance with the Museums Association definition of a museum or, if appropriate, the MGC definition of a 'national' museum;

an acceptable constitution and financial basis;

publication of an acceptable statement of collections management policy, and compliance with all legal and planning requirements;

provision of a range of public services and facilities appropriate to the nature, scale and location of the museum;

access to professional curatorial advice.

Detailed guidelines have been produced by an MGC steering group including representatives of the Museums Association, the Association of Independent Museums and the AMCs. A pilot scheme was run in the area covered by the North of England Museums Service during 1986 and a comprehensive consultation exercise was subsequently undertaken. There was general support for the scheme and it is now planned to implement registration nationally over a period of four years commencing in 1988.

The advantages of registration for museums can be summarised as follows:

eligibility for MGC and AMC grant-aid and subsidised services;

the fostering of confidence among other funding agencies (such as Tourist Boards) that a registered museum is, in principle, worthy of support;

the fostering of confidence among potential providers of material for a museum's collection that a registered museum is, in principle, a suitable repository;

the opportunity for a museum to publicise itself as an organisation which provides a basic range of services for the benefit of its visitors and other users.

As mentioned above, one of the key requirements for registration is an acceptable collections management policy. This policy needs to include the following information:

details of the museum's acquisition and disposal policy;

the nature of the museum's existing collection;

details concerning the documentation of the collection;

details concerning access to professional conservation advice.

With regard to the documentation standard, we consulted the Museum Documentation Association and the minimum requirement is as follows:

the maintenance of entry records of all items deposited in the museum, for example, as enquiries, loans or potential acquisitions;

the maintenance of a register with records about all accessions and long-term loans, each including an accession number and sufficient information for collections management purposes;

the marking or labelling of each accession and (where appropriate) each individual object with a unique accession or object number;

the maintenance of one or more indexes or equivalent information retrieval facilities, including (where appropriate) subject, donor and location lists;

if documentation of the collection has not been completed as set out above, a statement of the museum's policy to eliminate this backlog within a stated timescale should be provided.

The AMCs will play a leading role in coordinating the registration process at regional level but final decisions concerning the award of registered status to individual museums will be the responsibility of the MGC. An appeals committee will be formed to deal with contentious cases arising from rejection of applicants. A category of provisional registration will be available to museums which are striving to reach registration standard within a specified timescale. Provisionally registered museums will be eligible to receive grant-aid from the MGC and AMCs, subject to formal annual review. Fully registered museums will be expected to renew their applications for registration at five yearly intervals from the initial registration date.

The Commission is confident that the registration scheme will make a substantial contribution towards an improved standard of collections management in UK museums.

The third and final MGC initiative which needs highlighting is the publication of a report in 1987 concerning museum professional training and career structure (the Hale Report) (Museums and Galleries Commission, 1987). The Working Party which produced this report had the following terms of reference: 'to consider the professional training and career structure of people working or wishing to work in museums and galleries in the UK and to advise on how their training needs might best be met and their career structure improved'. The chief recommendation of the Hale Report was the establishment of an independent national coordinating body for training (the Museum Training Council). The Working Party also recommended

that basic training should generally be undertaken at pre-entry level, while in-service training should be available to all categories of museum staff throughout their careers in accordance with the needs of the employer and the individual.

The Working Party defined four levels of in-service training in order of advancement. Firstly, a one or two day familiarisation course for all entrants is proposed. This course would include a brief outline of museum ethics; museum functions; contemporary trends in the museum service; and the funding and organisation of museums in the United Kingdom. The Working Party felt that a familiarisation course would encourage all museum staff to see themselves as part of a team.

Secondly, the Working Party proposed a new Certificate in Museum Practice, to be obtained by all staff as soon as possible after entering museum service. The core syllabus for curatorial candidates for the Certificate would consist of four elements: care of collections (30%); interpretation (30%); management (20%); and the museum context (20%). The care of collections component would include the acquisition and disposal of collections; the documentation of collections; the conservation and storage of collections; and security, insurance and related matters. In addition to covering the core syllabus, candidates for the certificate would need to complete courses in a relevant specialist subject studied in the context of museum work. Graduates of recognised museum studies courses would be exempted from attending familiarisation and certificate courses. Non-curatorial staff would normally be appointed to museums for their specialist skills. To obtain the Certificate, these members of staff would be able to take 'conversion' courses comprising three main elements: understanding the museum; understanding the resources available; and understanding the organisation and management of the individual's specialist department within a museum. All candidates for the Certificate in Museum Practice would also be assessed on their work record over a given period of time.

The third level of in-service training proposed in the Hale Report is a new Advanced Certificate in Museum Practice. This would comprise three elements, involving the satisfactory assessment of a general management course concerned with principles of management; a higher museum studies course chiefly concerned with practical aspects of museum management and administration; and a two year work record. The Working Party suggested that one of the components of a Higher Museum Studies course might be finance and the management of resources. This would include collections management with an emphasis on the changing uses of museum collections, such as acquisition policies; preventive conservation; and the use of information technology.

The final part of the four-level approach to in-service training is a proposed senior management course. The successful completion of such a course would normally be a pre-condition for appointment to a senior museum post, but it is not proposed that the course should be linked with a specific qualification.

Although I have described the proposed in-service training structure at some length, I should re-emphasise the Working Party's recommendation that basic specialist training should be undertaken prior to gaining museum employment. In this connection the Hale Report noted a number of gaps in existing training provision, including training for documentation specialists. To remedy this deficiency, it recommended that institutions offering postgraduate information science or museum studies courses should consider the introduction of one or more modules relating to museum documentation. It has further recommended that the

Museum Documentation Association should advise the proposed Museum Training Council on the appropriate syllabuses for such modules.

At the time of writing (January 1988), the Commission is awaiting a response to the Hale Report from the Government's Office of Arts and Libraries. A favourable response, involving the injection of additional money, is essential if the proposals for a new system of training are to be realised. One point is already clear from the recently completed consultation exercise; the vast majority of people working in museums are supportive of the Hale Report and eagerly await the formation of a Museum Training Council which can set standards and coordinate training provision throughout the United Kingdom.

CONSULTANCY SUPPORT FOR MUSEUMS

32 CONSULTANCY SUPPORT FOR MUSEUMS

TIMOTHY M. AMBROSE

Professional consultants are widely involved in the planning and development of all types of cultural and recreational facilities in the UK, including museums. Consultants in such fields as interpretive planning, economic planning, architecture, design, engineering and landscape architecture are all widely used by organisations without their own in-house specialists. In many cases, teams of professional consultants drawn from a range of specialist areas, either from within parent companies or from companies working in collaboration with each other, are brought together for feasibility assessment, operational reviews or development studies. As the leisure industry has developed in the UK, there has been a corresponding increase in the number of consultants offering specialist services, and this is true of the situation in museums where we may well expect a growth in collections management consultancy in the future. The type of area consultants may be asked to work in are typically but not exclusively:

concept development;

economic feasibility assessment for new visitor facilities;

operational evaluation of existing facilities or systems;

assessment and design of management or collections management systems;

analysis of strategic projects.

I am sure that most of us would recognise that choosing a consultant to meet your particular needs is a task to treat with care and consideration. The best qualified consultant will give the greatest satisfaction all round and the best overall economies. A consultant should offer well-researched, imaginative and practical solutions to the client's needs, which because of scale or complexity lie outwith the client's capabilities.

Selecting the right consultant should avoid such problems as:

incomplete work;

delays;

extra costs;

recommendations which cannot be implemented.

The organisation sponsoring the development project should evaluate the consultants' costs, services and personnel and select consultants who will meet its needs effectively. Rebecca Morgan examines the selection procedure in her paper (Chapter 33).

I would briefly like to draw attention to six selection criteria which are important points for consideration and which may help to focus attention on key issues when considering the papers in this section:

Professional reputation and standing. Assess professional standing through informal discussion with referees;

Experience. Investigate consultants' track record and experience of projects of comparable size;

Staffing. Assess the efficiency of the firm and qualifications/experience of staff in the firm and its sub-contractors or partners;

Quality of work. Acquire references from consultants' former clients and especially note the following needs:

ability to work within agreed budget;
ability to meet time schedules;
amount of creative thinking applied to the job;
management and organisational ability on the project;
sensitivity to client's interest and concern;
amount of time and attention given by the firm's principals;
maintenance problems of facilities or systems now in operation;
progress in implementing planning study's recommendations.

Method and interest. Ensure good working relationship and effective management and operation of project;

Fees. Aim for value for money.

All in all, consultants can provide substantial help to museums, provided both parties maintain a well defined and well managed relationship in their work.

33 THE ROLE OF MANAGEMENT CONSULTANTS

REBECCA MORGAN

This paper addresses the role of management consultants (rather than museum specialist consultants) in the museum environment.

When employing management consultants, you should be looking to them to bring additional, complementary skills, expertise and experience to your project. Expertise and experience remain the attributes of the individual consultants and consultancies, and the skills required will be dependent on the individual project being undertaken. The skills which management consultants can bring in support of museums are wide ranging. The skills are applicable in all sectors of private, public and service industries, the lessons learnt and expertise gained in one area having practical application across all sectors. Examples of skills of this nature are:

Project management, the techniques of which are well understood within the consultancy environment. Good project management ensures that the project is delivered on time and within budget and that areas of potential risk are identified promptly and countered;

Specification and data modelling for, while the majority of users fully understand their requirements, the ability to articulate these needs completely, unambiguously, and in a fashion that can be understood by non-professionals is essential if the project is to deliver the expected systems and associated benefits;

System selection and contract negotiation, is a task that consultants undertake many times in the course of their work. As such they understand the key issues that will effect whether or not the hardware and software can support the required system. Good contract negotiation is essential if all parties are to fully appreciate their responsibilities and if the cash flow associated with the project is to be optimised;

The *implementation* of any system requires major, concerted, controlled effort if it is to run smoothly. Implementation planning experience can be invaluable to ensure that the risks are managed and no facet of the work is overlooked;

Once implemented, *performance measurement* allows the success of the project to be assessed, tangibly and, where necessary, steps taken to rectify problems that are inhibiting delivery.

Such skills enable a wider view than is normally available from within the museum to be brought to projects. However, individual consultants cannot be 'all things to all men'. It is therefore essential that a clear view of the expectations from consultants is gained prior to their being engaged. Employing consultants is a project in its own right and, as such, requires control and management. The key steps that should be undertaken where selecting consultants are:

Definition of need. Ensure that the scope of the task is understood and agreed within your own organisation and that the internal management of the project is allocated and in place;

Discussion. Having determined the scope and, if necessary specific inclusions and exclusions, be prepared to discuss these with the potential suppliers. They can only make informed proposals if they are aware of your needs in terms of the systems, the timescales and your budget;

Selection criteria. Within your organisation agree the criteria against which you will select the consultants. It is difficult to remember all features of a proposal or a presentation if you do not have a checklist against which to work. And, most importantly, the organisation should, in total, be content with the selection made. Preset criteria are essential if this is to be achieved. In agreeing the selection criteria both technical and personal attributes should be taken into account. Do the consultants proposed for the task have the appropriate skills mix and knowledge to meet your need? Additionally, are their personalities and attitudes in tune with those of your staff with whom they will be working?

Interview. Try to ensure that you have the opportunity to meet the people who will be carrying out the work so that the attributes of the individuals can be assessed. Make sure you know the reporting structure within the consultants' firm, so that if problems should occur you know and have access to the senior managers;

Contract. Having decided on a specific consultancy, draw up a contract that ensures that both parties know their responsibilities. The deliverables, timescale and scope should all be specified, if future misunderstandings are to be avoided.

Having acquired your consultants ensure that you manage their work. Insist on regular progress meetings so that you keep in touch with progress and the problems encountered. Set 'milestone' deliverables so that their progress can be monitored.

Finally, having decided to employ consultants, ensure that you get value by listening to their ideas and being prepared to discuss these with them. Consultants are often valued for the 'new view' they can bring to a project, do not minimise their effect by adopting a closed mind attitude to their recommendations. Partially implemented recommendations tend not to deliver the full benefits, so that a receptive management is probably the most vital facet in achieving successful implementation of your projects.

34 PROVIDING DOCUMENTATION AND AUTOMATION CONSULTANCY SUPPORT TO UK MUSEUMS

D. ANDREW ROBERTS

Following Rebecca Morgan's introduction to the role of a consultant (Chapter 33), I would like to comment on the MDAs experience in providing assistance to museums. My viewpoint is that of a museum specific organisation undertaking consultancy as one of a range of functions.

I should clarify the distinction we make between advice and consultancy and how the two aspects of our work interrelate. Stuart Holm has described his role as the MDA's Advisory Officer in carrying out training and providing advice to individual museums (Chapter 25). His work is supported by the grant-aid we received from the Museums and Galleries Commission and other bodies.

In the case of advisory visits, they have until now been provided on demand and free of charge. Training courses are arranged on either a nominal cost or on a cost recovery basis. In effect, the grant aiding bodies are contributing a block sum sufficient to support 150–200 days of consultancy a year, with the recipient museums being relieved of the need to make a direct contribution. If we are able to begin to appoint the network of field staff to which Stuart Holm referred, our ability to provide grant-aided support will dramatically expand, and we will be able to significantly improve the scale of help provided to local museums.

However, with severely limited resources our policy is to restrict the amount of free advisory time given to any one museum to around a half-day or one day visit a year, depending on the circumstances. If you bear in mind the references to the number of museum's in the country — between 2000 and 3000 — that would average out at one half day visit to a specific museum every 10–15 years with the present level of resources. Fortunately, not all museums are equally demanding!

If a museum asks for more substantial support than a brief advisory visit, we then cross the semantic threshold into consultancy. At a basic level, this may involve the museum requesting a formal written report on the advisory visit. Ideally we would like to provide such reports as part of the advisory package, but this is unrealistic with the pressure of work. If a museum does have a specific need, such as for a policy paper for its management committee, then we will encourage a financial contribution to offset the impact on the pool of advisory time.

If we are approached to provide more extensive assistance, we remove the project from the advisory arm of the organisation and treat it from the outset as a consultancy exercise, pulling in one or more staff to carry out the work, as seems appropriate. We have carried out a variety of projects over the years, for both national museums, small local authority museums and a number of outside organisations with related problems, such as archives and historic trusts.

The emphasis of these projects has tended to fall into five categories, with any one client sometimes moving from one category to another. I would like to run through

these categories, as it may help you identify potential roles for consultants in your own institution:

First, an independent evaluation of the museum's existing documentation, automation and collections management procedures. In a large departmental museum this can be a time consuming exercise, involving assessing the distinct characteristics of each working unit. In recent years, the structure of the review has tended to be based on the detailed assessment framework given in the *Planning the documentation of museum collections* book (Roberts, 1985);

Second, an identification of procedural and policy changes that might be needed, usually based on evidence accumulated during a preceding procedural evaluation. This might encompass specific statements about the need for new accessioning, loan or audit arrangements; the need for the museum to establish and adopt formal written policies; the need for revised or extended staff provision; and the need for replacement or new computer systems;

Third, a concentration on computer system alternatives, including an identification of software possibilities and different configuration options. This may either lead to the preparation of a request to be distributed to potential system vendors, or be used by the consultant as a basis for advising on a preferred computer facility. Until now, this has been the area in which we have felt least able to give specific guidance because of the limited number of alternative museum packages. However, the evidence in the conference exhibition (see Chapter 36) has confirmed our impression that we are at last at the point of being able to identify and contrast a number of tailored museum products at three or four price ranges. Similarly, the development of micros and networks and falling system prices has opened up the range of possibilities for museums.

Fourth, following through a procedural development or automation proposal by helping the museum implement the agreed changes, by providing practical support to existing museum staff.

Finally, designing a computer application to meet the agreed system specification. This is where consultancy work merges into another one of our roles of developing software and running a computer bureau. One of our staff — Jennifer Hirsh — specialises in doing applications of our systems. Other staff carry out applications of generic systems such as dBaseIII, if this seems appropriate.

Carrying out this type of work brings problems.

In our experience, UK museums often have unrealistic expectations of the input that can be made by a limited duration consultancy project.

I think there are three aspects to this. First, the museum may be unfamiliar with using consultants in this type of field; Tim Ambrose (Chapter 32) referred to the varied uses in design, etc., but collections management participation is more unusual. Second, the consultants may be reluctant to be firm about the feasible scope of a project. Third, and fundamentally, the museum may lack a member of staff with an immediate responsibility for the documentation or automation areas that are being evaluated. Communication between the museum and the consultant can be limited, causing problems when identifying the remit of the work and when following through its conclusions. This last issue reflects the situation described earlier (Chapter 14), when it was noted that there were only a handful of museums with a specialist documentation officer, registrar or collections manager.

CONSULTANCY SUPPORT FOR MUSEUMS

A related issue is that of cost. Museums — particularly local authority museums — draw breath when quoted consultancy costs, which in the MDA's case range from £200 to £400 per person per day, depending on the circumstances. Perhaps many museums are unconscious of the true cost of employing a senior member of staff?

A further problem which the MDA faces and which I should address is that of being seen to be impartial. We are not alone in being consultants who also have systems to sell and a bureau to promote. As packages such as MODES and TINmus come on stream, this issue becomes more serious. We do try and ensure that we are familiar with the available non-MDA systems and to refer museums to the most appropriate solutions. The current diversification of museum products presents us with a major task in keeping abreast of the options. At least by concentrating our involvement in the museum field, we are aware of the trends.

I feel confident that UK museums will be more receptive to and derive more benefit from the support of consultants in the future, and look forward to a challenging period.

35 MUSEUM AUTOMATION CONSULTANCY IN THE UNITED STATES

LENORE SARASAN

Museum automation consultancy in the United States is rather unusual in that it is generally provided by vendors rather than disinterested third parties. In the United States, as elsewhere, it is relatively difficult for a museum to find out what is happening with museum automation, how to assess one's needs, how to compare different software and hardware, or how to go about doing a project. Museums in other countries seem able to derive much of this information either from non-profit museum organisations, through independent research, and/or through the hiring of data processing consultants. American museums, however, have come to rely largely on vendors to supply most of this information, generally free of charge.

Notwithstanding the question of how appropriate or possible it is for a vendor to provide 'objective' consulting services, the issue of exploitation arises. It is not unusual, for example, to find a museum that intends to develop its own system from scratch calling several vendors and requesting that each travel hundreds or thousands of miles to the museum's site, at the vendor's own expense, to demonstrate their product. No disclosure is made that the museum has no intention of purchasing the software or services of any commercial vendor.

We have been automating museum collections for over ten years. During the last few years we have been asked on various occasions, without offer of remuneration: (1) to spend several days teaching a museum staff how to design and program an automated system because the museum could not afford to buy software or hire a consultant; (2) to provide a museum with the entire design of one of our software packages so that they might base their own system on it and then market it themselves; and (3) following the award of a contract to one of our competitors, to spend a couple of days with the competitor, explaining the special design features of our software so that our competitor could incorporate it into his system.

Whether the kinds of requests described above are based on naïvete, ignorance of business practices, or simply 'nerviness', they reflect a pervasive attitude toward museum automation vendors that is self-defeating to museums. We believe that the best automated collection systems to date have come from organisations, whether profit based or non-profit, that have indicated a genuine interest and commitment to the museum field. Museum automation companies do not generate profits commensurate with large corporations. To continue to provide museums with their services and products, these companies must be able to survive economically. They cannot do so if they give away their services and products and are taken rank advantage of by their potential clients.

There are various reasons why museums in the United States have more and more frequently turned to hardware and software vendors to provide free advice. First, an inability or lack of interst on the part of American non-profit museum organisations to provide quality information about automation. Second, a reluctance on the part of museum personnel to invest the time and energy needed to analyse their own needs

and research the field themselves. And third, a traditional attitude among museums to look for something for nothing, which seems to lead to viewing consultancy fees as prohibitively expensive. This last view is intriguing as various kinds of consultants are routinely used in American museums for a variety of tasks including conservation, exhibition planning, and the automation of financial systems, yet are not commonly found involved in the automation of collection systems.

There are several steps that could be taken to improve the consultancy picture in the United States. Non-profit museum organisations, such as the American Association of Museums, the American Association for State and Local History, the Association of Systematics Collections and the Museum Computer Network need to reassess their contributions and involvement in the area of museum automation. Indeed, some of these organisations currently encourage the attitudes toward vendors described above. There is a great need for these organisations to distribute, at a minimum, such basic automation information as lists of vendors, annotated bibliographies and descriptions of available software packages.

Next, museum personnel need to make a concerted effort to shake loose from a complex of attitudes that, we believe, are crippling them regarding collection automation. Some of these attitudes can be paraphrased as 'we are only a poor museum', 'we cannot afford to do it right but we have to do something', and 'they will never give me the money I need to do the project right, so I will not even ask'. These attitudes lead to museums undertaking technically sophisticated projects without sufficient resources to assure success.

Additionally, museum directors and administrators need to examine their positions *vis-à-vis* collection automation and consider why they are more inclined to take a professional approach to the automation of financial and membership/development activities while taking a shoe-string approach to the automation of collection functions. This practice is particularly ironic in light of the basic reasons and purposes for which most museums exist (that is to collect objects and maintain them and their related documentation) as well as the substantial questions of accountability for objects in the public trust that face institutions today.

Lastly, museum automation vendors must also accept some of the responsibility for the current state of consultancy in the United States. Some vendors discourage museums from seeking professional data processing consultancy and downplay the complexity of an automation project while others are all too eager to provide it themselves.

Museums are making greater and better use of automation today than they were five years ago, or even one year ago. Much of this activity, though, stems from technical improvements in software and hardware, not from improvements in how museums approach automation. For long term success, museums need to apply proven data processing techniques to projects, including the use of professional consultants.

 # COLLECTIONS MANAGEMENT SYSTEMS

36 VENDOR/USER FORUM AND SYSTEMS EXHIBITION

PHILIP DOUGHTY AND D. ANDREW ROBERTS

One feature of the conference was an exhibition of museum computer systems and an open forum at which representatives of the system vendors outlined their products and were questioned by delegates (Table 36.1).

The exhibition provided a valuable opportunity to view a new generation of micro and mini-based collections management systems, suitable for use by a wide range of museums.

Table 36.1 Organisations represented at the conference exhibition and forum

	System	Representatives
Abell Seddon Associates	Reformation	Brian Abell Seddon and Jon Seddon
Assyst Computer Services Ltd	Minisis	Chris Lewis and John Hutton
Databasix Limited	Adlib	Bert Degenhart Drenth and Mike Perry
Erros Computing Services Limited	STIPPLE	Dr Peter Cannon-Brookes, Paul Andersson and Rob Dixon
The Getty Conservation Institute	Conservation Information Network (CIN)	Barbara Snyder
IME Ltd/MDA	TINmus	Annette Herholdt
Master Software Corporation	Masterpiece	William J. D. Bond
The Museum Documentation Association	MODES	Richard Light and Jennifer Hirsh
Southdata Limited	Superfile	Peter Laurie
Vernon Systems	Collection	Bil Vernon, Georgia Lowe and Leigh Brotherston
The Williamson Group	ARTIS	Chris Dougherty
Willoughby Associates	Mimsy, Milam and Quixis	Lenor Sarasan and Marcy Reed

BIBLIOGRAPHY

Items marked * are available through the MDA Booksales Service.

Ambrose, T. M. (1987)
New museums. A start-up guide
Edinburgh: HMSO
ISBN 0 11 493120 8*

American Association of Museums (1984a)
Museums for a new century
A report of the Commission on Museums for a New Century
Washington, DC: American Association of Museums
ISBN 0 931201 08 X*

American Association of Museums (1984b)
Caring for collections. Strategies for conservation, maintenance and documentation
Washington, DC: American Association of Museums*

American Association of Museums Registrars Committee (1985)
Code of ethics for registrars
Washington, DC: American Association of Museums*

American Association of Museums Registrars Committee (1986)
Code of practice for couriering museum objects
Washington, DC: American Association of Museums*

Andrews, D. and Greenhalgh, M. (1987)
Computing for non-scientific applications
Leicester: University Press

Anon. (1976)
Minimum standards for professional museum training programs
Museum News (Nov/Dec), 19–26

Bearman, D. (1987a)
Functional requirements for collections management systems
Archival Informatics Technical Report, 1(3)*

Bearman, D. (1987b)
Automated systems for archives and museums: acquisition and implementation issues
Archival Informatics Technical Report, 1(4)*

Boylan, P. J. (1986)
Museums and the information technology revolution — the museum management and training challenge
In P. Van Mensch (ed). *The management needs of museum personnel*
Leiden: Reinwart Studies in Museology, 5, 67–84

Brunton, C. H. C., Besterman, T. P. and Cooper, J. A. (eds) (1985)
Guidelines for the curation of geological materials
London: Geological Society
ISBN 0 903317 30 3*

Case, M. (1987)
Smithsonian Institution collections management issues
Draft for discussion

Cato, P. S. (1986)
Guidelines for managing bird collections
(Museology, 7)
Lubbock, Texas: Texas Tech Press
ISBN 0 89672 130 2*

Coggins, C. (1969)
Illicit traffic in Pre-Columbian antiquities
Art Journal, 29, 94

Cushman, K. (1984)
Museum studies: the beginnings, 1900–1926
Museum Studies Journal, 1, 8–18

De Borhegyi, S. (1965)
Curatorial neglect of collections
Museum News, 43, 34–39

De Marco, T. (1978)
Structured analysis and system specification
New York: Yourdon

Dudley, D. H. and Wilkinson, I. B. (eds) (1979)
Museum registration methods
Washington, DC: American Association of Museums*

Edwards, L. (1985)
Report on fiscal data for the Biological Resources Program
Washington, DC: National Science Foundation

Fletcher, A. (1986)
Computerizing records from Leicestershire's museums
In Light, Roberts and Stewart, 1986
Pages 182–89*

Finlay, G. (1985)
Material history and curatorship: problems and prospects
Muse, 3, 34–39

Freeman, C. (1986)
The diffusion of innovations — microelectronics technology
In R. Roy and D. Wield. *Product design and technical innovation*
Philadelphia: Open University Press
Pages 193–200

Gallacher, T. (1982)
Role specialization and collections management
Gazette, 15, 24–29

Gautier, T. G. (1986)
National Museum of Natural History, Smithsonian Institution
In Light, Roberts and Stewart, 1986
Pages 48–54*

Genoways, H. H., Jones, C. and Rossolimo, O. L. (eds) (1987)
Mammal collection management
Lubbock, Texas: Texas Tech Press
ISBN 0 89672 157 4*

Gomon, J. (Chair), C. Bright, S. Cairns, F. Collier, C. Green, G. Hevel, D. Lellinger, W. Melson, V. Springer and R. Thorington (1987)
Report of Task Force on Collections to Robert S. Hoffman, Director
Washington: National Museum of Natural History, Smithsonian Institution

Graham, R. M. quoted in D. Hussain and K. M. Hussain (1984)
Information resource management
New Mexico State University (Richard D. Irwin, Inc.)

Halpin, M. (1987)
Quality and the post-modern museum
A paper prepared for the CMA Trainers Workship, *Delivering Quality Training*
Ottawa, 19 August 1987

Jones, S. G. and Roberts, D. A. (eds) (1985)
The Data Protection Act and museums. Implications for collection documentation
(MDA Occasional Paper, 8)
Cambridge: MDA
ISBN 0 905963 55 5*

Lancaster, F. and Smith, C. (1983)
General Information Programme and UNISIST — compatibility issues affecting information systems and services
Paris: UNESCO. PG1–83/WS/23

Lewis, G. D. (1983)
Learning goals in museum studies training
In Methods and techniques of museum training: the Leicester symposium 1979
Leicester: ICTOP
Pages 14–29

Light, R. B., Roberts, D. A. and Stewart, J. D. (eds) (1986)
Museum documentation systems: developments and applications
London: Butterworths
ISBN 0 408 10815 0*

McIntyre, D. (1987)
Developments in Australian museums since the 1970s: an overview
Museum, 39, (155), 169–75

Malaro, M. C. (1979)
Collections management policies
Museum News (Nov/Dec), 57–61

Malaro, M. C. (1985)
Legal primer on managing museum collections
Washington, DC: Smithsonian Institution
ISBN 0 87474 656 6*

Malt, C. (1987)
Museology and museum studies programs in the United States: part one
International Journal of Museum Management and Curatorship, 6, 165–72

Martin, J. (1984)
An information systems manifesto
Englewood Cliffs, New Jersey: Prentice-Hall Inc.
ISBN 0 13 464769 6

BIBLIOGRAPHY

Meyer, K. E. (1973)
The plundered past
New York: Atheneum Press

Museum Documentation Association (1981)
Practical museum documentation
Second edition
Cambridge: MDA
ISBN 0 905963 41 5*

Museums and Galleries Commission (1986)
*Review of the Museum Documentation
Association*
London: Museum and Galleries
Commission
(Limited circulation)

Museums and Galleries Commission (1987)
*Museum professional training and career
structure*
Report by a Working Party (The Hale
Report)
London: HMSO
ISBN 0 11 290455 6*

Museums Association (1987)
Code of practice for museum authorities
Code of conduct for museum curators
In Museums Yearbook 1987
London: Museums Association
ISBN 0 902102 61 3
Pages 6–14*

Orna, E. (1987)
Information policies for museums
(MDA Occasional Paper, 10)
Cambridge: MDA
ISBN 0 905963 60 1*

Orna, E. and Pettitt, C. W. (1980)
Information handling in museums
London: Library Association
ISBN 0 85157 300 2*

Paine, C. (1986)
The local museum
London: AMSSEE
ISBN 0 904752 03 8*

Porter, R. (1984)
The future of museum registration
Museum News, 62, 5–9

Porter, D. R. (1985)
Current thoughts on collections policy
(AASLH Technical Report, 1)
Nashville, Tenn.: AASLH*

Porter, D. R. (1986)
Developing a collections management manual
(AASLH Technical Report, 7)
Nashville, Tenn.: AASLH*

Price Waterhouse Associates (1985)
*National Museums of Canada: report on the
Survey of Collections Management Practices and
the Use of Technology in Canadian Museums,
1984*

Reibel, D. (1978)
Registration methods for the small museum
Nashville, Tenn.: AASLH

Roberts, D. A. (1985)
*Planning the documentation of museum
collections*
Cambridge: MDA
ISBN 0 905963 53 9*

Roberts, D. A. (1986a)
Documentation advice and training
development and career structure
MDA Information, 10, 18–25*

Roberts, D. A. (1986b)
*The state of documentation in non-national
museums in south-east England*
(MDA Occasional Paper, 9)
Cambridge: MDA
ISBN 0 905963 57 1*

Rogers, E. M. (1986)
Elements of diffusion
*In R. Roy and D. Wield. Product design and
technical innovation*
Philadelphia: Open University Press
Pages 184–92

Royal Ontario Museum (1982)
*Statement of principles and policies on ethics and
conduct*
Toronto: Royal Ontario Museum
ISBN 0 8854 291 7*

Sarasan, L. (1981)
Why museum computer projects fail
Museum News (Jan/Feb), 40–49

Sarasan, L. (1986)
A system for analysing museum
documentation
In Light, Roberts and Stewart, 1986
Pages 89–99*

Sarasan, L. (1987)
What to look for in an automated collections management system
Museum Studies Journal, 3 (1), 82–93

Sarasan, L. and Neuner, A. M. (1983)
Museum collections and computers
Report of an ASC survey
Laurence, Kansas: Association of Systematic Collections
ISBN 0 942924 03 7

Schulman, J. L. (1986)
The Detroit Art Registration Information System (DARIS)
In Light, Roberts and Stewart, 1986
Pages 77–88*

Slate, J. (1985)
Caring for the nation's common wealth. A national study assesses collections management, maintenance and conservation
Museum News, *64*, 38–45

Stansfield, G. (1985)
Collection management plans
Museum Professional Group News, 20

Tanner-Kaplash, S. (1986)
The Royal Ontario Museum, Toronto
In Light, Roberts and Stewart, 1986
Pages 25–34*

Taylor, L. W. (ed) (1987)
A common agenda for history museums
Conference proceedings, 19–20 February 1987
Nashville, Tenn.: AASLH
ISBN 0 910050 89 9

Thompson, J. M. A. (ed) (1986)
Manual of curatorship. A guide to museum practice
London: Butterworths
ISBN 0 408 01411 3*

University of Leicester (1984)
Review of the academic development of the Department of Museum Studies
Leicester: University. Board of Museum Studies. (Limited circulation)

University of Leicester (1987)
Learning goals for museum studies training
Leicester: University Department of Museum Studies

University of Melbourne (1971)
University of Melbourne catalogue of works of art
Catalogue of works of art in the University and its affiliated colleges, with a catalogue of the collection in the Department of Classical Studies
Melbourne: The University
ISBN 0 909454 00 0

Van de Voort, J. P. (1986)
The MARDOC project of Dutch maritime museums
In Light, Roberts and Stewart, 1986
Pages 257–64*

Varveris, T. (1980)
Cataloguer's manual for the visual arts
Sydney: Australian Gallery Director's Council
ISBN 06429 0841 9

Varveris, T. (1986)
A documentation system for Australian art museums
In Light, Roberts and Stewart, 1986
Pages 295–304*

Waddington, J. and Rudkin, D. M. (eds) (1986)
Workshop on care and maintenance of natural history collections. Proceedings
Toronto: Royal Ontario Museum
ISBN 0 88854 327 1*

Wald, P. (1974)
In the public interest
Museum News, 30–32

Weil, S. (1986)
Questioning some premises
Museum News, 64, 20–27

Williams, D. W. (1987)
A guide to museum computing
Nashville, Tenn.: American Association for State and Local History
ISBN 0 910050 86 4*

INDEX

■Stipple

Data management for the 1990s

Stipple Database Services Ltd.

Warren House, Thame Lane, Culham,
Oxfordshire OX14 3DT United Kingdom

Tel: (0) 235 24676